XXX:THE POWER OF SEX IN CON

WRITTEN AND DESIGNED BY PLAZM WRITING: SARAH DOUGHER

First published in the United States of America by
Rockport Publishers, Inc.
33 Commercial Street
Gloucester, Massachusetts 01930-5089
Telephone: (978) 282-9590
Fax: (978) 283-2742
www.rockpub.com

Library of Congress Cataloging-in-Publication Data
Berger, Joshua.
 XXX : the power of sex in contemporary design / Joshua Berger.
 p. cm.
 ISBN 1-56496-947-9 (hardcover)
 1. Graphic arts—United States—History—20th century. 2. Commercial
art—United States—History—20th century. 3. Sex in art. I. Title:
Triple X. II. Title.
 NC998.5.A1 B467 2003
 760'.04428—dc21 2002153976

ISBN 1-56496-947-9

10 9 8 7 6 5 4 3 2 1

Words and Images by Plazm
 Writing: Sarah Dougher
 Design: Joshua Berger
 Photography: Jeremy Bittermann

Printed in Hong Kong

CONTENTS

FOREWORD BY DAN SAVAGE 9
INTRODUCTION 10

1. GENDER: MASCULINITY, FEMININITY, DUALITY 12
2. REPRESENTING DESIRES 38
3. POWER DYNAMICS: AGE AND RACE 74
4. FETISH AND S&M 108
5. ROMANCE AND FANTASY 128
6. THE SEX ACT 156

 CONTRIBUTORS 186
 BIBLIOGRAPHY 188
 ABOUT THE AUTHORS 190

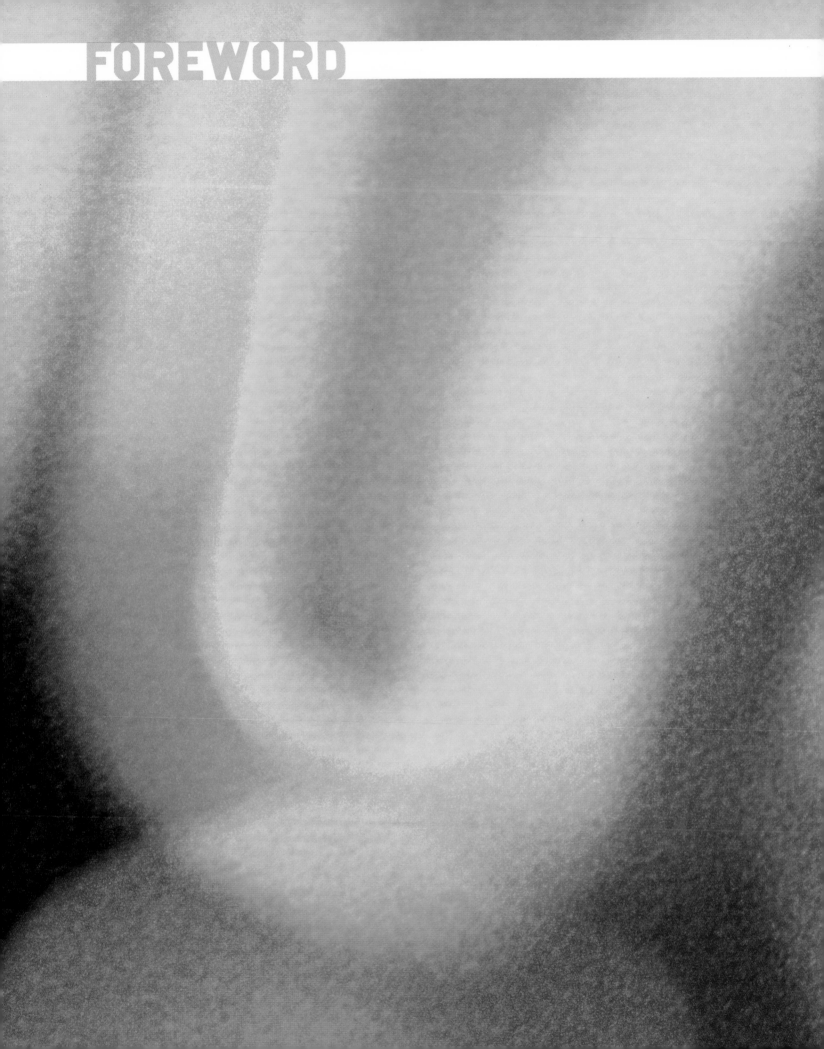

FOREWORD

Microwave ovens weren't something I'd ever given much thought. My mother bought one of the first brands available to the general public in the late 1970s, from Sears I think, and I used it every once in a while to heat up the odd hot dog or conduct an occasional scientific experiment. (What happens if you don't stop heating up a hot dog? It burns to a crisp from the inside out. Really.) As an adult, I never owned a microwave oven and I never really wanted one...until that ad started appearing on buses all over town. You probably saw this ad, as it was everywhere: A shirtless guy in jeans was balancing a microwave oven on his hip, the oven was cocked at a rakish angle, with one arm holding the top of the oven, and the other hanging down at his side. Oddly enough, it wasn't a new brand of portable microwave ovens that this shirtless guy was carrying around, but a full-size, countertop microwave oven. You couldn't see the guy's head (the picture was cut off at the neck), but you could see his abs, his shoulders, and his glorious, hairless chest.

The ad had its intended effect: After a single viewing (I saw the ad on the side of a bus), I was transformed from an adult who didn't give much thought to microwave ovens into an adult who could barely think of anything else.

Ah, the power of sex in graphic design. Sex in graphic design is, as author Sarah Dougher points out, ubiquitous. Sex is used to sell us absolutely everything—up to and including this book. While some complain that sexual images are overused in graphic design, those of us who own microwave ovens are evidence that sex in graphic design is wildly effective and, consequently, not going to die out anytime soon. The ability of a hot, humpy, cutting-edge photo or image to sell us something as tame and mundane as, yes, a microwave oven, all but guarantees the continued presence of good-looking naked bodies on buses, billboards, and in magazines. Since humans evolved to have sex more than once or twice in our long lives, our interest in sex, and our willingness to stare at pictures of people we would like to have sex with (even if they're standing there with a microwave oven tucked under one arm), is everlasting. And for those of us who can stare at naked people without feeling one iota of guilt, the ubiquity of sex in graphic design is a good thing.

But it wasn't always so, of course; once upon a time, sex wasn't used to sell us much of anything. Women's bodies began to be used to sell us cars and toothpaste, then men's bodies were used to sell us jeans and cigarettes, and then all hell broke loose. While we will never be able to stop the constant flow of sexual images that pour forth—and why would we want to stop them anyway?—we can and should understand their provenance, and how they work on us, and what the designers thought they were doing or hoped to achieve. Understanding why and how designers use certain images doesn't make them any less pleasurable to look at, but it does make it somewhat more difficult for you, the consumer, to be manipulated by the designer. Which is why a book like this one, in addition to being titillating, is actually useful and important. Look at the pictures, read the text, and learn.

Then, with any luck, you will be able to enjoy the ad without actually buying the microwave.

—Dan Savage

Syndicated sex columnist of "Savage Love" and author of *Savage Love: Straight Answers from America's Most Popular Sex Columnist*, *The Kid: What Happened After My Boyfriend and I Decided to Go Get Pregnant: An Adoption Story*, and *Skipping Toward Gomorrah: The Seven Deadly Sins and the Pursuit of Happiness in America*.

INTRODUCTION

Sex in graphic design is as ubiquitous as it is mundane. Its sheer omnipresence dulls the dynamic nature of human sexuality, yet it somehow never ceases to shock, titillate, or sell. In the late twentieth century, Western visual culture has become increasingly permissive with respect to the representations of sex and sexuality. Simultaneously, the culture surrounding us has created and re-created social rituals about sex and sexuality. The striking feature of most contemporary graphic design that uses elements of sex is its repetition. For the most part, normative gender categories and the visual lexicon of the sex act remain strikingly static despite the increasing prevalence of nonnormative sex and sexuality in public discourse. Since the publication in 2000 of *Sex Appeal: The Art of Allure in Graphic and Advertising Design*, edited by Stephen Heller, there has been no attempt to catalog and describe the role that sex and sexual imagery play in contemporary international graphic design. Contributors to *Sex Appeal* use a variety of writing styles to discuss the theme: theoretical analysis, fiction, and simple captioning.

XXX: The Power of Sex in Contemporary Design presents and describes graphic design that challenges the standard representative visual lexicon. We also seek to show how radical design often contains conventional assumptions about sex and sexuality. We include other images that, while not challenging in their graphic elements, contain messages that may test the boundaries of the conventional. *XXX* is organized thematically to best address the design that interests us and the theoretical discussion that has grown around the study of sex and sexuality.

It is essential to begin any discussion of the representation of sex with clear descriptions of what constitute gender, gendered bodies, and gendered acts. We do not take the masculine-feminine binary as our basis for understanding the range of gender expression in today's design. Rather, our discussion explores departures from standard gender representation and describes some of the more radical versions of gender in contemporary visual culture.

Chapter 2 explores the idea of sexuality primarily expressed as a desire for someone or something. Interlaced as it is with venues for consumer culture, the choice of objects in graphic design fans out among bodies and products, sometimes allying desires, sometimes differentiating them. The power hierarchies present in representations of race, age, and class show off not only highly conventional assumptions, but also how these assumptions interface with notions of gender and object choice. To be rich, white, and young is still the most standard and repetitive representation in graphic design, especially in advertising. The images in *XXX* often serve to describe our visual culture's underlying assumptions about these categories, and relate the few nonnormative representations to their rhetorical context.

In graphic design, environments and settings for the representations of sex and sexuality can be as important as bodies and what they do (or don't do). Chapters 4 and 5 explore the rise of sadomasochism (S&M) culture and fantasy as variations of this environment. S&M, from its origins in gay male culture to its mainstreaming in fashion and design, provides visual languages for sexual power and hierarchy in a potentially nongendered and culturally deviant manner. Our chapter on fantasy describes common scenarios and contexts in which sex and sexuality play roles, often exploiting hierarchy and the inversion of power structures to communicate possibility and—consciously or unconsciously—to reinforce stereotypes of gender, class, race, and sexual orientation.

In our concluding chapter, we discuss the role of the sex act, in many ways the central fact of, but also the most absent signifier in our study. The line between design and pornography is demarcated by intention, and also by the style and care with which it is designed. We do not feature porn in this book (and in fact our printer in Singapore refuses to print any representations of erect penises). Nevertheless, the sex act is well represented through implication, most directly with the subject of AIDS education and prevention. Condom manufacturers and public health agencies make valiant efforts to advertise the obvious benefits of safe sex, and designers come up with more beautiful and explicit renderings of this message. The reality of AIDS forces designers to create work that reflects reality and helps to change it. The most important issue in writing this book has been to present images as graphic designs as well as cultural artifacts. Realities such as the world AIDS crisis, gender inequity, or the repetition of stereotypes of class and race cannot help but inform our reading of these images. They exist in a dynamic relationship to this culture, in an ever-evolving relationship of reflection and creation.

Graphic design is stabilized in large part by economic demands, and the relationship of sex to capital is a complex one. We will address this subject at all times but by no means completely throughout the book. Although some of the art we feature in this book appears to exist outside of capital, we remain aware of the way that business defines ideas like sexuality and gender throughout all its mechanisms—not just advertising. The realms of entertainment, fashion, politics, and technology are all defining forces in our comprehension of sex and sexuality in graphic design, and they are themselves largely defined by capital.

1.GENDER: MASCULINITY, FEMININITY, DUALITY

In seeking to understand gender's role in contemporary graphic design, we have chosen to use the work of 1990s feminist and gender-studies theorists to provide useful categories by which to view these images. Theorists such as Judith Butler, Esther Newton, Gayle Rubin, and Judith Halberstam view gender—the categories of masculinity and femininity—fundamentally as cultural constructions, complex performances of social roles with a dynamic relationship to the physical body. Gender is not a natural category determined by specific genitalia or secondary sex characteristics. Rather, it is a set of practices that, when linked with particularly sexed bodies, appears as normative and/or deviant. Because the performance of gender roles is an essential ingredient in any representation of sex, it is central to our analysis of sex in contemporary graphic design.

Although most elaborately applied to film, drag, and other performance categories, the idea of gender as a non-natural category is useful for understanding the way sex works in graphic design. When we speak of graphic design, we almost always speak of the way images are used in the workings of the market, within a web of consumer desire and satisfaction via advertising, package and poster design, fashion stories, or print-media design. It is the designer or art director who "performs," expressing gender within these arenas. The requirements of the client and, ultimately, of the consumer, influence in part how a designer chooses to represent gender. Such requirements, which vary according to the product and target consumer, nonetheless result in design that generally reverts to a normative representation of gender.

Stephen Heller observes that because of the pervasive nature of sex in design, "recurrence is the reason for continual reinvention. What was once shocking—and shock is the key to grabbing consumer attention—quickly becomes ordinary" (Heller 2000, xv.). Flipping through any magazine with advertising makes clear the truth of this statement. However, it is sex that is used to shock, and not shifting gender categories.

Why is this the case? Why would gender categories of masculine and feminine remain relatively stable, while the boundaries of sexual permissiveness continue to be tested? And what is the relationship between these issues if we have already determined that representations of sexuality are built on those of gender? We want to call into question assumptions about the differences between who people *are* (man, woman) and what they *do* (have sex). Boundaries between *being* and *doing* are less stable than they initially appear. By assuming the dynamic nature of gender, and by acknowledging the role of power in these formations, we intentionally dislocate gender categories of "masculine" and "feminine" from sexed bodies and from sex acts.

In his long history of work with the music industry, particularly the punk scene of 1980s and 1990s Seattle, Art Chantry often used imagery that challenged traditional gender attributes. In his poster for the rock band Flaming Lips [page 16], he uses the body of a transvestite to evoke a standard crotch shot. The irony was apparently lost on the club's management, which rejected the poster for being "offensive to women." In the CD packaging for the band Cookie, Chantry again leads the viewer to question the gender of the represented figure, who is half "man" and half "woman." However, the gendered characteristics—short hair vs. long hair, eye makeup, tough jaw line—are disconcerting, since these characteristics look like drag costuming. Turning the CD over, we get a glimpse of the band in a photograph. Their gender characteristics are particularly prominent and call into question the viewer's "natural" systems of gender identification.

Chantry's album covers for the Seattle band Mono Men [page 18] use 1950s pinup images of hyperfeminine women, creating an ironic statement about gender. This "wrecker" (of homes? of men?) plays on the pervasive characterization of a potentially destructive woman who is nonetheless naked. These designs are the first in a series of 7-inch records that featured naked women on the front and exploding drag race cars on the back. Once more, women are characterized as powerful and potentially destructive, yet vulnerable. Chantry often takes up the paradoxical female figure who is both strong and even militant [page 24] (as demonstrated by her sash-qua-bullet belt)—but also sexually available and vulnerable. Hysteric Glamour's images [page 24] are similar inasmuch as the tokens of power (women resembling a famous revolutionary icon or a Greek warrior) are simultaneously vulnerable, and not supported by any power other than sexual allure, belying the effectiveness of their militancy.

Hypermasculine images challenge the viewer as well. For his large hardcover art book on the male nude, the photographer Rankin located models by placing an ad in London's *Time Out* magazine, seeking nonprofessional "everyday" male bodies; men of all ages, body types, and ethnicities stepped forward for the project. Sea Design was charged with designing this book as a follow-up to Rankin's 1999 *Nudes* (female nude models). The images in the book provoke the question—what do we do with naked men? "Naked women come already supplied with a narrative," Rankin wrote in the introduction. With men, much of the narrative comes in the humor with which these bodies are presented: penis in a hot-dog bun, man in a kilt blown up, man looking at his own penis in a mirror—not particularly sophisticated humor, but humor nonetheless. In other images, the male body is obscured by a baby, or Saran wrap, or someone else's hands. Hiding the parts—keeping them in control—seems to be the other end of the spectrum for Rankin. The striking cover image of a black man with fake nails and a feather headdress is further controlled by Rankin by never allowing the face to show [pages 34–35]. The intrigue of genderbending drag exists on a faceless body, which ironically invites you to open the book and peer inside.

Categories of gender, as opposed to sex practices, are slower to morph within the context of graphic design (and perhaps more importantly in the context of early twenty-first century culture) because their attributes are so fundamental to the manner in which power is represented. Challenges to the existing representations of power structures through non-normative gender categories do not shock; they are instead relegated to deviant expression and, ultimately, disregarded. Thus, although they momentarily disrupt or even invert convention, they are put squarely in their place through repressive cultural norms that refuse to allow them into the mainstream. Often, the social construction that is represented feels the sting of political marginalization as well.

Perhaps the most disconcerting gender identification is located in the realm of androgyny—a fundamentally reactive identification since it defines itself against both femininity and masculinity, but contains them both. In the language of design it is represented either as a human figure containing no obvious sex traits, or a figure with an excess of both masculine and feminine traits. In a German advertisement for a "unisex hairstyle" [page 17], Cayenne Werbagentur splices unisex-hairstyled heads onto other body parts, both male and female. The effect is disconcerting because it places male heads on female torsos, with male lower halves, and follows through the campaign with variations on this theme. The images are

effective because they question gendered beauty standards and suggest that although the product they advertise is unisex, androgyny (of hairstyle) is something a person can generally choose easily, unlike the gender characteristics one is born with.

Mirko Ilic represents androgyny more abstractly, describing the intricacies of sexual organs and the sex act without actually making direct representations. Instead, he works with shape and texture in a manner that suggests sweat, semen, hair, a shaft, or a hole. The evocative and yet indefinable forms are often placed on bright backgrounds, and their surfaces look textured with lacquer, conveying a smooth and placid feel. At the same time, the dripping, straining, inserting, licking, wiggling, and knotting together dramatically infuse these images with motion. We recognize them as male and female only by metaphorical distance, in a manner similar to the way carpenters call any manner of protruding or holelike tools male or female.

The gendering of language, a foreign concept to English speakers, gives the advertising campaign for a men's fragrance called Lynx a humorous effect. The Lynx ads, created by Bartle Bogle Hegarty (BBH), have built on a tradition of self parody with an award-winning campaign that features beautiful women losing control to ordinary men due to the "Lynx Effect." The latest idea takes a new angle on attraction to the Lynx-wearing hero by associating feminine qualities with inanimate objects. The playful situations include a cement mixer pulling the bedcovers from a man in bed, and a chair trying to take a peek at a man in the bath. [page 21] The campaign was written and directed by BBH creatives Matt Waller and Dave Monk, who came up with the concept of the French feminine objects, and studied a French/English dictionary to find the appropriate characters for the ads. The typeface was designed to resemble school textbooks, and the photographic style is similarly stark and simple.

The most interesting challenges to the binary gender code of hypermasculinity and hyperfemininity come when gender performance is being explicitly represented. Otherwise, it is not immediately obvious that gender is a concept that goes beyond "natural" categories. The most familiar way of recognizing gender performance is in the act of the drag queen: a man dressed as a woman, generally performing in some capacity. Esther Newton describes drag as a way that allows discontinuities between gender and sex to exist without representing a dysfunctional relationship to either gender or sex. That is, we are comfortable seeing a representation of a man dressed as a woman, as long as we are aware of the ruse. Otherwise, transgressive representations of gender become much more complicated and are generally not a part of mainstream design. In addition, transsexual and transgender representations have yet to enter mainstream design culture in any significant way.

Although sex radicals in other cultural contexts such as music, contemporary art, literature, and performance are redefining gender in a way that complicates received notions of the gender binary, graphic design has yet to make significant inroads in this redefinition. In part this is because so much graphic work is stabilized, for better or worse, by the marketplace and a general audience with a common visual language, which has a low tolerance for ambiguity. However, this ambiguity fuels new discourses on gender identity, and we hope it will soon find its way into the common visual culture.

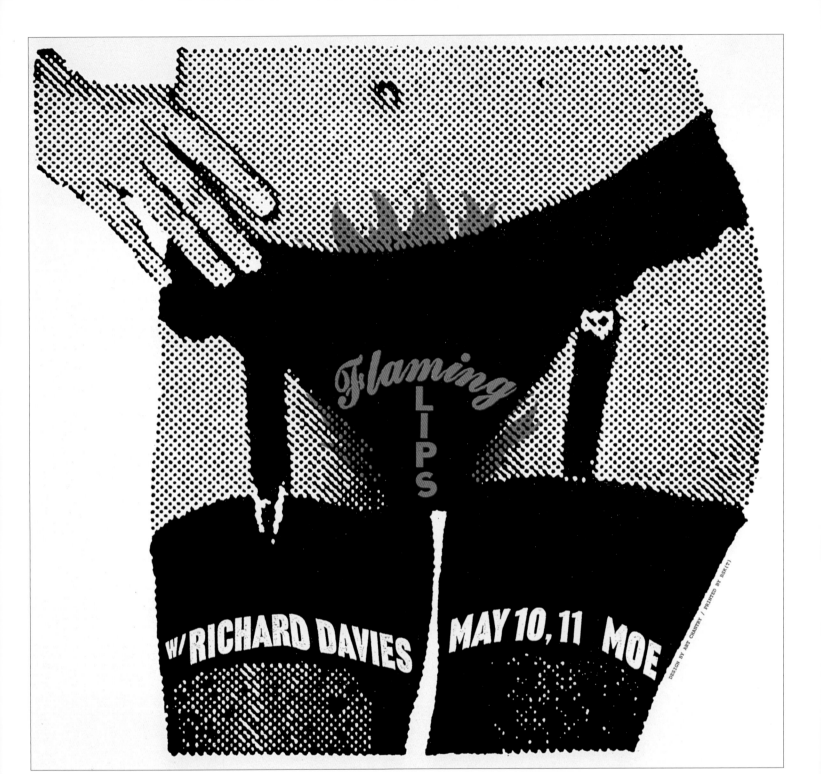

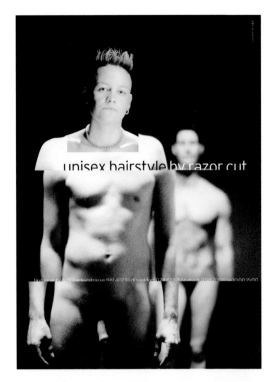 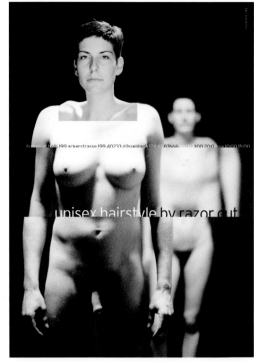

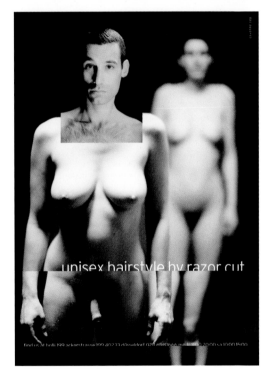 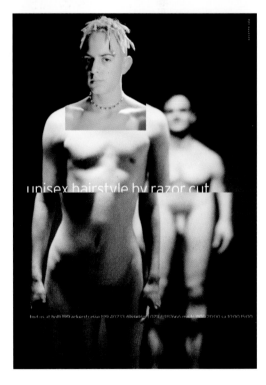

◄ Title: Flaming Lips poster
Designer: Art Chantry
Studio: Art Chantry Design Co.
Client: Moe
Client Services: rock 'n' roll club

Crotch shot with a twist, this representation
of a transvestite confounded club owners who
refused to use the poster on account of its
"offensiveness to women."

▲ Title: Unisex
Art Direction: Bernd Bucker
Typography: Lars Monshausen
Photographer: Thomas Jape
Studio: Cayenne Werbagentur
Client: Holli 199
Client's Service: Hair styling

Cybertransformation or just a haircut?
"Unisex" goes a long way toward dislocating
sex traits from outward identity (via the hair-
cut), making androgyny, at least as a fashion
statement, available to all.

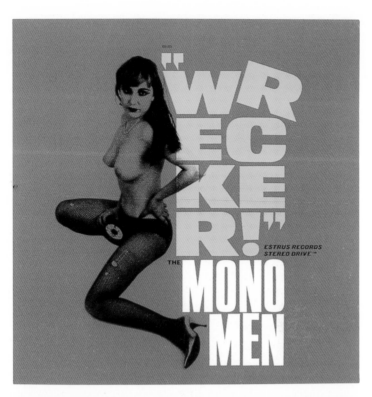

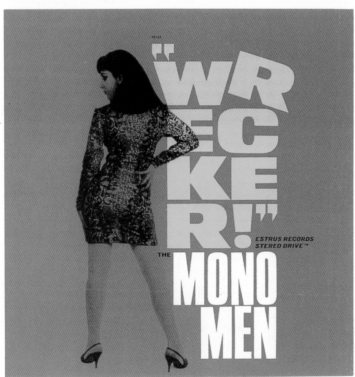

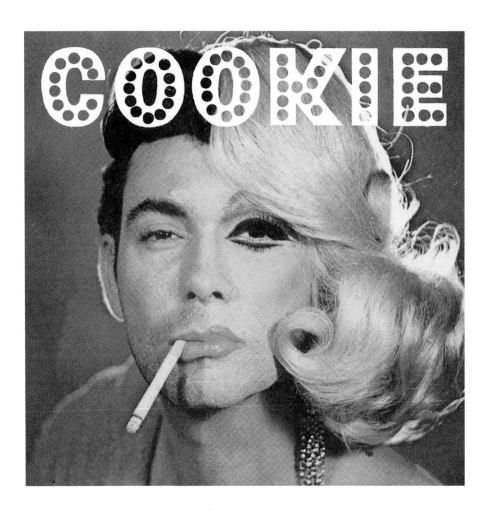

Title: Wrecker 1 and 2
Designer: Art Chantry
Studio: Art Chantry Design Co.
Client: Mono Men
Client Service: rock 'n' roll band

Saturated with irony, Chantry's album sleeve designs for the Mono Men exploits stereotypes of women and men to create a clever commentary on "normal" gender roles.

Title: Cookie CD cover
Designer: Art Chantry
Studio: Art Chantry Design Co.
Client: Infect Records

For the band Cookie, Art Chantry manipulates gender codes to dislocate viewer expectations of masculine and feminine characteristics, and ends up creating something that looks half drag king and half drag queen.

Title: Aphex Twin—*Windowlicker*
Studio/Designer: The Designers Republic
Photographer: Chris Cunningham
Client: Warp Records LTD

By placing the artist's face on top of a woman's body, this CD cover creates a monstrous amalgamation of male and female genders. In so doing, the designer gives the stereotypical attributes of the normative woman's body (big breasts, small waist, big hips, all visible in the bikini) a new context. It questions the gender binary's codes of attractiveness, but ultimately leads to one of two conclusions: bearded woman or Photoshopped man?

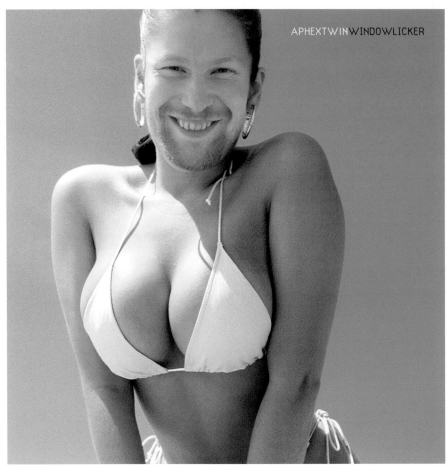

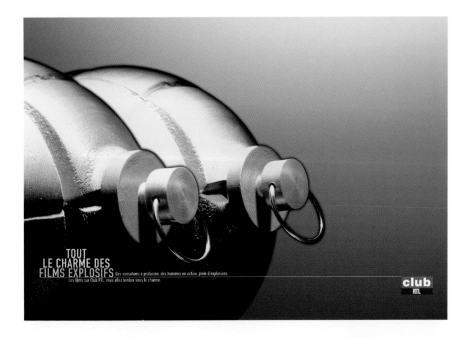

TOUT
LE CHARME DES
FILMS EXPLOSIFS Des sensations à profusion, des hommes en action, plein d'explosions.
Les films sur Club RTL, vous allez tomber sous le charme.

club
RTL

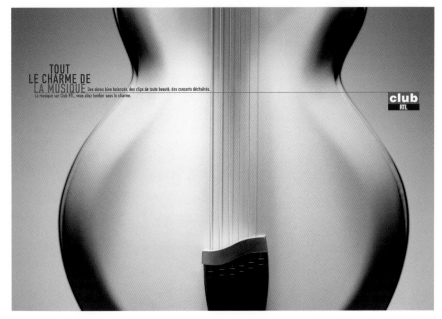

TOUT
LE CHARME DE
LA MUSIQUE Des slows bien balancés, des clips de toute beauté, des concerts déchaînés.
La musique sur Club RTL, vous allez tomber sous le charme.

club
RTL

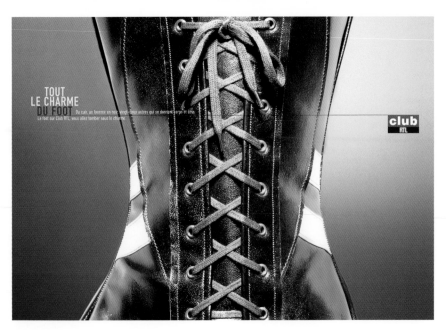

TOUT
LE CHARME
DU FOOT Du cuir, un homme en noir, vingt-deux autres qui se donnent corps et âme.
Le foot sur Club RTL, vous allez tomber sous le charme.

club
RTL

Title: Toutes les Charmes
Art Director: Claudine Mergaerts
Designer: RTL Color
Photographer: Christophe Gilbert
Studio: EURO RSCG
Client: RTL TV station

Abstracted objects made to look like women's body parts comprise this campaign to reposition the Club RTL TV station to a younger core target: men 18 to 35 years old. The objective was to make the TV station particularly attractive to young men and to suggest that the new programs of Club RTL are sexier and more appealing than the competition.

Title: Lynx Effect
Creative Director: Rosie Arnold
Art Directors: Dave Monk, Matt Waller
Copywriters: Matt Waller, Dave Monk
Photographer: Malcom Venville
Typography: Chris Chapman
Client: Elida Fabergé
Agency: Bartle Bogle Hegarty (BBH)
Product: Lynx (Known as AXE outside the UK)
Distribution: UK

The attraction supplied by Lynx men's cologne makes even inanimate objects—with feminine gender designation in French—rush to the man who wears it. The effect is humorous on one level. On a deeper reading, which is certainly not the aim of the ad, the images of "feminine" desire are mechanized, monstrous, and uncontrollable. This is the Lynx Effect.

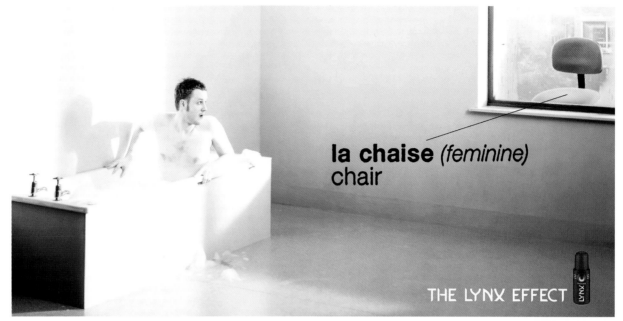

la chaise *(feminine)*
chair

THE LYNX EFFECT

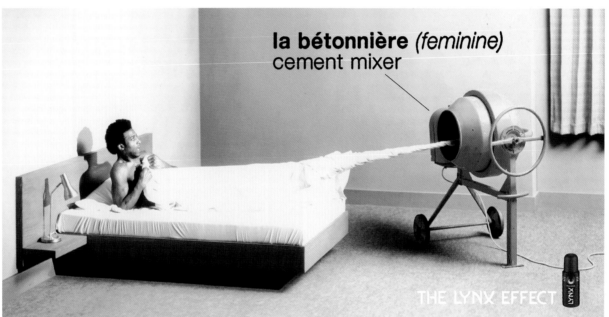

la bétonnière *(feminine)*
cement mixer

THE LYNX EFFECT

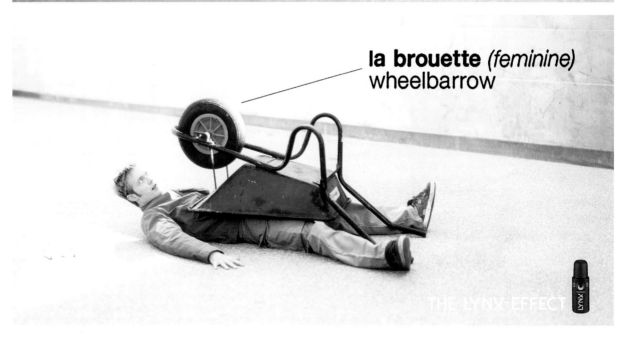

la brouette *(feminine)*
wheelbarrow

THE LYNX EFFECT

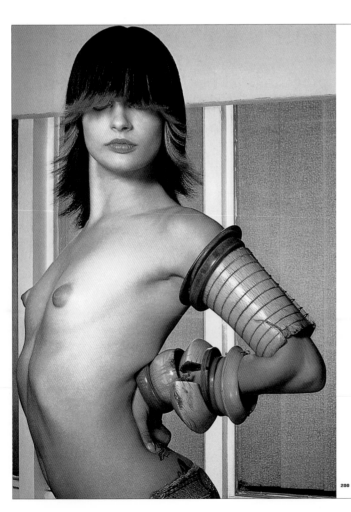

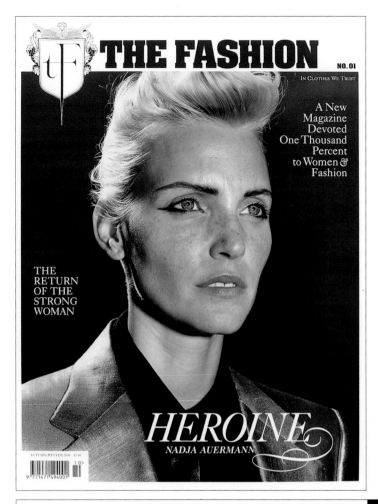

THE FASHION NO. 01

IN CLOTHES WE TRUST

A New Magazine Devoted One Thousand Percent to Women & Fashion

THE RETURN OF THE STRONG WOMAN

HEROINE
NADJA AUERMANN

AUTUMN/WINTER 2000 $5.00

Title: Cover and spreads of *The Fashion*
Art Director: Markus Kiersztan
Designer: Markus Kiersztan
Client: *The Fashion*

Although androgyny has permeated fashion in the West since the mid-1970s, this cover proclaims "The Return of the Strong Woman." In addition to looking much like a man, this variation of female "strength" garners her fashion accoutrements from a butch aesthetic.

For me, cutting hair is architecture with a human element - Vidal Sassoon

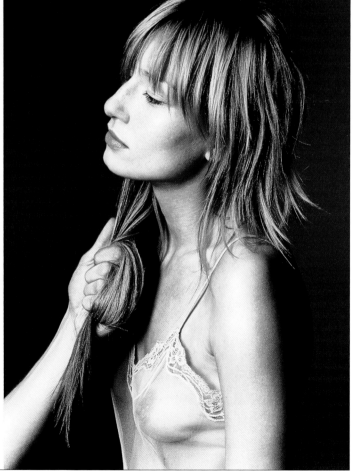

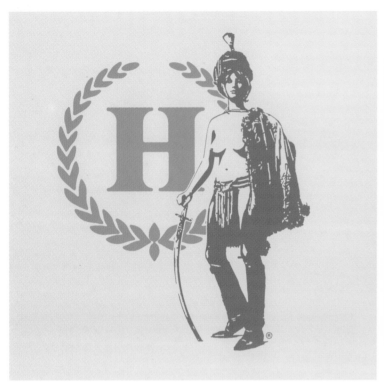

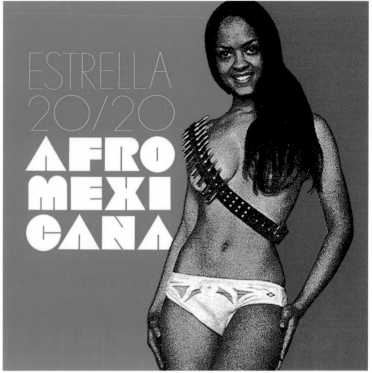

▲ Title: Guard
Studio: Hysteric Glamour Workshop
Designer: Stephan Jay-Rayon
Client: Hysteric Glamour
Client Service: Japanese streetwear

▲ Title: Estrella 20/20: Afro-Cubana
Studio: Art Chantry Design Co.
Designer: Art Chantry
Client: Dave Crider/Estrus Records

▶ Title: Sophia Guevara
Studio: Hysteric Glamour Workshop
Designer: Stephan Jay-Rayon
Client: Hysteric Glamour
Client Service: Japanese streetwear

Even the ancient Greeks were obsessed with
the weapon-wielding woman in the figure of the
goddess Athena. These examples demonstrate
the continued potency of this representation.

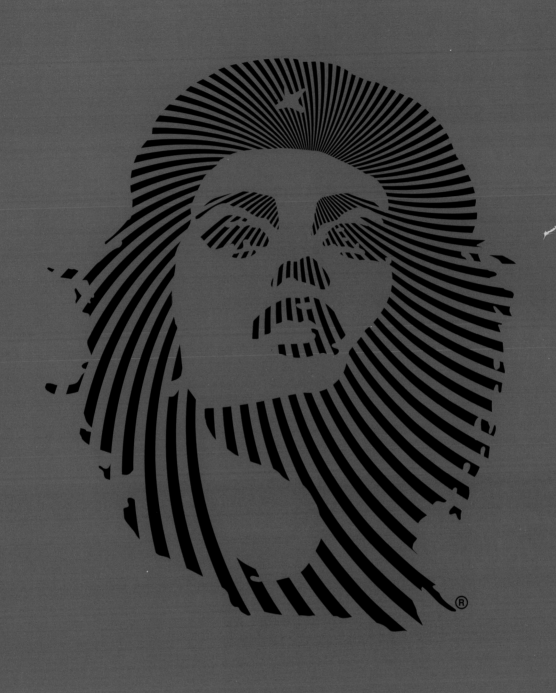

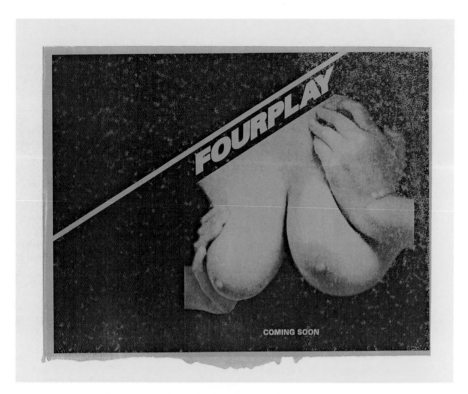

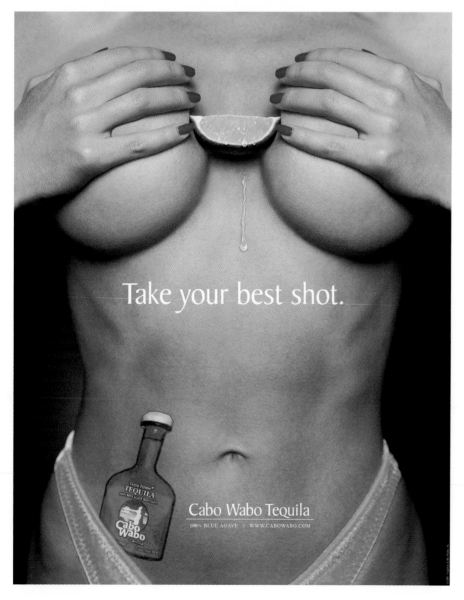

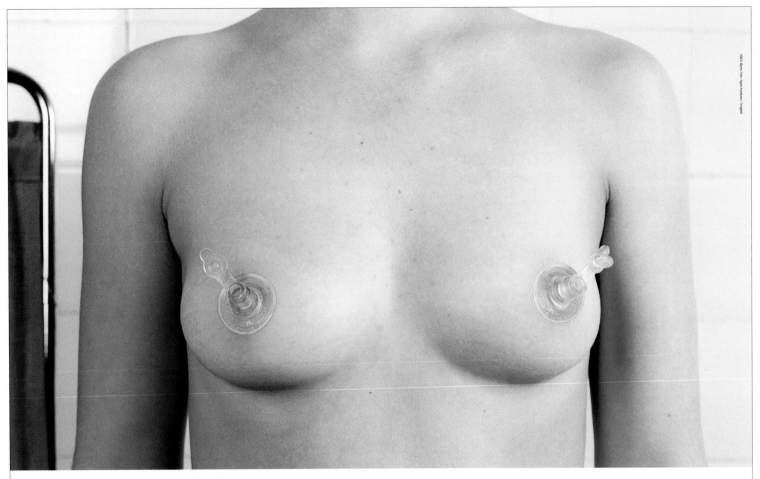

En plastisk operasjon skal være en veloverveid handling.

Derfor er det viktig med profesjonell rådgivning før et eventuelt inngrep. Selv om vi i Askim Klinikken er spesialister på dette området, og utfører hundrevis av slike operasjoner i året, ser vi ikke på dette som en enkel avgjørelse. Vi tar oss god tid med hver klient, slik at vi er sikre på at vi gjør det rette. Det er ikke som å blåse opp en ball, og så slippe luften ut igjen.

Ansvarlig lege: Dr. Just Omtvedt, Spesialist i plastisk kirurgi

ASKIM KLINIKKEN
Plastisk og kosmetisk kirurgi
www.askimklinikken.no
tlf. 69 88 11 13

Title: Fourplay
Designer: Jesse Alexander
Client: Ryan Rasheed/nightclub

The purpose of this image was to announce an upcoming party with four DJs. The client requested an image that would advertise the evening as "hot." The designer seems to have benefited from the experience, writing: "It was overall a positive experience that helped me to understand the power of an objectified woman."

Title: Take your best shot.
Art Director: Todd Gallopo
Designer: Todd Gallopo
Studio: Meat and Potatoes, Inc
Photographer: Storm Hale

Designed for Sammy Hagar's tequila company and targeted toward men's magazines, this image keeps with the most staid images of female sexuality. The many meanings of the word "shot," which appears near this woman's solar plexus, imply not only a swig of Cabo Wabo, but something potentially more sexual or lethal.

Title: Askim Klinikken ad
Designers: Eva Grefstad Knutsen, Renate Bjornsti
Photography: Sigve Aspelund
Agency: BBDO Myres, Oslo
Client: Askim Klinikken
Service: Plastic and Cosmetic Surgery

Although the implications of having caps put on one's nipples might only appeal to the over-lactating mother, this startling imagery draws attention to the service of the client—plastic and cosmetic surgery.

Title (L to R): Balance/Ravnoteza, Hug, Dew
Designer: Mirko Ilic´
Studio: Mirko Ilic´ Corp.
Illustrator: Mirko Ilic´

Ilic´'s images raise the question of how
human anatomy functions when it is stylized
and taken out of familiar context. Decidedly
male and female simultaneously, his images
ask us to imagine something beyond each
and, yet, containing both.

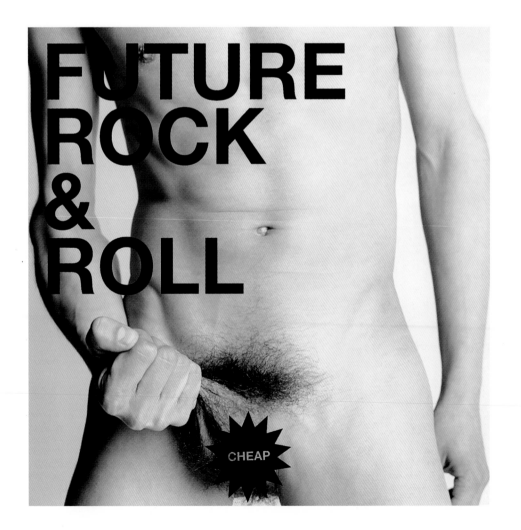

FUTURE ROCK & ROLL

CHEAP

Title: *Future Rock & Roll: Sonic Mook Experiment*
Concept and Art Direction: Martin Tickner
Photography: Mark Blower

Directly associating "cheap" masturbation with rock 'n' roll, these CD cover designs for Sonic Mook Experiment also show young women taking a defiant position, perhaps against the very association of rock with self-indulgent pleasure. "I'm not" and "You can't fuck them fight them" confront the viewer with an almost antisexual stance. In 2001, Sonic Mook Experiment staged a four-day festival featuring over twenty groups with band members of an average age of 24. Sean McLusky began Sonic Mook Experiment in 1997 as a reaction to the formulaic club experience that prevailed at the time. The Sonic Mook events pioneered the practice of multiroom, multimusic-style eclecticism in clubs.

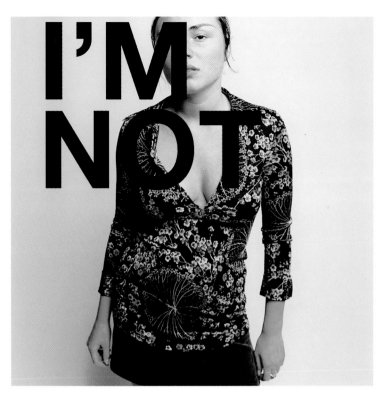

I'M NOT

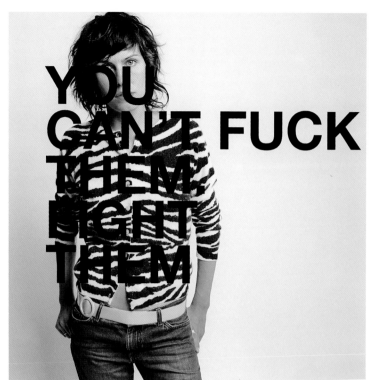

YOU CAN'T FUCK THEM, FIGHT THEM

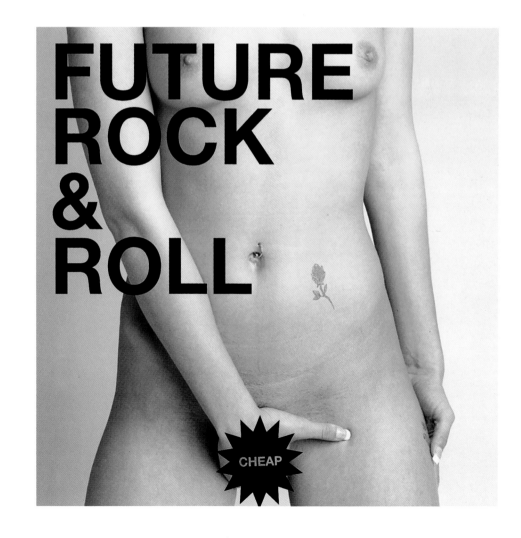

FUTURE ROCK & ROLL

CHEAP

▼ Ad appearing in the *San Francisco Bay Guardian*; created by Poundhouse.com, 529 SW 3rd Avenue, Portland, Oreg. 97204.

◄ Ad appearing in *Maxim* (U.K. edition); created by jungle.com, Clifton House, Gorsey Lane, Coleshill, Warwickshire B46 1SW, England.

► Ad appearing in *Gameweek*; created by Lik Sang International, Unit 2.3/F, 93 King Lam Street, Dragon Industrial Building, Lai Chi Kok, Hong Kong, KLN.

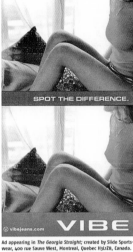

SPOT THE DIFFERENCE.

Ad appearing in *The Georgia Straight*; created by Slide Sportswear, 400 rue Sauve West, Montreal, Quebec H3L1Z8, Canada.

Ads appearing in *The World in English* (France); created for Kellogg's, P.O. Box CAMB, Battle Creek, Mich. 49016.

Ad appearing in *Bicycling*; created by the Martin Agency, One Shockoe Plaza, Richmond, Va. 23219; created for Performance, One Performance Way, Chapel Hill, N.C. 27514.

Seen enough old bags?

Try a new face.

TREBBIANNO
H A N D B A G S

Ad appearing in *Outside* magazine; created by Wieden & Kennedy, 224 Northwest 13th Avenue, Portland, Oreg. 97209.

AIR IS WHAT MAKES IT GOOD

Ad appearing in *Accessories* magazine; created by Machera Advertising, 37 West 27th Street, New York, N.Y. 10018.

Almost as complicated as a woman. Except it's on time.

IWC

ALPHA OMEGA

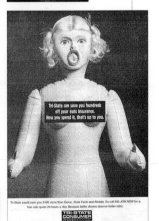

Ad appearing in *Architectural Digest* magazine; created by Wirz Advertising Agency, Ueplibertstrasse 132, 8045 Zurich, Switzerland.

Tri-State can save you hundreds off your auto insurance. How you spend it, that's up to you.

Ad appearing in the New York *Daily News*; created by Goldberg, Fossa, Seid, Levenson Group, 16 West 22nd Street, New York, N.Y. 10010.

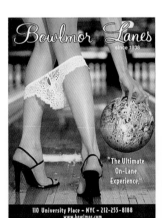

Bowlmor Lanes since 1938

"The Ultimate On-Lane Experience."

110 University Place - NYC - 212-255-8188
www.bowlmor.com

Ad appearing in *Time Out New York* for Bowlmor Lanes, 110 University Place, New York, N.Y. 10003; Bowlmor would not return calls seeking information on its advertising.

Ad appearing in *The Net*; created by Catalyst Pictures, 34 Chester Square, Ashton-under-Lyne, Lancs, OL6 7TW England for Empire Direct, The Clock Buildings, Roundhay Road, Leeds, LS8 2SH England.

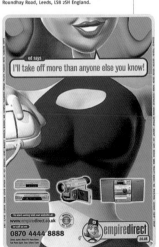

ed says
I'll take off more than anyone else you know!

www.empiredirect.co.uk
0870 4444 8888
empiredirect.co.uk

no**comment**

Trust us, a food processor won't get you there.

Free & Easy.
(2 words you won't hear coming out of her mouth.)

COLLEGIAN CLASSIFIEDS.COM

www.CollegianClassifieds.com

Ad appearing in *The Lantern* (a student publication at Ohio State University); created for Collegian Classifieds.com by Bidlack Creative Services, 617 Detroit Street, Suite 125, Ann Arbor, Mich. 48104.

JEWELRY.COM

Ad appearing in *U.S. News & World Report* magazine; created for Jewelry.com by Robert Chandler & Partners, 9320 Wilshire Boulevard, Beverly Hills, Calif. 90212.

Ad appearing in *Details* magazine; created for Game Cave by Game Cave, 421 East Huntington Drive, Monrovia, Calif. 91016.

Discover the perfect music gift

BUY HER THE RIGHT CD THIS YEAR AND GIFTS AREN'T ALL YOU'LL BE UNWRAPPING.

CDNOW

Ad appearing in *People* magazine; created for CDNOW by Hampel Stefanides, 111 Fifth Avenue, 11th Floor, New York, N.Y. 10003.

PLEASE ADDRESS SUBMISSIONS to No Comment, Ms., 20 Exchange Place, 22nd Floor, New York, N.Y. 10005. Include the entire page on which the item appeared, date and name of publication, and your name and address. We regret we cannot return No Comment submissions.

What's Wrong With These Pictures?
Does nudity sell? Of course it does—so well that ads with naked bodies rarely make the cut for No Comment any-more. But people still send them in, and we wonder: is the problem with nudity, or is it a lack of equal opportunity bareness? Where are the naked guys selling vodka? Then this nude dude arrived in the mail. So tell us, is he—are any of these photos—No Comment-worthy? Do you care if the models that sell games (perfume, booze) are fully clothed or in the buff?

Write to: **Comments Please, Ms. Magazine, 20 Exchange Place, 22nd Floor, New York, N.Y. 10005, or e-mail tellus@msmagazine.com.**

sonoma
main street manayunk 215-483-9400

Truth

Top: Ad appearing in *Philadelphia*; for Sonoma Restaurant, 4411 Main St., Philadelphia, Pa. 19127.

Left: Ad appearing in various magazines; for Calvin Klein, 725 5th Ave., Trump Tower, New York, N.Y. 10022.

Right: Ad appearing in *Marie Claire* U.K. edition; for Mattel U.K., Vanwall Business Park, Vanwall Road, Maidenhead Berks, SL64UB U.K.

THE BARE NECESSITY THIS SUMMER

SCRABBLE

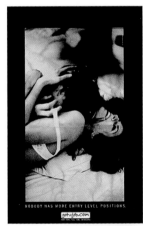

NOBODY HAS MORE ENTRY LEVEL POSITIONS.

getajob.com

Ad appearing in *Mademoiselle* magazine; created by In Marketing, 40 West Land Drive, Glen Cove, N.Y. 11542.

Candies
candies.com

Poster ad available for sale on college campuses; created by Ryan Drossman Marc USA, 100 Fifth Avenue, New York, N.Y. 10011.

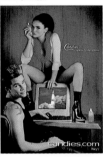

FIND OUT ABOUT IMAGE QUALITY FROM SOMEONE WHO'S BEEN THERE

deja

Ad appearing in *Smart Money* magazine; created by DiNoto Lee, 665 Broadway, New York, N.Y. 10012.

Please Address Submissions to No Comment, Ms., 20 Exchange Place, 22nd Floor, New York, N.Y. 10005. Include the entire page on which the item appeared, date and name of publication and your name and address. We regret we cannot return No Comment submissions.

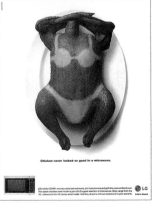

Chicken never looked so good in a microwave.

LG

Ad appearing in *Good Weekend, The Sydney Morning Herald Magazine*; created by Singleton, Ogilvy and Mather, Level 18, 201 Sussex Street, Sydney NSW 2000, Australia.

Ms. magazine, No Comment section

Ms., America's oldest and most established feminist magazine, has been a consistent and emphatic voice in the struggle for the social and economic equality of women in the U.S. and around the world. Part of its critique involves featuring advertising designs sent in by readers. Most of these No Comment ads are fairly straightforward in their offensiveness: treating women as property, conquest, or objects of violence. In addition, *Ms.* seeks to enliven the debate about images of women in advertising by featuring campaigns that they believe are empowering, or question assumptions and stereo-types. A unique feature of this section is that it gives readers contact information for the agencies that design this material so that readers may provide their own feed-back directly. Because *Ms.* magazine no longer accepts advertising itself, this dialog is particularly useful.

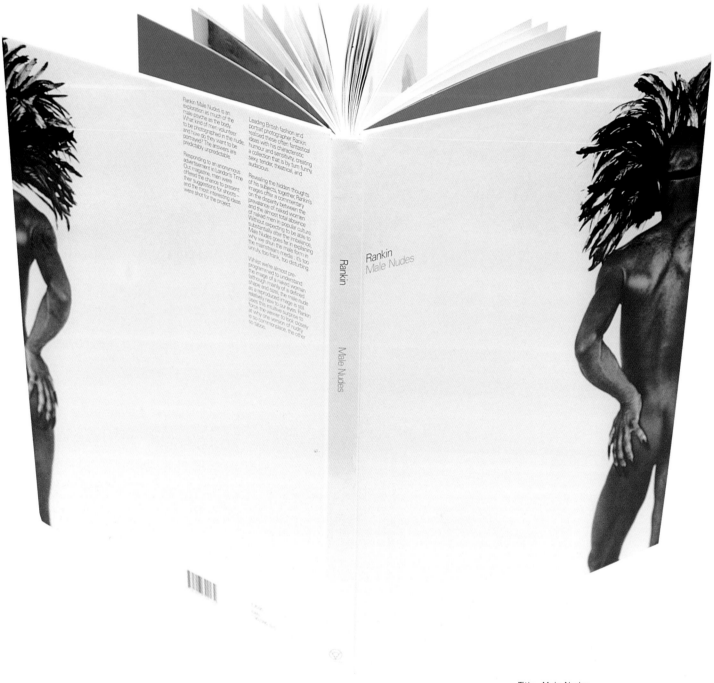

Rankin Male Nudes is an exploration as much of the male psyche as the body. What kind of men volunteer to be photographed in the nude, and how do they want to be portrayed? The answers are predictably unpredictable.

Responding to an anonymous advertisement in London's Time Out magazine, men were offered the chance to present their suggestions for shoots... and the most interesting ideas were shot for the project.

Leading British fashion and portrait photographer Rankin realised these often fantastical ideas with his characteristic humour and sensitivity, creating a collection that is by turn funny, sexy, tender, theatrical, and audacious.

Revealing the hidden thoughts of his subjects, together, Rankin's images offer a commentary on the disparity between the prevalence of naked women and the almost total absence of naked men in popular culture. Without expecting to be able to substantially alter the imbalance, Male Nudes goes far in explaining why we shun the male form in the mainstream media. It's too unruly, too frank, too disturbing.

Whilst we're almost pre-programmed to understand the image of a naked woman (through mainly of a defined shape and size), the male nude as a reproduced image is still relatively new to our eyes. Rankin gives this venture surprise to force the viewer to look closely at why one version of nudity is so commonplace, the other so taboo.

Rankin
Male Nudes

Rankin
Male Nudes

Title: *Male Nudes*
Designers: Bryan Edmondson, Carsten Klein
Studio Name: SEA Design
Art Directors: Bryan Edmondson, John Simpson
Designer: 12x
Photographer: Rankin
Client: Vision On Publishing

The most familiar version of the gender deviant is the drag queen, here, introducing the book as its cover model. A book about male nudes that features a man dressed as a woman on the cover makes an odd statement about the nature of masculinity—that it is the "natural" state, whereas "femininity" is a state of disguise, deception, and carnival.

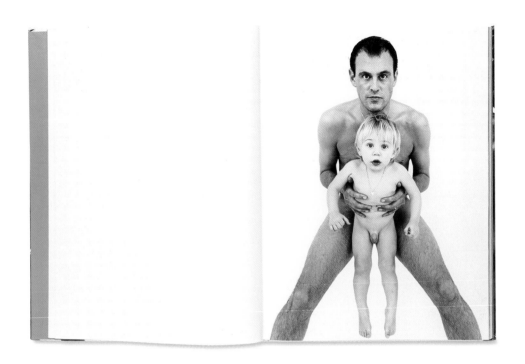

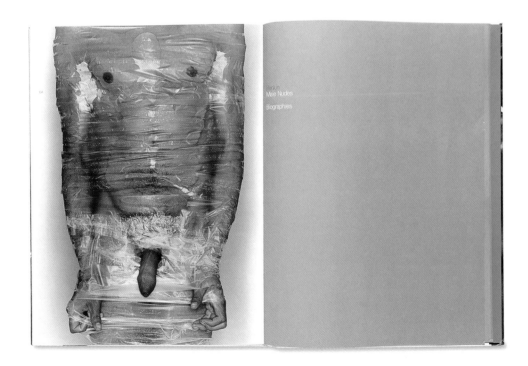

Renjun
Male Nudes
Biographies

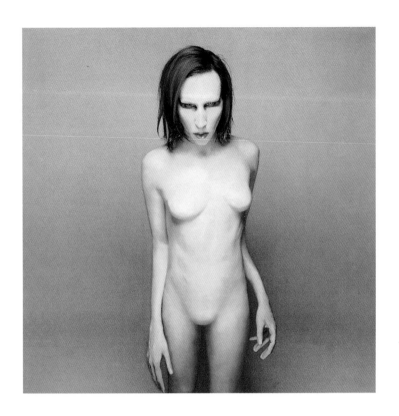
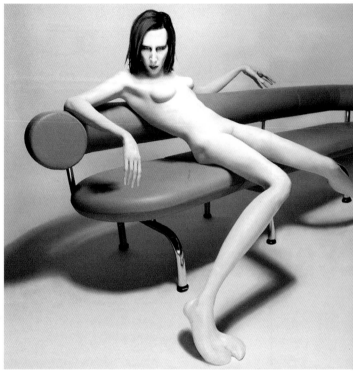

Ⴤ : Ruminations on the Nature of Gender, Desire, and Mutation

When you get down to it, practically any act of human charisma, whether aiming for political, cultural, or spiritual influence, in some way, maybe in just a partial way, which is maybe the best way, ends up changing something, very often something like the human actor itself, into something else. This is a simple fact well understood by aspiring politicians, rock stars, and self-help gurus alike, all hard at work remixing the history of their given identities to descend a half-step from the tenor of their own time and place, and in doing so to ignite something neither here nor there, this nor that, but tantalizingly in between or, even better, beyond. Traditionally, the most radiant path to this kind of self-fashioning has involved a visit to the hot spot between masculinity and femininity, to the place where one sex changes into another. As every faggy villain in the movies tells us, androgyny means power of the most glamorous degree, and of the scariest order: danger, amorality, intrigue, all open their petals in the face of the convincingly sexually ambiguous.

But what really jumps out as glamorously threatening has always demanded more than mere androgyny. Where Ziggy, Iggy, and Eno's glittery bisexuality scared people's pants off back in the 1970s, it was their extraterrestrialism that really pushed them over the edge. Since then, the freakiest developments in glam have moved in increasingly bulbous and muscular directions, often involving a kind of postgenderbending verging on the genuinely grotesque. Swollen, lumpy, and muscle bound, this turn in fashion has forsaken the emaciated slouch and aristocratic dishabille of 1970s glam (as preserved in Heroin Chic) for a more aggressive and prosthetic body type, recasting the Thin White Duke as a Thicknecked Hobgoblin, or a Hunchbacked Hulk. Like a science experiment gone weird, the sparkly, drugged-out glow so alluring in the eyes, cheeks, and lips of the languidly gorgeous has turned rubbery and synthetic, and been stretched tight over the bulging sinews of coiled man-beasts and loping she devils. Think Matthew Barney's satyrs or Thierry Mugler's entomological couture. These beasts want something from you, most likely something sexual, but what?

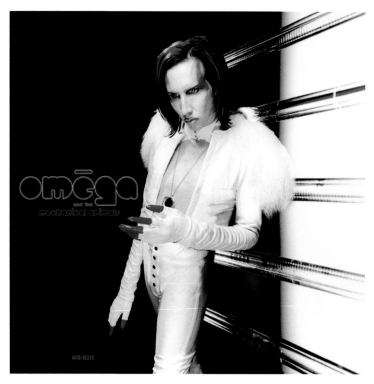

Along with recent developments in genetics, epidemiology, and cosmetic surgery, the bulking up and weirding out of glam may have something to do with the changing contours of the most mainstream of sexuality. What brings a boy or girl to the limit of themselves now that sex reversal has become the most common of talk-show denouements? The woman's a man! the boyfriend's a girl! the mom is a dad! As gender trouble increasingly fails to surprise on its own, what's sexy and scary moves elsewhere, from somewhere between man and woman (still not necessarily boring), to somewhere between human and animal (yeah!), or maybe even animal and mineral (hmm). But whatever its axis, real glamour does more than just leave a sparkly trail; rather, it deposits the onlooker in a private whirlpool of flame, face to face with something at once violently indecipherable and magnetically attractive, a thing whose gender is generally only the beginning of its mystery. Real glamour, in other words, is about the charisma of your predator; besides changing itself, it changes what you want. The man is a goat-man! Who are you?
—Slats Grobnik and Madge Garland from *Plazm magazine* #20

Title: Marilyn Manson *Mechanical Animals* CD insert
Studio: Bau-Da Design Lab
Art Director and Designer: PR Brown
Client: Marilyn Manson/Nothing Records

This histrionic performer is famous for his mutations of image. Bringing the shock of underground goth culture to the surface in his earlier incarnations, the CD packaging for *Mechanical Animals* toys with Manson's gender, giving him something vaguely resembling an impenetrable woman's anatomy.

Sexuality is very different from gender. Sexuality does not inherently contain hierarchy or power structures (except inasmuch as heterosexuality claims the title of "normal"), whereas gender categories are infused with distinct articulations of power, conferred and reinforced by culture. Sexuality can be based on object choice; it is a way of describing to whom we are sexually attracted and why, and it has a convenient fluidity that is exploited by contemporary designers. In addition, sexuality is not solely the sex act. Rather, it is how desire is expressed and represented over various contexts. Sexuality has an object—even if that object is the self—and, consequently, its relationship to consumer objects is of primary importance, particularly when we look at advertising design. People are represented as not just desiring each other, but desiring each other in the presence of a product and, consequently, desiring product—or implying this relationship to the viewer. Elation and orgasmic joy is equated with the attributes of a product, and conversely, the product is associated with an attractive person or their positive attributes. Sex sells—but how? What is the relationship between the representation of desire and the visual rhetoric of selling?

Hetero/Homology

To make a complete sampling, we must acknowledge the full breadth of sexualities that are represented in contemporary design. Heterosexual desire is the most common and uncomplicated way of representing sexuality. It is in this construction that stereotypes and conventions are used most heavily to communicate the idea of sexuality, and differentiation comes by explicitness. However, representation of same-sex love and love of self are both becoming more pervasive in design. As is the case with categories of gender, nonnormative sexualities are generally intended to shock or display the deviance reserved for subcultural expression; their appearance in the graphics of the mainstream emerges as the slow waning of a vast cultural repression, begun in the 1970s and continuing to this day.

Normative sexuality is represented as heterosexual desire, and stands out only by means of contrast. This contrast comes in the form of different object choices or modes of erotic expression. As androgyny surfaced in fashion throughout the 1990s, the manner in which men and women were represented began to relax into categories that did not feature bodies with pronounced sex characteristics. Objects of desire became homologous and people were depicted as desiring the same thing—just slightly varied versions of themselves. The ambiguity and identity in these images created options for the representation of homosexual desire (albeit highly stylized). Rather than projecting any complex politics of identity, most representations of "homo" desire focused on the narcissistic identity of the people involved, an aestheticized version of the Freudian (mis)diagnosis of "inversion."

An interesting example of this theme is the record cover series for the artist Annie [page 65]. Striving to demonstrate the musician's roots in disco's past and its current relevancy in graphic terms, Annie is represented as having sex with herself in a debauched, sexually charged and drug-fueled bath house scene (populated primarily by gay men) reminiscent of New York in the early 1970s. These images of a person desiring herself do not represent homosexual desire as much as they do a homologous desire, a graphic precursor to a more authentic representation of homosexuality.

Homos

Only in the past ten years or so has homosexual desire surfaced in mainstream design. An increasingly (self) identified market of gay consumers has caused designers, advertisers, marketers, and their clients to pay attention to this previously ignored category. The increasing permissiveness in public sexual culture has made homosexuality no longer completely

taboo, and it can still both excite moral controversy and have a standard role in the titillation of the male gaze. Ironically, marketing for homosexual consumers highlights the relative lack of excitement that actually attends most gay lives (cf. Bridgestone tire advertising) [page 71], especially when sexuality, rather than sex, is at the forefront of the representation. Not particularly interesting from a design standpoint, these images are good examples of the relatively new phenomenon of gay lifestyle marketing that normalizes and desexualizes gay people (especially lesbians—the men are at least wearing a little leather). Sure, these couples are gay, but they are ostensibly selecting tires over the Internet, not making out for your viewing pleasure. The copy suggests that they are queer: for the lesbian couple it is the word "liberation," and for the men, it is the age-old stereotype of gay men knowing how to "accessorize." There is not a clear sexual relationship between these two men and women. Rather, social context gives educated viewers a privileged glimpse into the nature of their sexuality.

By contrast, other representations of lesbians and gay men are almost exclusively focused on the sexualization of their identities. This is nothing new, of course, and only surprising because it is such a staid and repetitive theme. Mainstream designers often use homosexuality to stand out, invoking a sense of youth and coolness, and increasing the consumer perception of their product or service as "inclusive" of both gay and straight consumers. Sisley, the Italian clothing line owned by Benetton, uses the images of two very feminine women touching and kissing—shot by fashion photographer Terry Richardson and run in *Out* magazine—to accomplish this positioning

Two women having sex in front of or with a man is standard porn fare, and refers to the fetishization of lesbian sex as a voyeuristic fantasy for straight men. In its ad for the CineVegas 2002 International Film Festival [page 51], the client was interested in "young," "hip," and "sexy"—and R & R Partners used the ubiquitous Las Vegas standby, the strip joint, as a location for their ad. A would-be filmmaker frames the girls as one pours water on the other's breasts. This theme is repeated in a Hysteric Glamour T-shirt and merchandising design [page 57]. This Japanese clothing line requested design elements for this primarily female line that uses vintage porn and 1950s American kitsch culture images. Ironic inasmuch as the English language in this design is not automatically comprehensible to Japanese consumers, "The Best Thing About You Is Your Girlfriend" holds meaning that is both suggestive and aggressive. The voyeuristic lesbian-themed porn juxtaposed with the text confuses the standard heterosexual male gaze expected of this kind of image: Who is "You"? Who is "Your Girlfriend"? Are they the women in the picture? A female viewer? Is it a challenge, or a threat? There are more questions than answers that form the work of Hysteric Glamour. It is mildly provocative but ultimately simply fashionable—a repetition of the standard voyeuristic fare.

Rather than invoking the image of the lesbian to titillate, Rachel Carns of underground punk-metal band The Need, and designer of their album artwork, both represents and self-represents on this piece [page 65]. The Need describe themselves as "biotic upstarts, shape-shifts, identities fractured and strategic," and the design for this duo shows the band members in drag, with morphed cross-species love and boxing imagery in startling juxtaposition. Drawing from the venerable Xerox-based tradition of cut and paste, this design recalls do-it-yourself graphics from the last thirty years of punk, but places the design in a new, queer context. Carns writes, "There are a million ways to be queer, but at essence (and across race, class, and assumed-gender lines) to identify as Queer means that Who We Are is rooted precisely in Who, and How We Fuck..." The Need are self-identified queers who take full responsibility for their own positioning, reinfusing the typical voyeuristic lesbian scenario into one that is possible for lesbians not only to create, but enjoy.

Gay male sexual identity has been more problematic for mainstream graphic design, especially in American design. Images of gay men are more overtly sexual but not aimed for the titillation of straight men (unlike their lesbian

parallels). These images are often seen as threatening to straight masculinity and are not widely used beyond gay-targeted marketing or fashion stories. The Italian brand Sisley, in a series of gay-themed spreads, featured a provocative photograph of two buff, bare-chested young men sucking on lollipops in a suggestive way. The Benetton magazine *Colors* featured a gay bi-racial couple kissing on the cover of issue 28, which discussed the theme of "touch." It was quite a bold move, and "hugely controversial" according to a *Colors* spokesperson. The cover was unique because the magazine was not explicitly about gay themes but used gay sexuality to exemplify touch both on the cover of its magazine and on an inside spread, an article on kissing. In other stories, the issue explored adornment, modification, and taboo [pages 46–47]. The Benetton brand, along with their subsidiary Sisley, have pushed the boundaries of advertising design since their inception, using *Colors* to describe and explore global politics and culture for more than twenty years.

Graphic design featuring gay men does not deviate far from idealized versions of bodies and identities. Young, fashionable, and generally with hairless bodies, the code of "good" looks for gay men is nearly as strict as it is for design conceptions of straight women. Mirko Ilić's invitation for a Gay Pride 2002 event in New York [page 69] is a good example of design that is aware of this (often unattainable) standard but also questions it. The trifold panels open to slowly reveal an eye, then a face, then the torso of a man wearing a mask, earring, and studded bracelet. The word "provocateur" is also revealed slowly, the "pro"—a politically tinged word—coming first. Ilić is concerned with surface—the smooth skin of the man and the gloss of the paper it is printed on are disturbed by holes that create a layering effect, as well as the scratches and distressed typography that disrupt the surface. The ideal identity or body is not whole in this piece, and the viewer is rewarded as the body is revealed to be more complex on further investigation.

A more obscure image associated with gay male identity is the 1950s bodybuilder. Although these images, found in magazines or on the covers of pulp novels, played an essential role in the underground, closeted life of many American gay men from the 1930s through the 1960s, they are not widely recognized outside that community. Although retro-style pinup images of women are quite common, particularly in contemporary rock 'n' roll graphic design, Hank Trotter throws a wrench in the gender works by featuring a male pinup on some of his posters. Trotter's work is best known from his stint as art director with Seattle record label Sub Pop, and his short-lived pinup magazine, *Kutie* (which has since become a Web-based publication). Trotter's use of midcentury style without restrictive midcentury assumptions about sexuality allows male desire to be represented in an appropriately complex manner, without diminishing the aesthetic pleasure of his pinup influences. A second example of this style of design comes from Taschen's retrospective on Tom of Finland, whose images of gay men traverse a wide variety of twentieth-century ideals and stereotypes of gay male sexuality.

Self Love

The representation of desire for the self, or desire for the self in the presence of a product (in advertising) is a major category in the survey of graphic design. These images sometimes draw on the fascination of voyeurism to make their impact. Markus Kiersztan's ad [page 43] for Spanish mineral water brand La Casera features sequential spreads representing a woman in two extremes—parched and drenched—suggests a metaphorical relation to sex by showing tension and release. The product is small and stands alone in a stark, black background, advertising the power of satisfaction afforded by the drink. The change of the woman's expression from slightly on edge, tired, and dirty, contrasted with the washed clean relief as she is drenched, is orgasmic.

Another version of the self-loving lady is in a series of Australian Galliano ads produced by MOJO partners [page 50]. The client informed the agency that they wanted the product to be shown in a way that demonstrated it as a private and pleasurable treat, a drink for the end of a hard day at work. MOJO writes, "Masturbation and, in this case, female masturbation seemed a logical extension of that escapism. To link the two seemed a contemporary, natural, and open thing to do."

Like lesbian sex, the representation of woman having an orgasm is right out of the porn lexicon. Male pleasure is generally not portrayed explicitly, although Austrian maverick Stefan Sagmeister's envelope-pushing images feature this very portrayal. In the announcements for the opening of his new shop in New York, Sagmeister takes self love to an extreme degree by representing himself naked [page 45]. Rather than providing fodder for a voyeuristic fantasy, the self representation instead offers an exhibitionistic one (Sagmeister himself). In these images, Sagmeister shows that he has the "balls" to open the shop, and has the ability to execute action—ultimately, these images are more about power than they are about sex. Like an ancient Greek Herm—the property markers that consisted of a pillar (sometimes with a head) and a large, erect phallus— Sagmeister marks his territory. His exposure also makes him vulnerable, demonstrating the solutions that he can provide in his new studio, delivering the unexpected, the unconventional, and the self-involved, and certainly not for the prudish or fainthearted.

In developing the concept for Lou Reed's art for the CD *Ecstasy*, [page 48] Sagmeister asked Reed to turn the camera on himself to capture the moment of "ecstasy" that would reflect the content of the product. Reed exposed himself, creating a series of images that have mystical overtones as well as an overt physicality. Lou Reed's sexuality, as it is represented on the front of his CD, is not necessarily seductive. The expression on his face shows that sexuality can be embodied in a look, that it is not always beautiful, that it can look like both joy and anguish. This confluence of emotional power is fundamental to the creative designer and is part of what makes sexuality such an enticing and useful subject.

In some sense, the idea of sexuality permeates this entire study. Obviously, representations of the desire of younger/older people, S&M, and the multiplicity of fantasy worlds that follow encompass the overarching idea of sexuality. The manner in which desire is represented is most often driven by a specific, albeit conscious, messaging: heterosexual desire is the norm, the standard, and the middle of the road. Only when overt sexuality is present, represented by explicit images of people who are having, are about to have, or just had sex, do we see derivations within the heterosexual model.

Representations of homosexual desire are generally used to create a sense of the forbidden, voyeuristic, or socially progressive/cool, especially when they are aimed at primarily straight consumers. Media such as the Web site the Commercial Closet (www.comercialcloset.org) and national gay magazines now feature not only gay-targeted ads, but also analysis about how and why this sexuality is used for selling products to both gay and straight consumers. Serious critique of this "identity marketing" is rare, since for many gays and lesbians, "visibility" (even if it is in an ad for beer) can appear to be more important than actually gaining political and social parity. Designers' use of sexuality will continue to reflect social realities. It is our hope that they use their power to transform social realities as well.

Title: Caesare Mineral Water Ad
Art direction: Markus Kierzstan
Client: Caesare
Client's product: Mineral water

A woman's pleasure is metaphorically and literally
associated with a delicious beverage. In this ad for
mineral water, a cool drink and a splash of water
provide relief from tension and need.

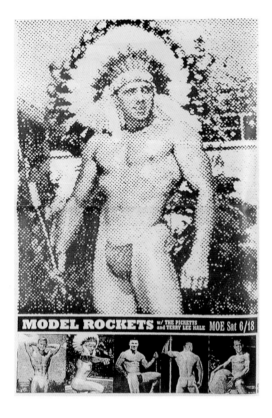

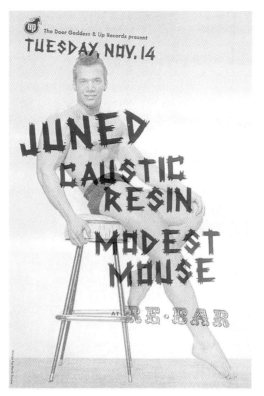

▲ Title: Posters for Model Rockets/The Picketts
and Terry Lee Hale, Juned/Caustic Resin and
Modest Mouse
Designer: Hank Trotter
Studio: Twodot Design

Hank Trotter uses the decidedly homoerotic
muscleman imagery of 1950s bodybuilders to
complicate male gender characteristics and
male desire. The coded nature of this image
style is not lost on those for whom it was the
first and, sometimes, only access to gay male
sexuality. For others, it is simply a picture of
a beefcake in short shorts.

▶ Title: Studio announcement
Designer: Stefan Sagmeister
Studio: Sagmeister

Turning self promotion into an extreme act of
exhibitionism, and cleverly revealing its true
nature, Stephen Sagmeister's ad for his new
studio allows us to judge for ourselves: Are we
ready to do business with this naked man?

45

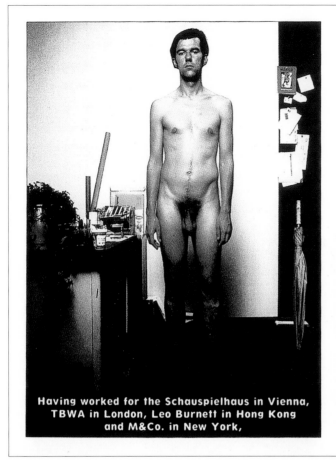

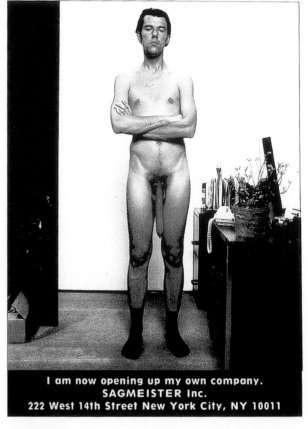

Having worked for the Schauspielhaus in Vienna,
TBWA in London, Leo Burnett in Hong Kong
and M&Co. in New York,

I am now opening up my own company.
SAGMEISTER Inc.
222 West 14th Street New York City, NY 10011

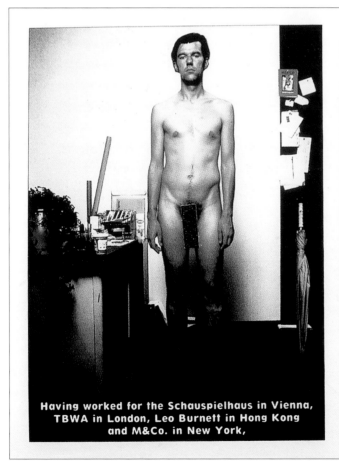

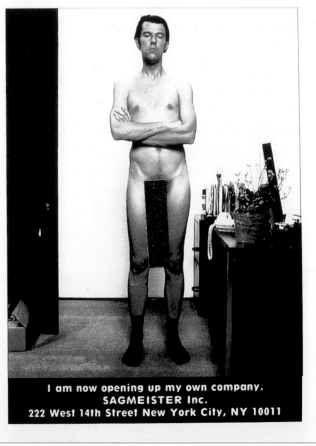

Having worked for the Schauspielhaus in Vienna,
TBWA in London, Leo Burnett in Hong Kong
and M&Co. in New York,

I am now opening up my own company.
SAGMEISTER Inc.
222 West 14th Street New York City, NY 10011

ein magazin qui parle about el resto del mondo

COLORS

28

Touch Tacto

COLORS 28 /Oct.-Nov. 98

80028

Sped. in A.P. 45% - ART.2 C20/B L.662/96 VERONA Aus 7.50A$ | BRD DM9.50 | Can 8C$ | Esp 700Ptas | Fr 32FF | Hellas 1700DR | Hong Kong HK$70 | Ital L6.000 | Nederl 9.95 FL | Switz 8SF | UK £4 | USA $6.50

Title: *Colors* 28 Touch
Editorial Director: Oliviero Toscani
Editor in Chief: Adam Broomberg
Art Director: Thomas Hilland
Designers: Jean Baptiste Bolon, Juliana Stein
Photographer: Cover: L. Ferich/Sygma
TOC: F. Morandin
Pages 4–5: H. Logan/Network
Studio: *Colors* magazine

This issue of *Colors* was about touch. The editors looked at the body as a political site, comparing how different cultures, religions, and political regimes deal with the body, from sex to tattoos to torture.

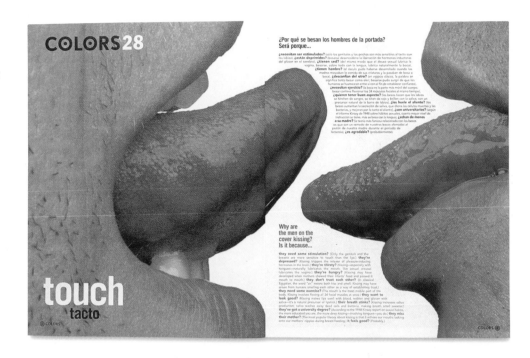

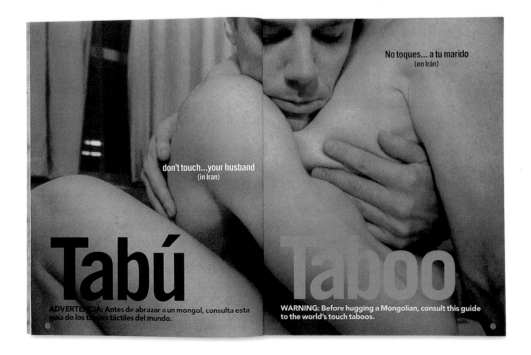

Title: CD packaging for *Ecstasy*
Designer: Stefan Sagmeister
Studio: Sagmeister
Photographer: Lou Reed
Client: Lou Reed

A self portrait of Lou Reed that explores the
physical and mystical states of ecstasy—
topics that mirror those treated on the CD
within. The photograph of the singer in this
delicate moment implies that the degree of
revelation and exhibition on the album will
be higher than usual.

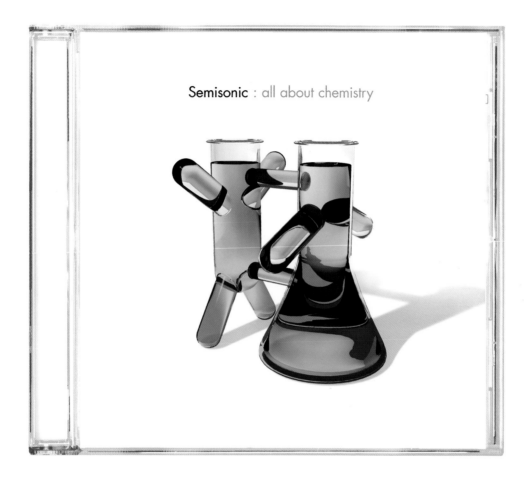

Semisonic : all about chemistry

Title: CD packaging for *All About Chemistry*
Art Director: Todd Gallopo
Designer/Studio:Joel Bajrech/Best Studio
Studio: Meat and Potatoes, Inc.
Client: MCA Records

Conceived by the lead singer of Semisonic,
this album artwork emphasizes how "men
and women [are] connected by the mind and
hips, sharing fluids in a very clinical way."
By graphically reducing the sexual interaction
between men and women, the title of the
album, *All About Chemistry*, takes on an
ironic note.

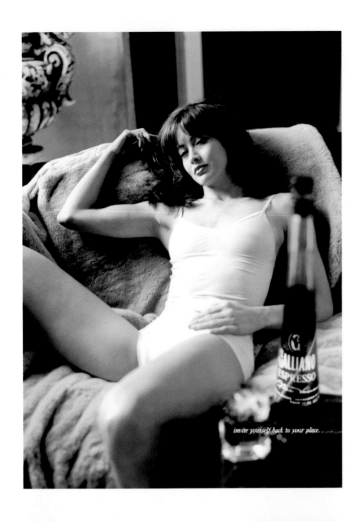

invite yourself back to your place.

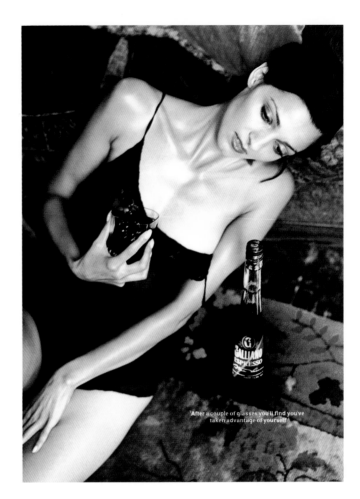

'After a couple of glasses you'll find you've
taken advantage of yourself'

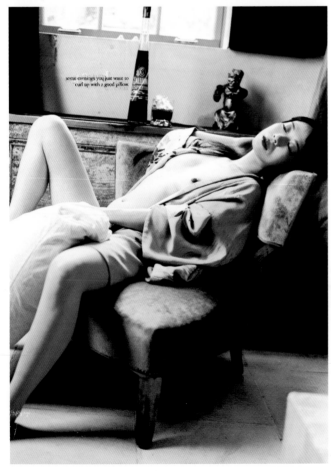

some evenings you just want to
curl up with a good pillow.

51

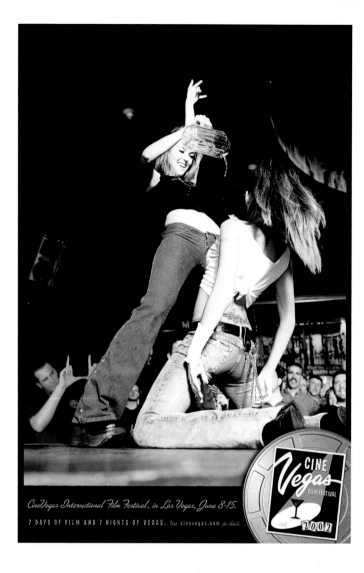

CineVegas International Film Festival, in Las Vegas, June 8-15.

7 DAYS OF FILM AND 7 NIGHTS OF VEGAS. Visit cinevegas.com for details.

Title: CineVegas Poster Campaign, Coyote Ugly
Art Director: Becca Morton
Designer: Becca Morton
Photographer: Tyler Gourley
Copywriter: Gage Clegg
Creative Directors: Ron Lopez, Randy Snow
Account Leaders: Rob Dondero, Jennifer Logan
Studio: R & R Partners
Client: CineVegas International Film Festival and
L. Mimosa Jones

Framing this ad for an International Film Festival
in the style of a lowbrow American movie about
stripping barmaids, R & R captures their client's
wish for "young" and "sexy" while simultaneously
portraying Las Vegas' distinctive culture.

Concept Creators: Simon Cox, Ash Helpsall
Art Directors: Simon Cox, Ash Helpsall
Photographer: Tamara Slazenger
Client: Galliano
Agency: MOJO Partners
Product: Espresso liqueur

The subtle rewards of masturbation are enhanced
by a shot of espresso liqueur. This campaign
emphasizes privacy, self reward, and the somehow
feminine nature of drinking this particular elixir,
particularly if you can watch a woman do it in
front of you.

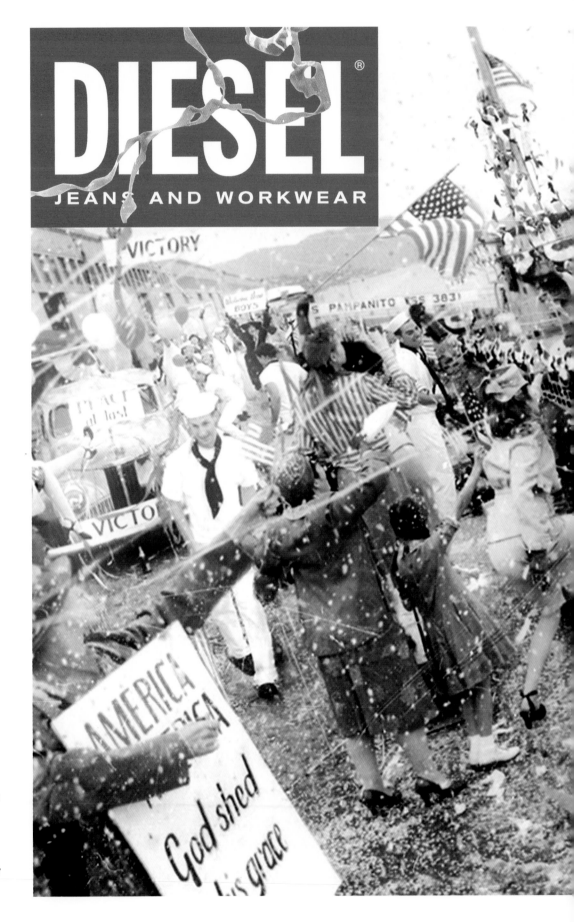

Title: Sailors
Design: Diesel
Studio: Diesel

Playing on nostalgic images of VE celebrations in New York City, this photo of two soldiers kissing is decidedly radical, especially considering the "don't ask, don't tell" policy that governs the behavior of military personnel in the United States. Although gay people are everywhere, gay culture often remains hidden. This image demonstrates this phenomenon while also playing on a Navy fetish common in the most popularized stereotypes of gay masculinity. As an advertisement, it characterizes Diesel jeans as a tolerant, even pro-gay brand.

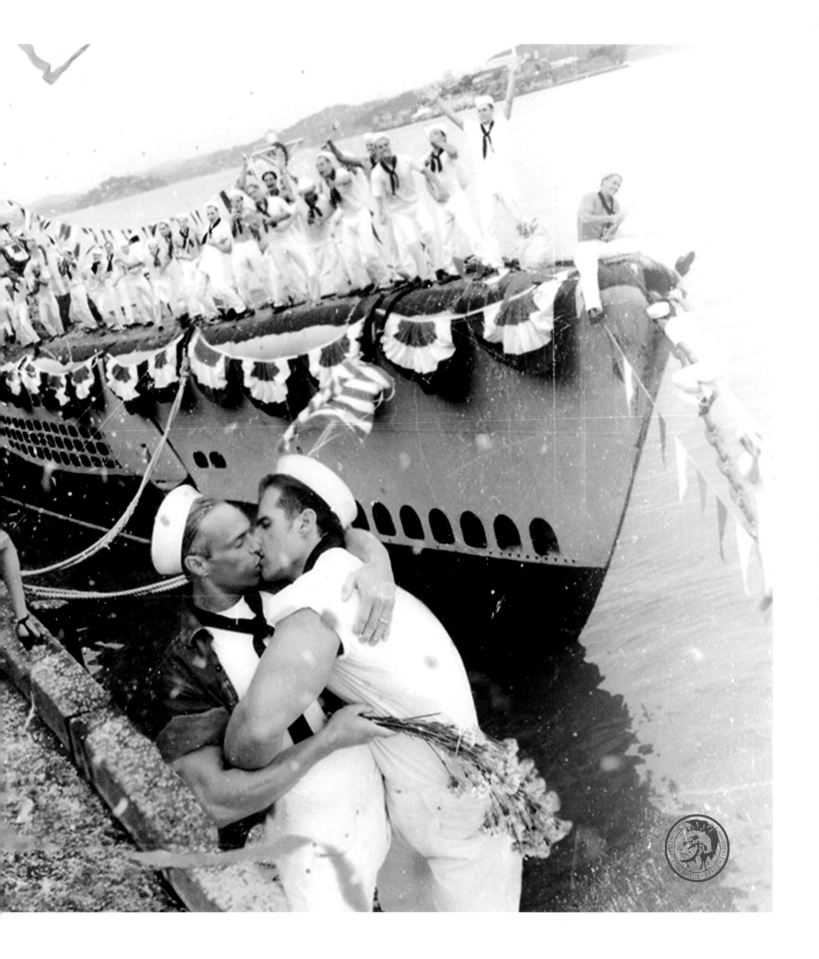

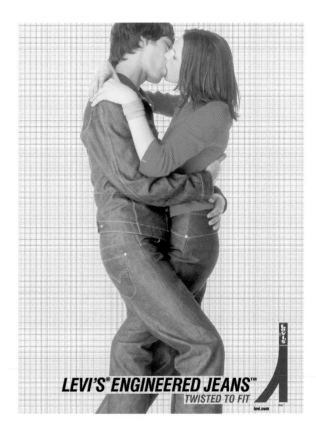

LEVI'S® ENGINEERED JEANS™
TWISTED TO FIT
levi.com

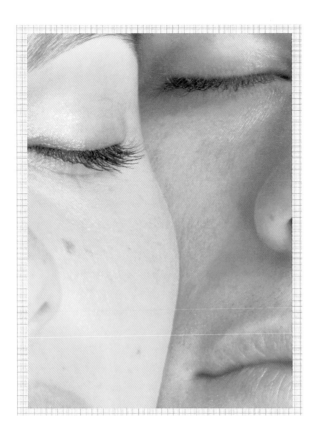

Title: Levi Strauss Europe Print Campaign
"Kiss" and "Cheek"
Creative Director: Russell Ramsey, BBH
Art Director: Verity Fenner, BBH
Copywriter: Claudia Southgate, BBH
Designer/Art Director: Alan Aboud (Posters/Retail)
Photographer: Rankin
Agency: Bartle Bogle Hegarty (BBH)
Client: Levi Strauss Europe
Product: Levi's Engineered Jeans

Using the forms of bodies and engineered jeans,
mutual heterosexual desire is aestheticized. The
lack of explicitness makes it possible for this ad to
appeal to a very mainstream consumer base and at
the same time turn jeans into "art." The comfort of
the jeans is implied to help the wearer be more
comfortable when making out.

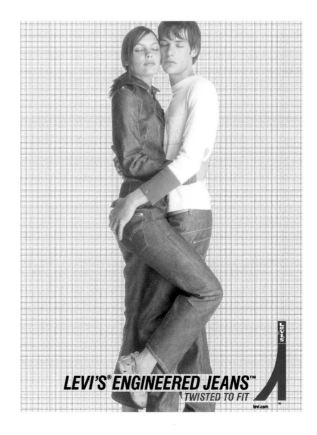

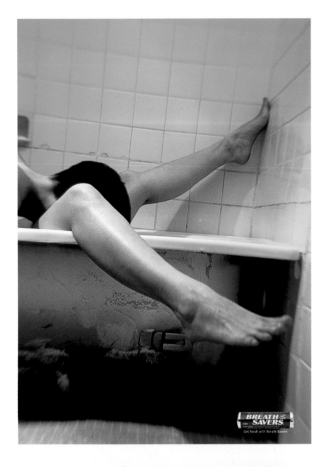

▼ Title: The Best Thing
Studio: Hysteric Glamour Workshop
Designer: Stephan Jay-Rayon
Client: Hysteric Glamour
Client Service: Japanese streetwear

Derisive yet imprecise, this insult featured on a line of Japanese women's streetwear uses voyeuristic lesbian porn to make a bizarre and vague statement, questioning the viewers' position vis-a-vis lesbian desire.

◄ Title: Get Fresh
Designer: Angela Low
Studio: @lement
Photographer: Sze Ling
Copywriter: James Lim
Client: Jasons International Pte.Ltd. (Jasons Supermarket)

The brief for this project requested materials to launch a new mint without using the clichéd allusions to "refreshing and cool." The play on words with the tag line, "Get Fresh" suggested a direction that resonated with young consumers, and introduced "a subculture that was current and topical"—gay men. The posters came down but the awareness level and the sales of mints went up. Ironically, section 377(a) of Singapore's penal code reads: *"Any male person who, in public or private, commits or abets the commission of or procures the commission by any male person of, any act of gross indecency with another male person, shall be punished with imprisonment for a term which may extend to two years."*

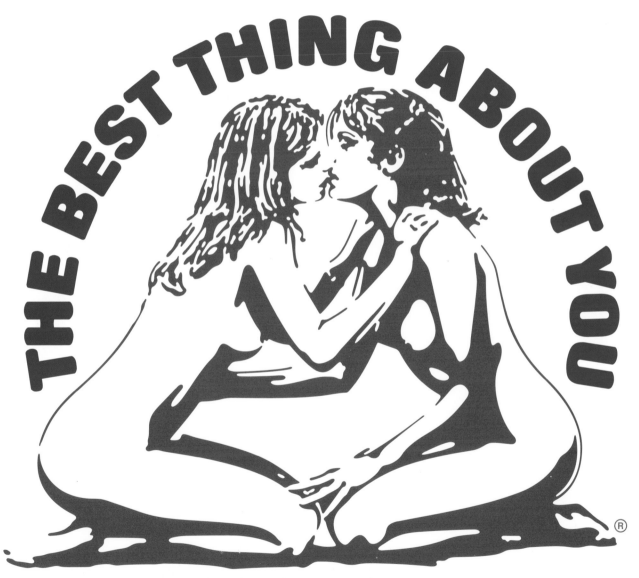

Title: Body Landscapes
Art Director: Victor Arriazu
Designer: Luis Moreno
Photographer: David Levin
Agency: Vinizius Young and Rubicom
Client: Majorica
Client's Product/Service: Jewelry

The objective of these graphics was to renovate the brand image showing the client's new collection and "to show the pieces as a part of the woman's essence." Essentially naked, the woman's body in this context acts as an alluring rack. Aside from not being published in the Middle Eastern markets, there was no controversy surrounding this campaign.

Title: I'd Rather Show My Buns
Designer: PETA
Photographer: Robert Sebree

Whereas fur was once an item of clothing that symbolized wealth and beauty, the People for the Ethical Treatment of Animals have recruited models to demonstrate that they would rather go naked than wear fur. PETA writes: "A beautiful woman (or man) will always attract attention, and to help animals, that's what we need to do." Although attracting controversy for replacing the objectification of animals with the objectification of women, PETA has had marked success with this particular campaign.

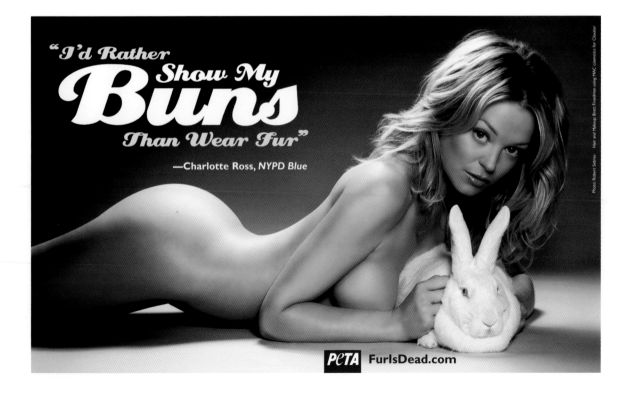

"I'd Rather Show My Buns Than Wear Fur"
—Charlotte Ross, NYPD Blue

PETA FurIsDead.com

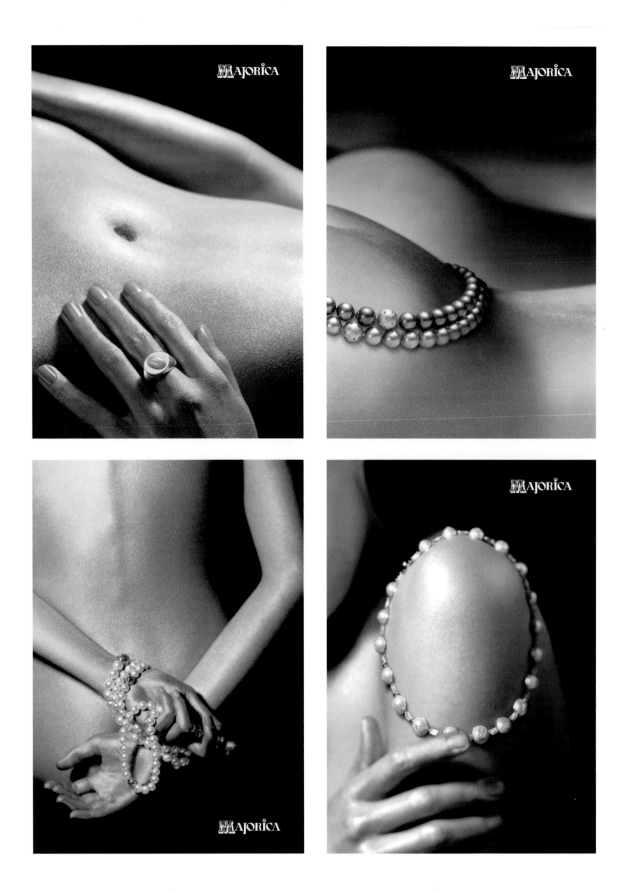

▲ Title: Araki
Editorial and Creative Directors: Markus Kiersztan,
Petra Langhammer
Design: Markus Kiersztan, Petra Langhammer
Photographer: Nobuyoshi Araki
Client: *Big* magazine 17

The photography of Nobuyoshi Araki overcomes
taboos and is articulated by his obsession with the
desire of the exhibitionist and the instinct of the
voyeur. His work here documents and demonstrates
Japanese systems of sexuality and sex, as well as
the changing definitions of Japanese femininity.

▶ Title: *Tom of Finland, The Art of Pleasure*
Publisher: Taschen
Designers: Catinka Keul, Burkhard Riemschnieder

Tom of Finland developed an illustrative style that
moved images of gay male sexuality away from the
covers of pulp magazines and body builder pinups
into diverse and explicit representations of men
having sex in all kinds of ways. This overview of his
work shows his development from a comic illustra-
tor in the 1950s to an icon of the contemporary
leather daddy.

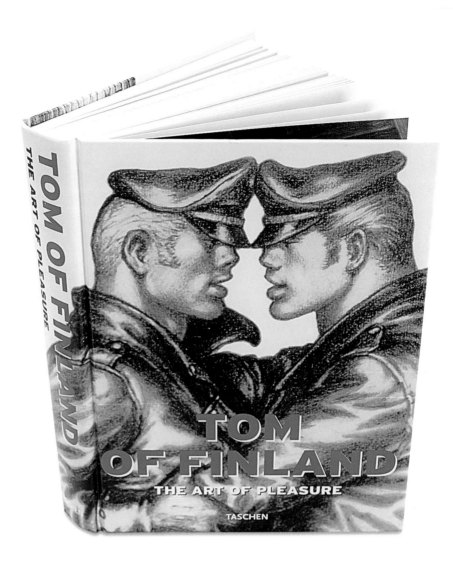

THE 70s: THE CLONE YEARS

THE 80s: THE FETISHIST YEARS

THE 50s: THE LUMBERJACK YEARS

THE 60s: THE BIKER YEARS

FIDELITY 'FD1341' STEREO RADIO/CASSETTE
RECORDER ▪ SINGLE CASSETTE ▪ AUTO STOP ▪ SOFT EJECT DOOR
▪ BUILT IN MICROPHONE ▪ HEADPHONE SOCKET (WOW) ▪ NO C.D.
▪ TELESCOPIC AERIAL ▪ MAINS OR BATTERY OPERATED — REQUIRES
 FOUR HP2 BATTERIES (NOT INCL.).
PT- 4000166911212 £29·99

MIDNIGHT RIDER

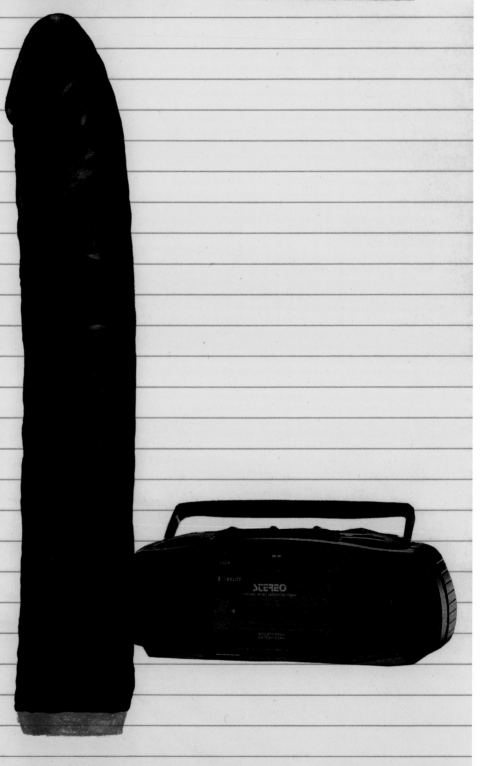

A GLISTENING 10" LENGTH OF REALISTIC VIBRO POWER.
CODE 0104A £17·75

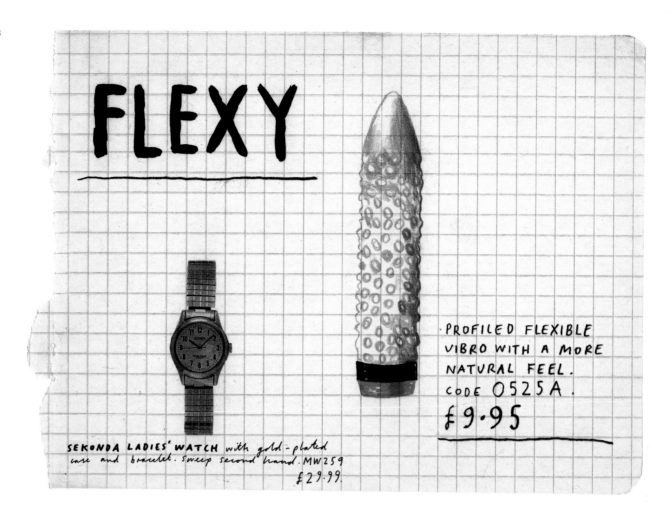

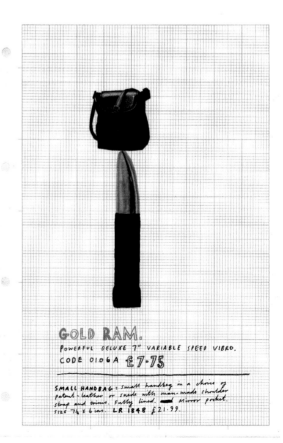

Designer/Illustrator: Paul Davis

Paul Davis juxtaposes consumer products with dildos, and elaborates on the materials of each. These product descriptions serve to both sexualize objects like shoes and boom boxes, and to turn dildos into legitimate objects of consumer desire. As usual, Davis's renditions are humorous and break down sexual taboo.

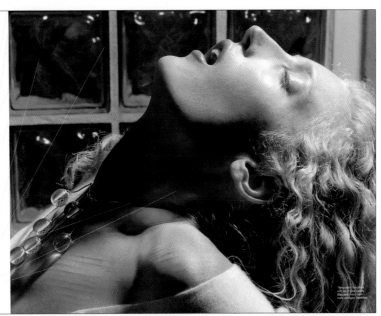

V.

THE
RAPTURE

by
DIMITRI
DANILOFF

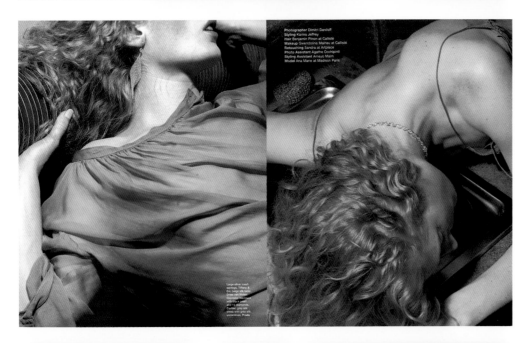

Photographer Dimitri Daniloff
Styling Karina Jeffrey
Hair Benjamin Pinon at Callisté
Makeup Gwendoline Mairieu at Callisté
Retouching Sandra at Artpiece
Photo Assistant Agathe Occhipinti
Styling Assistant Ameyo Malm
Model Ana Marie at Madison Paris

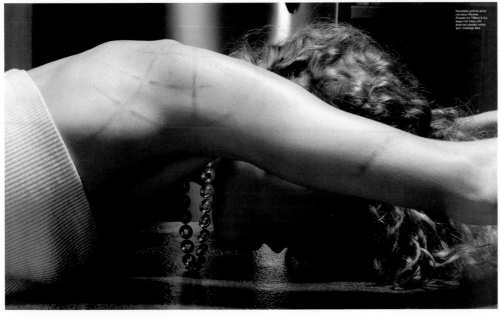

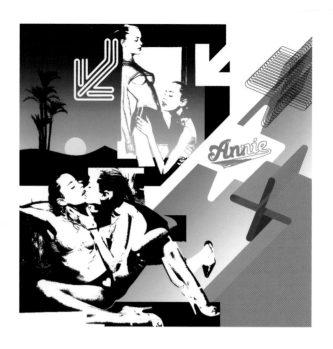

◁ Title: The Rapture
Creative Director: Steven Baillie
Photography: Dimitri Danilloff
Client: *Surface* magazine

The orgasmic expression, set off by glossy
makeup, appears sexual but may also be reli-
gious, according to the title of this story. The
scratch and scar marks on the women's upper
torsos conflate the religious self-flagellation
with an S&M scene.

▽ Title: The Need CD packaging
Studio: Lux
Designer: Rachel Carns

CD artwork for underground punk-metal band
The Need features the self-fashioned drag of
its artist. Juxtaposing technology, nature, and
the body, Carns suggests worlds where hierar-
chies of species and brain over body no
longer function, and to good effect.

△ Title: Annie Campaign
Illustrator: Jasper Goodall
Studio: Red Design
Client: Loaded Records

The musician is portrayed as having sex with
a copy of herself in a confused sauna or
swimming pool sexual scenario, reminiscent
of 1970s disco culture.

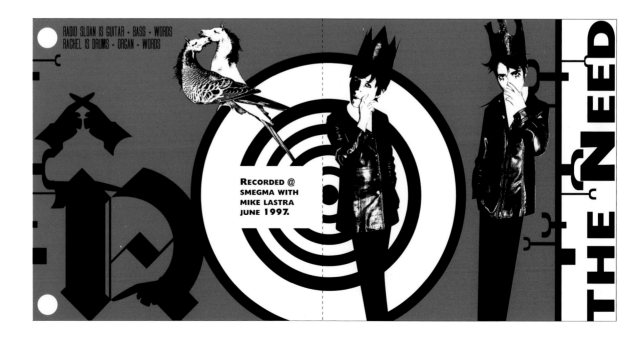

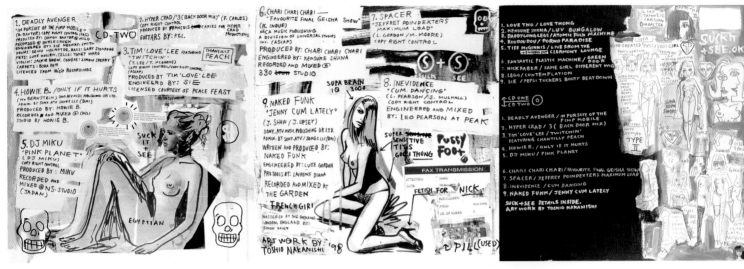

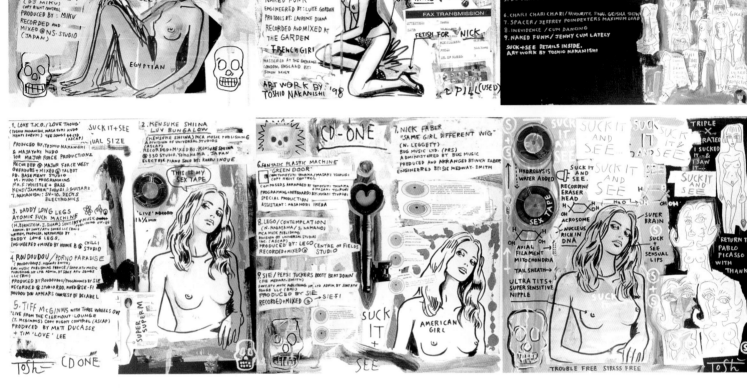

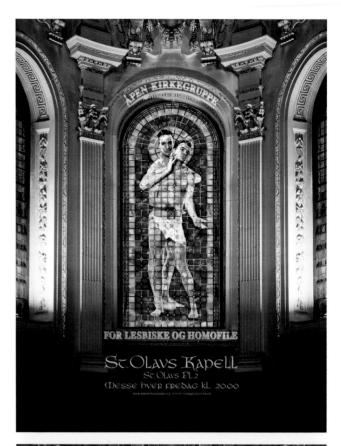

Title: *Suck it and See* album art
Illustration and Design: Toshio Nakanishi
Client: Pussyfoot Records

Nakanishi's illustrative style and wierd juxtapositions
place renderings of Picasso faces with cell diagrams and
a quasimedical analysis of the female body. The addition
of keys, skulls, and reel-to-reel tape create a chaotic
feeling that explores the overlap of hidden and obvious.

Title: Askim Clinic Open Church
Designer: Tor Einstabland
Illustrator: Tor Einstabland
Photography: Ian Pearce
Agency: BBDO Myres, Oslo
Client: St. Olavs Kapel, Apen Kirkegruppe
Service: Gay and Lesbian Christian Church

Featuring same-sex couples in an illustration that mimics
stained glass, the designer merges the gay and lesbian
image into imaginary Christian iconography. Although
such groups as the Apen Kirkegruppe have been growing
in popularity over the past thirty years, it is significant
that the designer chose to use such sexual images to
advertise a church.

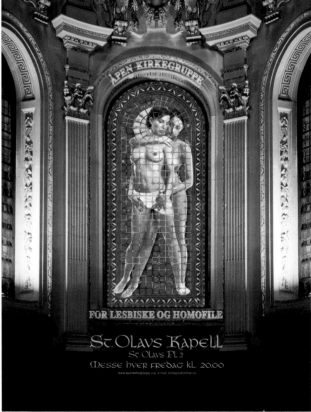

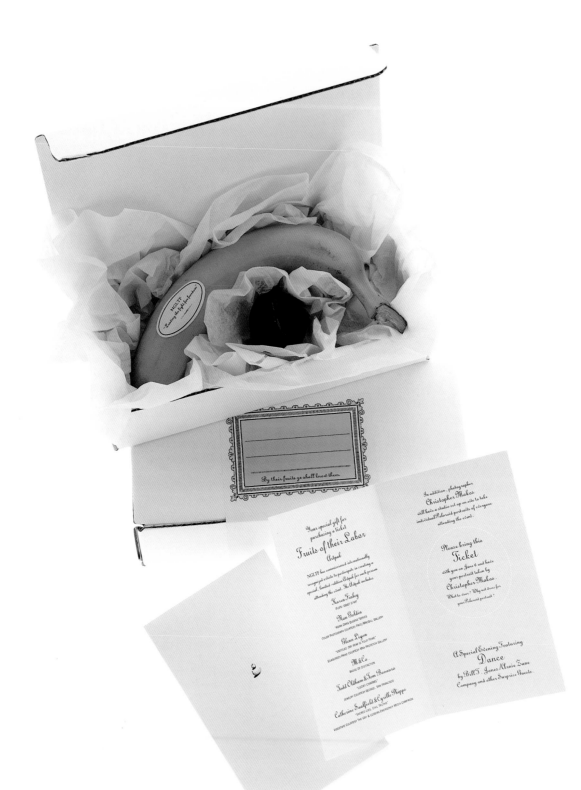

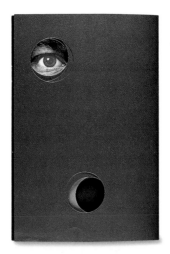
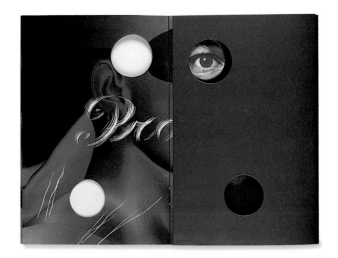

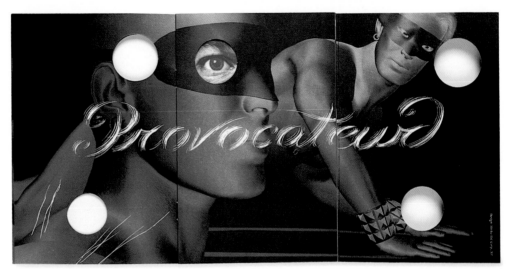

◀ Title: Gay and Lesbian Task Force Gala invitation
Designers: Stefan Sagmeister, Tom Walker
Production: Keira Alexander
Studio: M&Co.

The design of these boxes, using bananas and
plums, was meant to invite "fruits" to come
together for a good cause. Some three thousand of
these boxes were sent out in the middle of a New
York heat wave. Production was the problematic
element: delayed fruit deliveries, wrapping and
rewrapping, short tissue supplies. But all were
eventually sent out and the dinner was a success.

▶ Title: Gay Pride party invitation
Designer: Mirko Ilic´
Illustrator: Mirko Ilic´
Studio: Mirko Ilic´ Corp

Ilic´'s more representational work for a gay pride
party uses his penchant for the representation of
surface and body parts. Each hole reveals a bit
more body until a naked masked man wearing a
studded bracelet is revealed, a hole allowing a tail-
like appendage to his otherwise conventional body.
The scratches on the surface of the image also
suggest a cutting, which can be read as a sexual-
ized disruption of the otherwise smooth plane.

Warum man der Königin von Saba keinen Tages-Anzeiger zu lesen geben sollte:

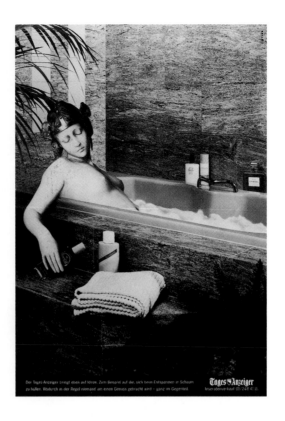

Der Tages-Anzeiger bringt eben auf Ideen. Zum Beispiel auf die, sich beim Entspannen in Schaum zu hüllen. Wodurch in der Regel niemand um einen Genuss gebracht wird – ganz im Gegenteil. **Tages Anzeiger** Inserateverkauf 01 / 248 40 11.

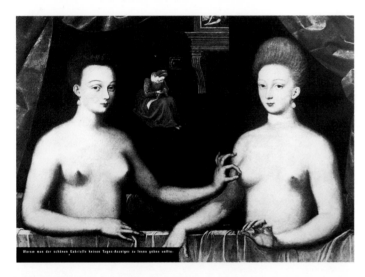

Warum man der schönen Gabrielle keinen Tages-Anzeiger zu lesen geben sollte:

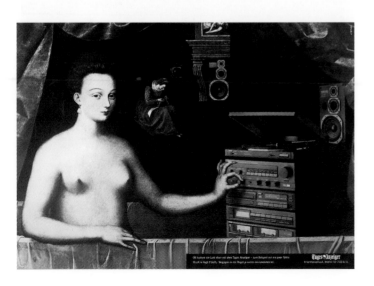

◄ Title: Stereo, Bathtub
Designer: Rüdi Wyler
Studio: Wyler Werbung
Client: Tages Anzeiger
Client's Product: Newspaper

By replacing consumer objects in erotic masterwork paintings, this ad agency shows the importance of placement in ad buying. Instead of tweaking the nipple of another woman, a woman turns a stereo knob. A woman in an exposed and vulnerable pose is replaced by a fairly modest bathtub scene. The result is a humorous comment on the replacement of the erotic desire with consumer desire.

▶ Title: Bridgestone Tire male and female diversity ads
Art Director: Elvis Wilson
Photographer: Dean Dixon
Studio: Gish, Sherwood and Friends, Inc.
Client: Bridgestone/Firestone North American Tire

Casually reclining on stacks of tires, these gay consumers are targeted and simultaneously desexualized in a campaign that the client requested to be "not too offensive or too suggestive" when viewed by straight people.

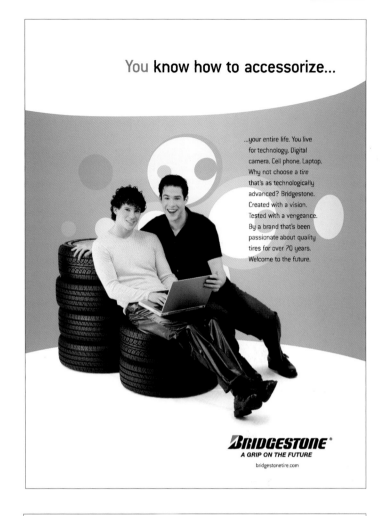

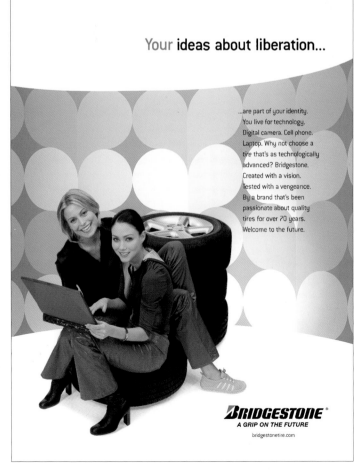

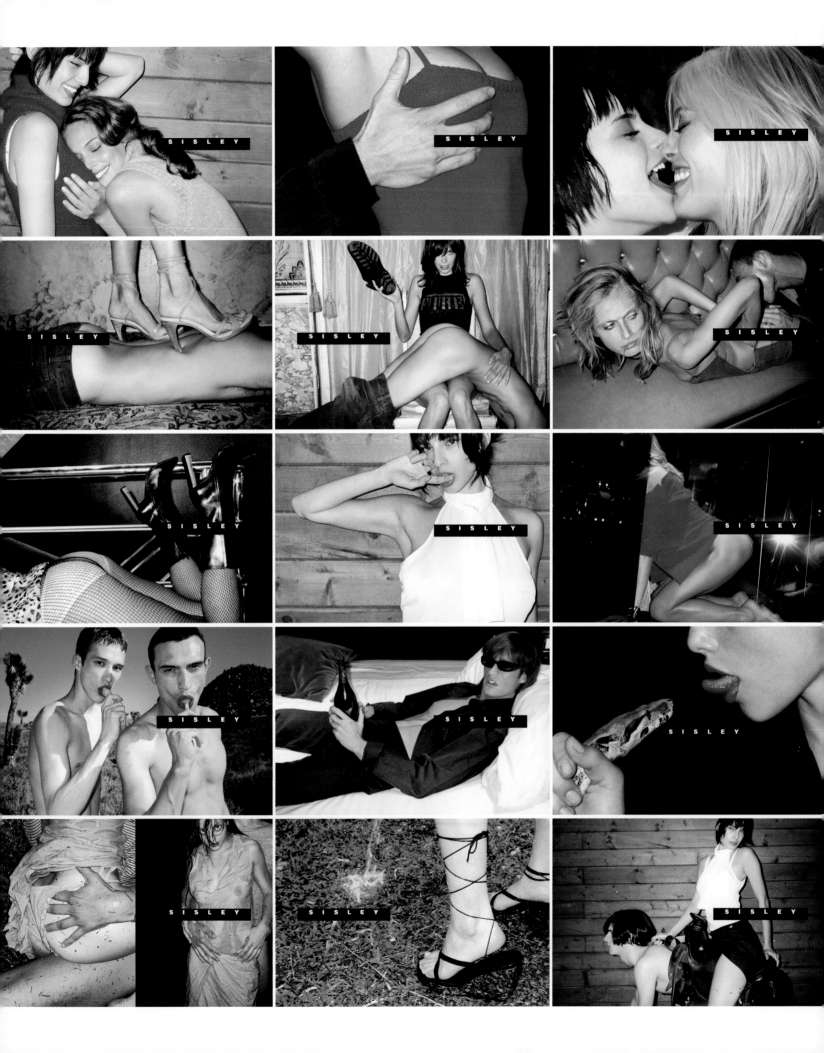

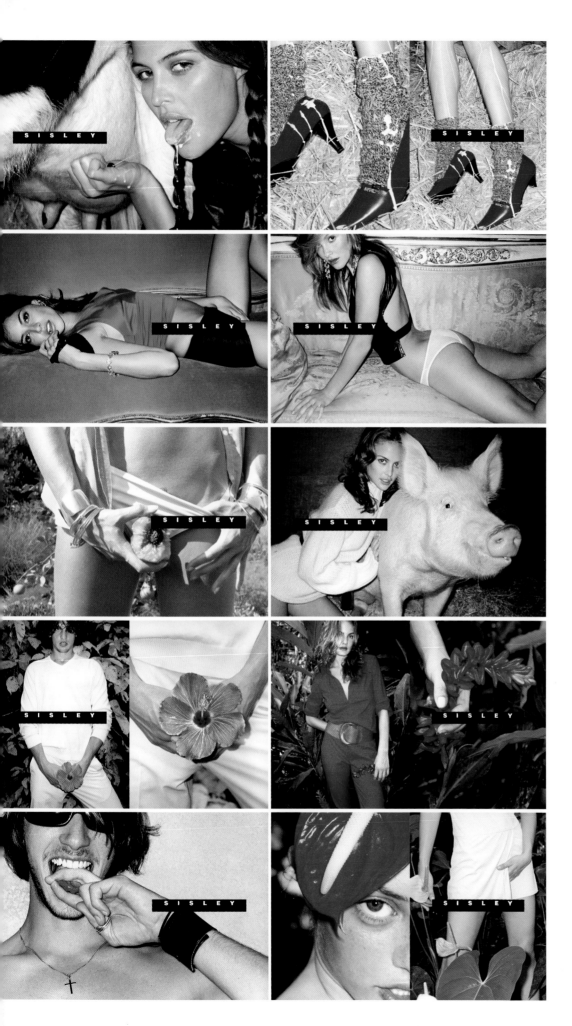

Photographer: Terry Richardson
Client: Sisley (Benetton Group)

Targeting both gay and straight consumers who appreciate femme-on-femme action, these Sisley ads come from a campaign that pushes the envelope of shock. Getting walked on, spanked, and having sex with animals all comprise the wide sexual appetites in these Sisley clothing advertisements—making cutting edge sex synonymous with cutting edge fashion.

Many of the relationships between people that are represented in design featuring sex and sexuality revolve around issues of power. The dynamic between the lover and the beloved, the active and the passive, the penetrator and the penetrated, the rich and the poor, the old and the young, the beautiful and the repulsive—are all sexual to some degree but also contain a dynamic of power rather than simply being about sex. In addition, these simple dichotomies are often not comprehensive enough to encompass the unique ranges of sexuality as they are expressed in visual media, much less in human experience. This chapter seeks to isolate the issues of power as they relate to sex and to describe our visual culture's underlying assumptions about the categories of age and race, relating the few nonnormative representations to their rhetorical context. Each of these themes could potentially encompass an entire book of its own. Our goal is to present visual examples that exemplify standards and stereotypes and show examples of work that challenge received notions of power hierarchies.

Age

Within the visual culture of the early twenty-first century, stereotypes regarding old age and sexuality are rampant—that is, when older people are represented at all. The invisibility of the elderly in a media and marketing climate that favors the young relies on simplistic renditions, often negatively stereotyping not only sexual dysfunction, but issues related to mind, body, heath, personality, and work capacity.

Second-wave feminism, combined with the graying of the baby-boom generation, has allowed older women and men in Western culture a degree of control over their sexuality that is unsurpassed by any preceding generation. As these conditions in the wider culture have changed, stereotypes of older people as represented in graphic design have been both revamped and reinforced. Stereotypes of the past include the older woman as sexual predator toward the younger man (a la Mrs. Robinson) and the older woman as sexless (past childbearing years so, hence, sexually unattractive), the older woman as dependent upon their husbands or family for their identity (sexual or otherwise), and prurient, hypersexual older men. One campaign that challenged these stereotypes was for the German clothing company, OUI, which wanted to counter traditional fashion advertising in which signs of aging are taboo. In 1999, RG Wiesmeier Werbeagentur AG started the market relaunch of OUI with the following position: fashion for the stronger of the two sexes, with woman portrayed as the stronger sex.

The agency accomplished this by showing men dressed as women. In 2002, the advertising campaign has changed, but the message (strong women) remained the same. Sending out messages of sexual ambiguities or provocations was never the agency's or client's intention. Instead, the focus was on breaking taboo, not representing explicit sexuality, by portraying age and the signs of aging as beautiful. This campaign was critically and commercially successful, winning the 2001 Fashion Marketing Prize of the Year/2002 Annual Award of German Journalists for Pioneering Print Campaigns. The magazines in which the OUI ads ran received thousands of letters to the editor: nothing but grateful agreement.

In another taboo-breaking image, Rankin's book on male nudes shows a variety of male body types, including older men. The first image in the book features an older man with a very small penis whose naked belly proclaims "proud" [page 80]. Nearly all the images in the book explore the theme of masculinity by way of the body. This photograph is another instance of the taboo of age being broken and the full spectrum of human sexuality is made available.

With the exception of the ironic humor of using former U.S. presidential candidate Bob Dole as a spokesmodel, most ads for Viagra (the drug that treats penile erectile dysfunction) feature sheepish older men who are embarrassed to discuss their problem. These men are generally represented as possessing everything else that symbolizes male power, yet the advertisements imply that their essential unseen attribute of manhood is not functioning properly. Innovative creative from McCann-Erikson Madrid infuse both humor and the female gaze into their Viagra ads, creating a series of film noir–styled images of women screaming, staring at "it" [pages 92–94]. The Viagra pill on the facing page lets us know that their "fear" is of some unseen giant penis, the power of which they face with fear. Because the images also suggest surprise and humor, we could also interpret their reactions as a surprised relief.

Youth

Americans are terrified of the sexualization of children. Perhaps this is because of the real threat of sexual victimization of children and contemporary media hype regarding threats to children. It could also be because of the changing social climate that rewards victims' confessions of abuse, which is no longer a taboo subject. There is also a distinctly litigious environment that attempts to hold institutions such as schools or churches responsible for the actions of their powerful members. The problem of child sex abuse has finally become front-page news. It is obvious that sexual crimes against children are less about sex than they are about the abuse of adult power. This power dynamic shows up in almost every representation of sexualized youth. Because youth and the beauty of youth are fetishized across a wide spectrum of graphic expression, it is important to differentiate the contexts for the production of these images in order to read them accurately. Boys and girls, adolescent and younger, are placed in sexualized situations, in an iconographic tradition dating back to at least ancient Greece. Legal or moral issues aside, it is startling to discover the relatively staid and stereotypical representations of youth that continue to appeal to both designers and to the general public.

Babies are generally immune from sex-oriented advertising. This does not prevent heavy, gender-based representation and marketing to babies and their parents, often featuring the typical pink/blue color code and characterizations of "what boys like" and "what girls like." In a strange departure from this standard, a Spanish Opel ad [page 84] encourages the viewer to think of a nursing baby boy in sexual competition with his father for the attention of his mother. The caption reads "Between 8 and 8:15, another man is playing with your wife's breasts." Ultimately, this ad is charming but a bit disturbing.

Almost as rare as babies in sexy graphics are young children. Art Chantry's graphics for the rock band Hole [page 78] features a photo of a naked little girl in a bathtub. The girl is actually the histrionic lead singer Courtney Love herself, whose clownish grown-woman-qua-sexy-little-girl schtick was her modus operandi and fashion statement throughout the early 1990s. This image caused the 7-inch (18 cm) sleeve to be rejected by printer after printer, its homemade snapshot-like look verging on kiddie porn (it was Love's idea to use the image in the first place). Exploiting the image of a young child is obviously problematic. The image is provocative because it questions whether self representation in the arena of childhood sexuality is morally tenable.

The most common sexualized stereotypes for adolescent men and women derive from the common themes of female overdevelopment and male puerility. These themes are based, to some degree, on the biological fact that girls develop more quickly than do boys. In addition, adolescent girls are encouraged to devote hours making themselves sexually attractive to boys, while boys remain devoted to homosocial environments that reject all but the most fantasy-based versions of femininity. Unfortunately, this fantasy realm persists for many long beyond the adolescent years, propagating some of the more uninteresting and sexist images littering our visual culture.

The teenage boy fantasy comprises the design concept for rock band Blink-182's album *Enema of the State* [page 102]. Initially, the band did not have a title for the album, which features the hit-paean to male adolescent stupidity, "What's My Age Again?" Designer Tim Stedman worked with the band to develop the concept. The band members are featured along with various other male teenagers, and with porn star Janine. The boys are completely overpowered by Janine's naughty nurse role; her pose on the front cover (and the album title) implying the submissive and emasculating sex act, anal penetration by a woman.

Ironically, both this image of teenaged sexuality and the stereotype of older virility (or lack of it) confirm long-held assumptions about these stages of life. Yet they discuss something that is generally outside the realm of advertising: penises and male sexuality, problematic though they may appear. These ads are part of a larger discourse on male sexuality that has opened only very recently, and largely due to the feminist movement. The power of male sexuality is no longer taken for granted, but it is, rather, viewed as a valid topic of discussion, and as appropriately complex.

In a simplistic rendition of adolescence, girl-on-the-edge-of-womanhood is the basis for Brazilian shoemaker Via Uno's advertisements. Their aim was to differentiate the Via Uno brand from its competitors, and to appeal to the teen consumer market [page 79]. In creating the campaign, RBA Publicidade's intention was to approach the target public without

turning Via Uno into a brand specifically for teenage girls. The concept "the days you were a little girl are over" eventually guided them to the strategy and prompted them to explore sexuality. They write: "Approaching this issue was a way we found to talk about something that is very close to teenaged consumers, setting up a link with the brand. We did not have any problem because the approach was soft, elegant, and not aggressive at all."

Each stage of life has sexualized stereotypes that attend it. Using these stereotypes makes it easier to reduce human variety and diversity. It also helps to keep static social structures in place. As long as makeup companies can convince women that natural signs of aging will make them sexually unattractive, as long as rock bands make it cool for men to objectify and fear women, as long as fashion magazines tell young women they need to be thin to be sexually attractive, as long as Viagra ads tell men they have to be rich and powerful to get the ladies (and that sex is the same as a hard penis), we will have to contend with these stereotypes. So much design uses these commonly held images and systems of cultural hierarchy to motivate the messaging of their clients, taking away dimension and complexity from human expression.

Race

The intersections between sex and race in graphic design reveal relationships of power. In this way, they have continuity with the power play that is apparent in relationships that contain a differential of class or age. Normative hierarchies favor representations of the young, white, and rich more than any other type. Race is a category that highlights the power differentials present in normative representations.

Because our survey is international, what constitutes "normative" race representation can be somewhat problematic. We have chosen to focus on representations that seem to either confirm or dispel racial stereotypes as they are conflated with stereotypes of sexuality and gender. The most common stereotype of race in graphic design is of black women, which is consistent with oppressive structures of the culture at large. Disenfranchised because of gender and race, black women are stereotyped as sex-crazed savages who would as soon eat a man as have sex with him. Often couched in a visual rhetoric of retro imagery, this stereotype is recycled ad nauseum.

An interesting play on this generalization are Moshino's works from Girl Studio. Despite the product or service being advertised or represented by Moshino's graphics, his style emphasizes an amalgam of psychedelic forms that recall Victor Moscoso posters of the 1960s with a uniquely contemporary feel. Moshino's representation of black women occurs throughout his work, emphasizing the Afro hairstyle, as well as curvy bodies. His work presents a combination of racial and sexual stereotype mitigated by his location outside the culture that created those stereotypes in the first place. As he mentions in his book *Moshino's Works for Girl Studio* (É.T. Insolite, Tokyo, 1998): "I wanted to design something that implies some sort of new movement, like a combination of hippies and Ukiyo-e woodblock prints, or orientalism and black culture."

The complexities of cross-cultural racism, North-South economic disparity, and lingering institutional racism within a broad spectrum of U.S. cultural phenomena deserves a study of its own—the images we include here merely scratch the surface.

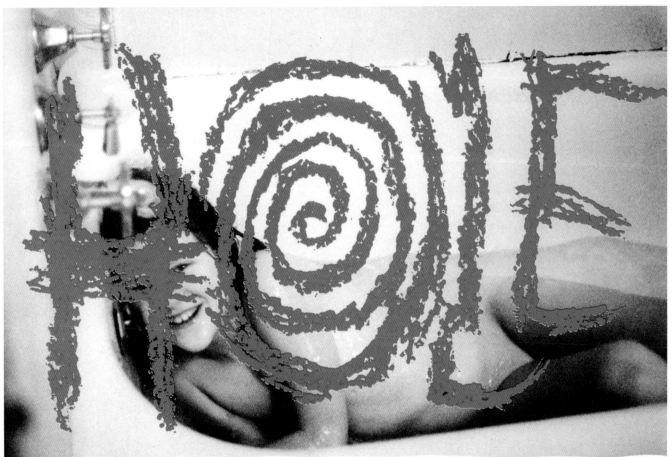

▲ Title: Hole single sleeve cover
Designer: Art Chantry
Typography: Courtney Love
Studio: Art Chantry Co.
Client: Sub Pop/Hole

This 7-inch record sleeve featured a naked
photo of the band's lead singer as a child.
Although she encouraged the designer to use
it, this piece nonetheless found resistance
from a number of printers before it was
finally produced.

▶ Title: Goldfishes/Teddybear
Art Director: Manolo de Quadros
Copywriters: Marciano Fuchs, Claudia Schroeder
Photographer: Celso Chittolina
Studio: RBA Publicidade
Client: Via Uno
Client's Product: Women's shoes

Translation: The days when you were a little girl
are over.

This shoe ad series uses the humor of the
voyeuristic fish and teddy bear watching a
teenage girl get dressed, stressing her newfound
sexuality (aided by the use of heels). The reader
of this ad is complicit in the spying, but the
presence of the fish mitigates this otherwise
creepy situation.

Seu tempo de garotinha já passou.

Seu tempo de garotinha já passou.

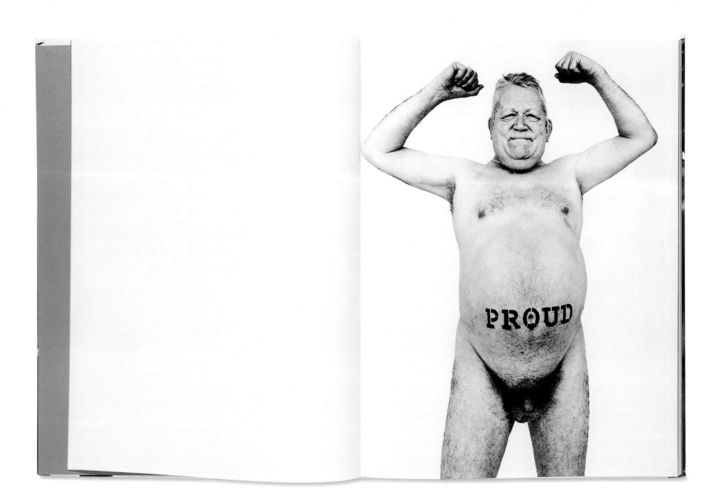

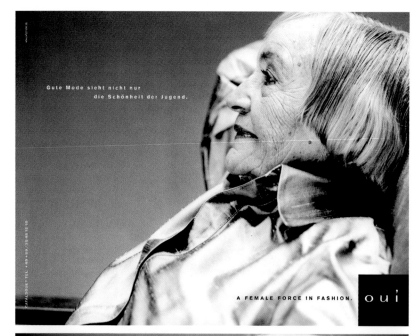

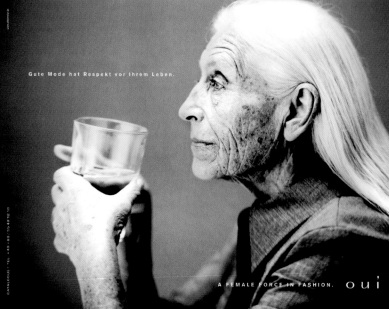

Title: *Male Nudes*
Designers: Bryan Edmondson, Carsten Klein
Art Directors: Bryan Edmondson, John Simpson
Photographer: Rankin
Studio: 12X
Client: Rankin, Vision On Publishing

The diversity of male nudes in Rankin's survey includes older men, whose sexuality is rarely explored, except in parody.

Title: Oui 2002
Artistic Director: Susanne Ahlers
Creative Director: Carlos Obers
Photographer: Anatol Kotte
Studio: RG Wiesmeier Werbeagentur AG
Client: Oui Group Munich

By simply featuring older women in their advertising, *Oui* challenges stereotypes of old women as nonsexual and not attractive. By using figures with whom their target market could identify, Oui makes an honest attempt to both reflect and acknowledge the complexities of their consumers.

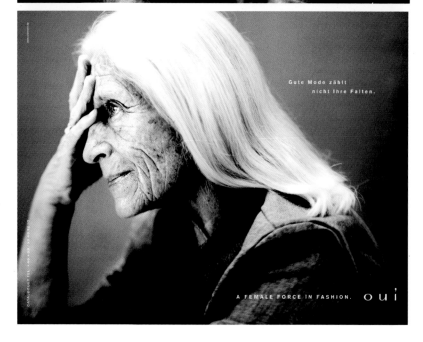

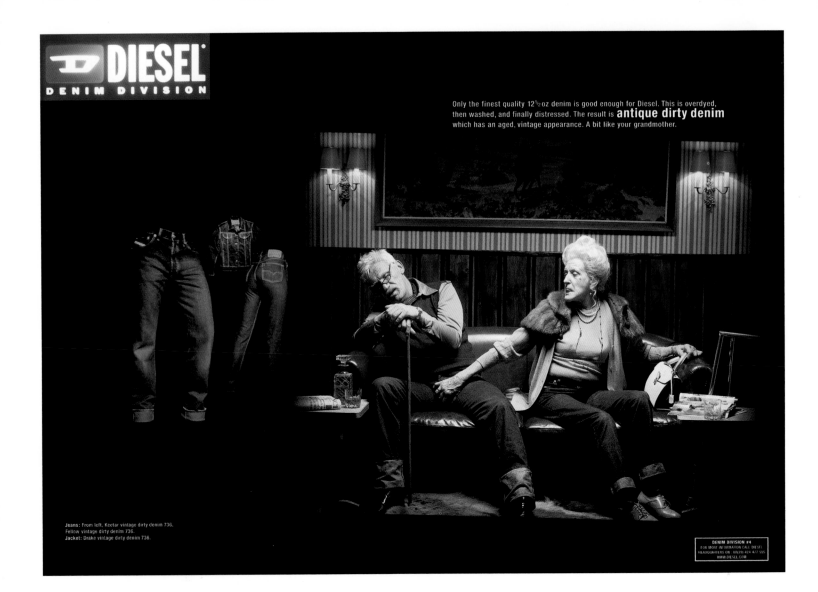

Only the finest quality 12½ oz denim is good enough for Diesel. This is overdyed, then washed, and finally distressed. The result is **antique dirty denim** which has an aged, vintage appearance. A bit like your grandmother.

Jeans: From left, Keetar vintage dirty denim 736.
Fellow vintage dirty denim 736.
Jacket: Drake vintage dirty denim 736.

DENIM DIVISION #4.
FOR MORE INFORMATION CALL DIESEL
HEADQUARTERS ON : 00(39) 424 477 555
WWW.DIESEL.COM

▲ Title: Vintage Dirty Denim
Design: Diesel
Studio: Diesel

This advertisement for "vintage dirty denim" features images of older people who are in fact wearing said jeans. Because this ad is targeted for a younger market, the caricatures of "old man" and "old woman" are typical: the man has lost his virility and the woman is a sexual predator.

▶ Title: Communion
Editors: Tim Moss, Koji Yoshida
Guest Editor: Kyoichi Tsuzuki
Art Director: Markus Kiersztan
Design: Garland Lyn, David Lee
Photographer: Luis Sanchis
Client: *Big* magazine 26

By using the setting of the Japanese love-hotel, Kierzstan brings the idea of tradition into a contemporary, urban space, where young lovers can rent rooms by the hour to escape the confines of their cramped family homes.

PHOTOGRAPHED BY LUIS SANCHIS

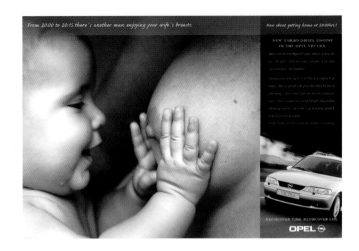

Title: Breast
Art Director: Rebeca Diaz
Designers: Rebeca Diaz, Isabel Lopez
Photographer: Sara Zorraquino
Studio: McCann-Erickson, Madrid
Client: Opel

Facing Oedipal competition from his infant son, the Opel driver is encouraged to get home quickly and reassert his proprietary control over his wife's breasts.

Title: Pinocchio
Designer: Rüdi Wyler
Studio: Wyler Werbung
Client: *Das* Magazin
Client's Product: Magazine

The copy of this trade advertisement for media buying reads that when something is well placed, it gets noticed. A child's Pinocchio doll is sexualized—the long nose is replaced by a long phallus—to make the point about advertising placement. This ad is humorous because it displaces a story and an object of youth into an adult world where getting noticed (whether you are an ad or a human being) relies to some extent on sexuality.

Title: *Young Lust: The Aerosmith Anthology* CD package
Art Director: Vartan Kurjian/Universal Music Enterprises
Designer/Sudio: Todd Gallopo/Meat and Potatoes, Inc.
Photographer: Gabrielle Revere
Studio: Meat and Potatoes, Inc.
Client: Universal Music Enterprises

In creating the CD packaging for this Aerosmith anthology, the designers wanted to use an image that communicated a "universal visual of young lust" and create and "image as universal and sometimes sexual as the music of Aerosmith." From the musicians, who brought us such classics as "Dude (looks like a lady)" and "Love in an Elevator," here "universal" means the same stereotypes of adolescent sexuality with a particular emphasis on the bra, and its imagined owner, topless.

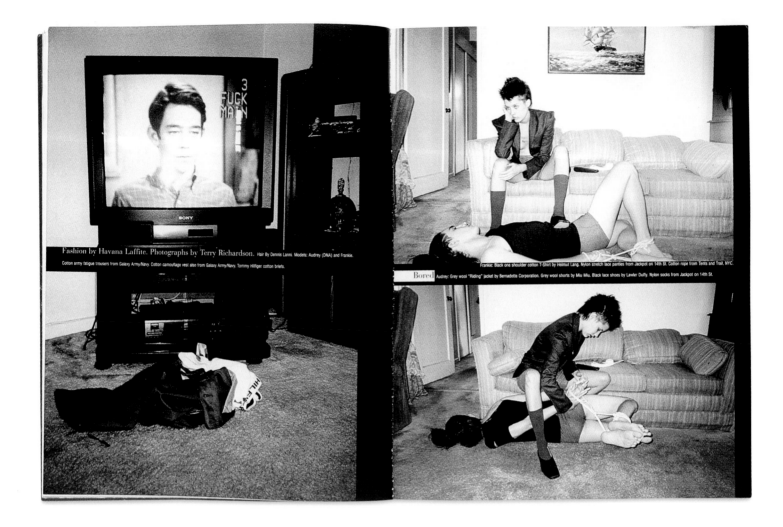

Fashion by Havana Laffite. Photographs by Terry Richardson. Hair By Dennis Lanni. Models: Audrey (DNA) and Frankie.

Cotton army fatigue trousers from Galaxy Army/Navy. Cotton camouflage vest also from Galaxy Army/Navy. Tommy Hilfiger cotton briefs.

Frankie: Black one shoulder cotton T-Shirt by Helmut Lang. Nylon stretch lace panties from Jackpot on 14th St. Cotton rope from Tents and Trail, NYC.

Bored Audrey: Grey wool "Riding" jacket by Bernadette Corporation. Grey wool shorts by Miu Miu. Black lace shoes by Lawler Duffy. Nylon socks from Jackpot on 14th St.

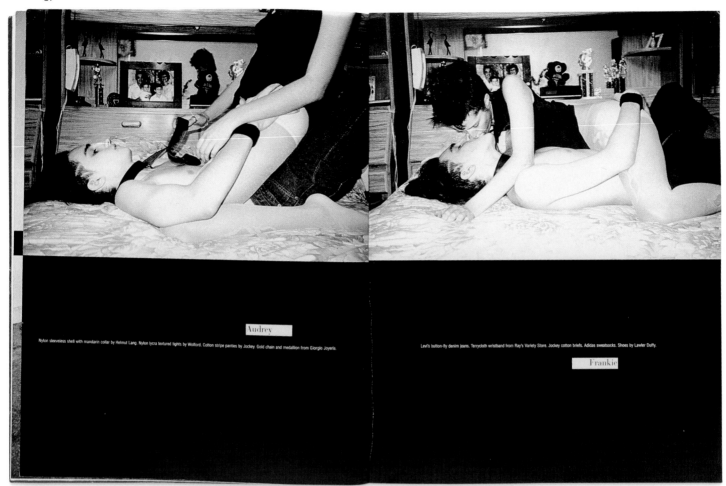

Audrey

Nylon sleeveless shell with mandarin collar by Helmut Lang. Nylon lycra textured tights by Wolford. Cotton stripe panties by Jockey. Gold chain and medallion from Giorgio Joyeria.

Levi's button-fly denim jeans. Terrycloth wristband from Ray's Variety Store. Jockey cotton briefs. Adidas sweatsocks. Shoes by Lawler Duffy.

Frankie

Title: Bored
Creative Director: Marcelo Jüneman
Editorial and Design Director: Gary Koepke
Fashion Director: Debbi Manson
Photographer and Stylist: Terry Richardson
Client: *Big* magazine 15

It appears these androgynous teens have nothing better to do than watch the *Brady Bunch* and tie each other up. This depiction of teen sexuality is remarkable because it does not use stereotypes of teens, nor is it particularly explicit. The blank expressions on the faces of the models create a situation where objectification is even displaced. These images are ultimately part of a fashion story that is supposed to appeal to readers of a fashion magazine. The sexual sophistication and fashion sense characterized the models as adults, their bodies clearly remind us that they are teens. This story is shot in black and white, adding to the documentary feel of the piece. There is a reference to home video and sex in the word "fuck" on the screen instead of "play," and the inference that one is interchangeable with the other. The series borders on much of Larry Clark's world, which has been both vilified and glorified.

Big

ISSUE 26
US $15 CANADA $20
PRINTED IN SPAIN

日本景

Tradition

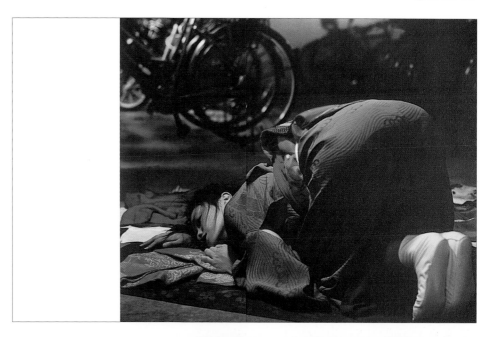

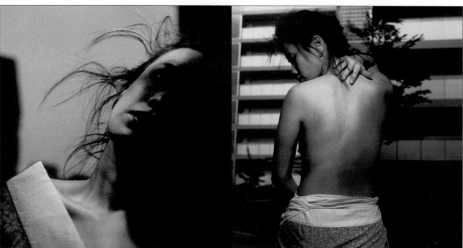

PHOTOGRAPHED BY LUIS SANCHIS

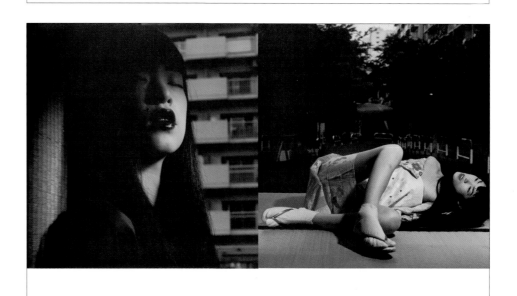

Title: *Big* magazine 26 cover and spreads
Editors: Tim Moss, Koji Yoshida
Guest Editor: Kyoichi Tsuzuki
Art Director: Markus Kiersztan
Designers: Garland Lyn, David Lee
Photographer: Luis Sanchis
Client: *Big* magazine 26

In the "Tradition" issue of *Big* magazine,
Kierzstan had his models mimic the poses
of Japanese porn movies. These images are
startling because they clearly evoke a filmic
feel, but the referent is unfamiliar to the
Western gaze. Kierzstan juxtaposes traditional
Japanese kimonos with pornographic poses
drawing parallels between roles of women
throughout Japanese cultural history. What
remains hidden, and how it remains hidden,
becomes as essential as what is revealed.

監督　佐々木元寿
企画
撮影／池田清
ナレーター　関正一

スウ　ポル大全集

性犯罪史シリーズ

巴狼
いろおおかみ

製作／前田宗男
脚本／松野　順
監督／川合茂貴
撮影／�22野　忠

〈カラー〉
東京芸術映画協会作品
〈成人映画〉

浮気

柳川優子
大月麗子
奈美
城
三千代
福山拳一郎
浩

Title: Generation Sex
Art Director: Markus Kierzstan
Client: Aspect/Street Design File

Kyoichi Tsuzuki, in his column "When Pigs Design" in *Idea* magazine 281, writes "the reason I wanted him to design the cover was straightforward and simple. I wanted someone like him, who is capable of looking at it purely as a graphic design with no prejudice towards those types of posters. Also I assumed he would be able to notice its peculiar beauty from an outsider... Although the actual work and communication was done via e-mail, we both agreed on the ample sensation these posters conferred to both of us." Tsuzuki refers as well to the "bad" fonts and designs of these posters, how they were probably designed by amateurs, and with a small budget.

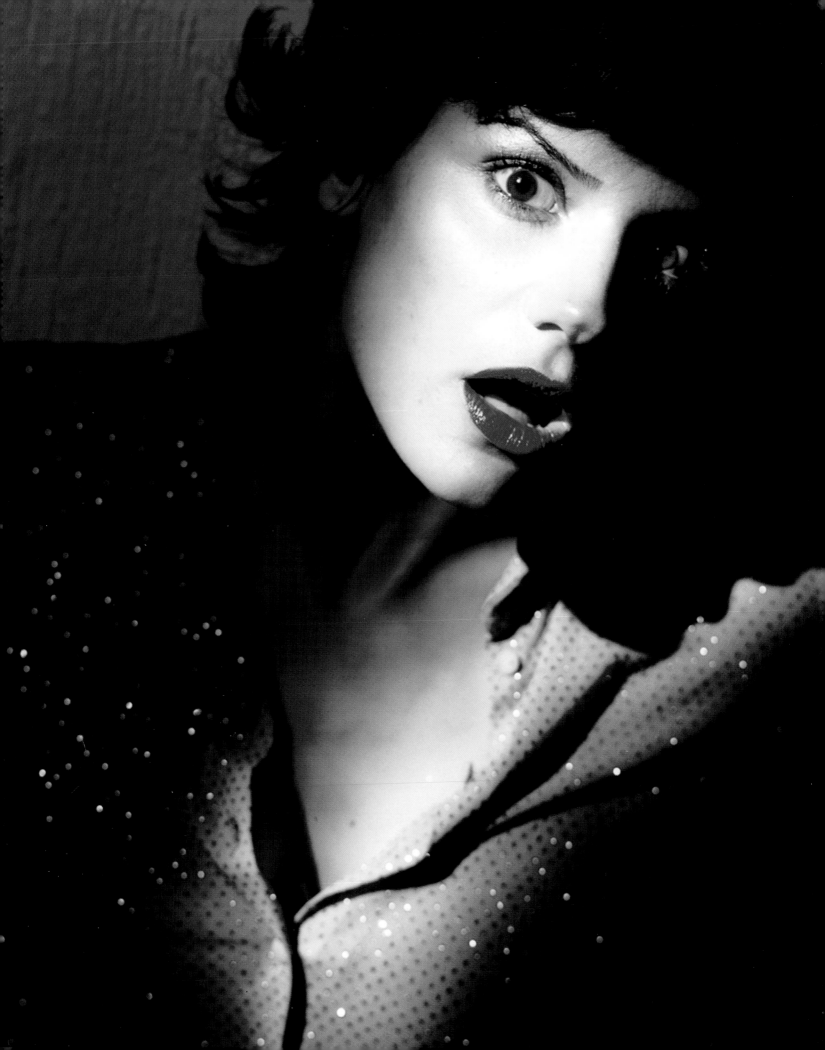

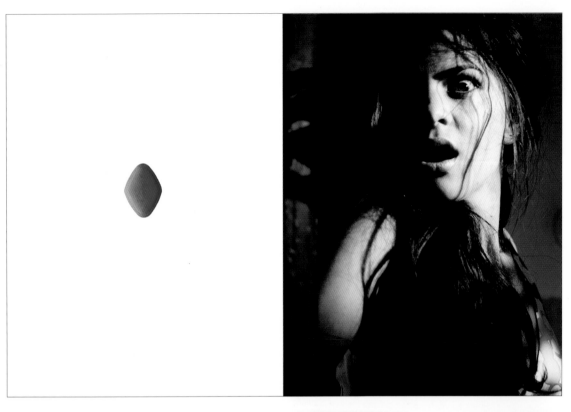

◂ Title: What the Hell Is That?
Art Director: Rebeca Diaz
Designers: Rebeca Diaz, Isabel Lopez
Photographer: Sergi Lopez
Studio: McCann-Erickson, Madrid
Client: Pfizer—Viagra

In striking contrast to North American pharmaceutical advertising campaigns for Viagra, this Spanish ad uses humor to excellent effect. Rather than focusing on a man's reaction to his rediscovered virility, in this series it is the woman's surprised (frightened?) expression that takes center stage.

▲ Title: D'Angelo CD cover
Art Director: Len Peltier
Photographer: Thierry LesGoudes
Client: D'Angelo

D'Angelo is often credited for a return to a singer-song-writer tradition in black music after the reign of hip-hop. Although marketed as such, D'Angelo himself is market-ed to his fans as something of a sensitive soul. His naked torso on the cover of his Grammy-winning album, *Voodoo* (best Male R&B Vocal Performance and Best R&B Album), demonstrates that the vulnerability of the man and his music are backed up by incredible strength.

▶ Title: Package illustration for Beauteen
Designer/Illustrator: Katsura Moshino
Studio: Girl Studio
Client: Hoyu
Product: Hair Color

When given the assignment to create packaging that would appeal to girls in the teens and twenties, Moshino used a cute image with what he calls a "fashion forward attitude." This image of a black woman ironically sold a lot of hair dye to Japanese teenagers. This product became number one in the industry. Until this box, most hair dye used photographs of women; now illustration is the overwhelming favorite of most brands.

▶ Title: Suigara
Designer/Illustrator: Katsura Moshino
Studio: Girl Studio
Client: *Remix* magazine, cover illustration of Club Sight

Moshino created an image to feel like Blow Fly, a strange character from 1970s funk music. When at the club, DJs would ask the artist if the girl in the picture was licking a penis. As a result, the image of the magazine was enhanced.

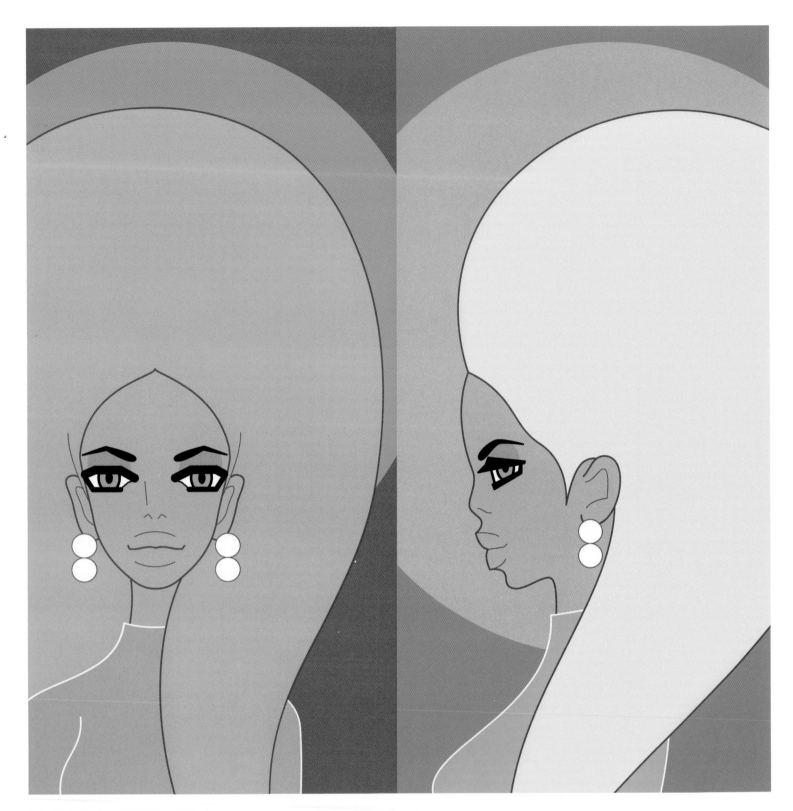

Title: Illustration for Connection Soul by DJ Paul
Designer/Illustrator: Katsura Moshino
Studio: Girl Studio
Client: G.A.S. Sound Production
Production: DJs Mix Tape

This image was used for the cover a mix tape made by DJ
Paul, a friend and fan of the artist. Because the music is
"mellow and sexy," the artist wanted imagery to match.
Another rich DJ tried to get Moshino to design the cover
of his tape, but Moshino refused, making the rival DJ
jealous. DJ Paul's tape sold out quickly, in part, because
of the cover illustration.

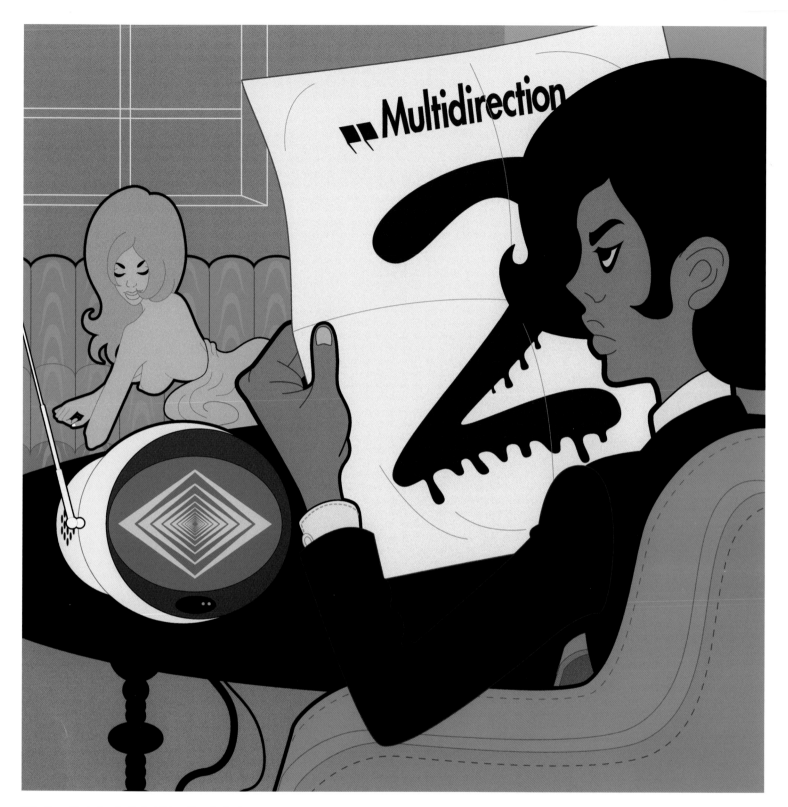

Title: Cover illustration for United Future Organization's
compilation album (1995)
Designer/Illustrator: Katsura Moshino
Studio: Girl Studio
Client: Talkin' Loud Records/Phonogram Records, Japan

The project brief for this project was to base the imagery
on 1970s spy movie atmosphere. Another point was to
enhance the visual image of United Future Organization
who was the producer of this compilation—to achieve
commercial success without changing the cool attitude.

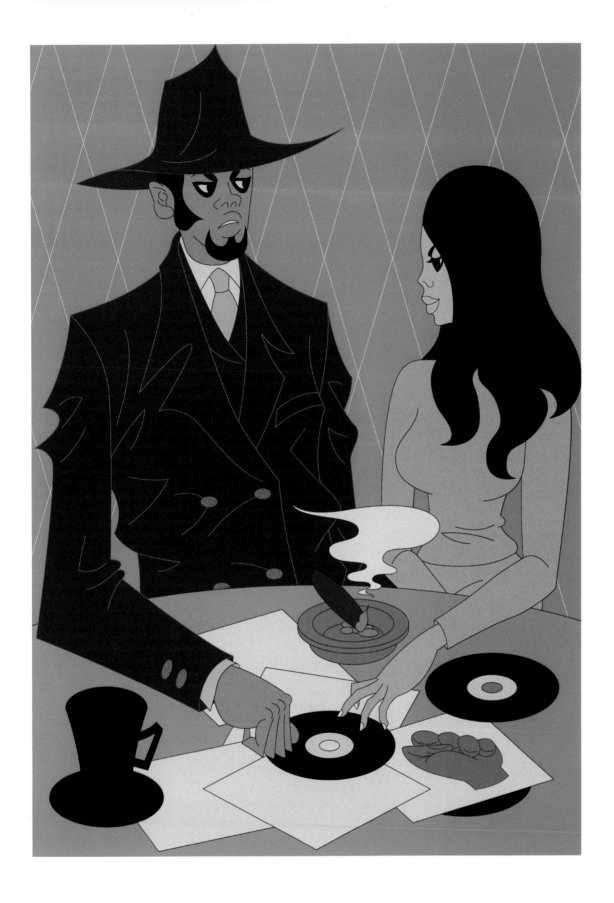

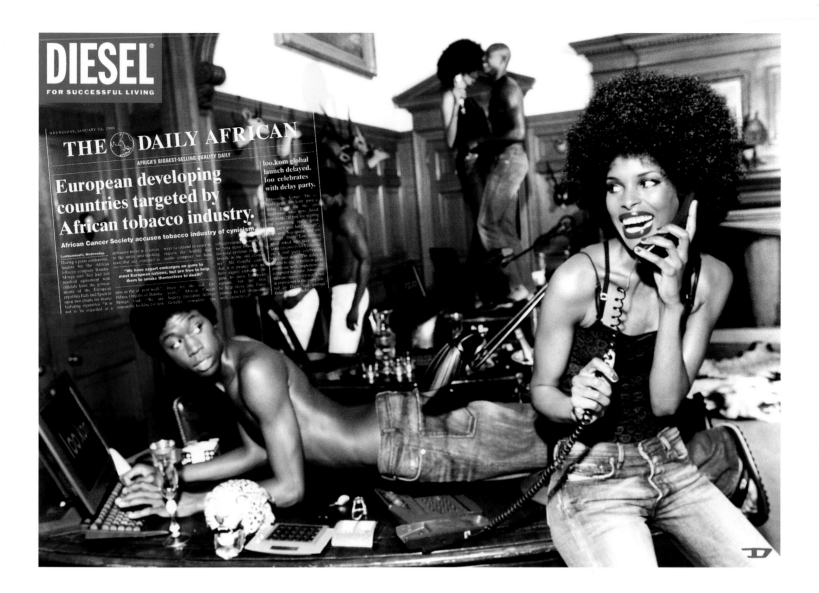

Title: Vibration
Designer/Illustrator: Katsura Moshino
Studio: Girl Studio
Client: Self promotion

This image was for a postcard, advertising Girl Studio. The aim of the designer was to have it be displayed on the wall like a pinup girl photo.

Title: Daily African
Design: Diesel
Studio: Diesel

As is often the case, it is difficult to tell exactly what kind of narrative is being enacted in a Diesel advertisement. There are clearly some sexual elements in this image, with people in the background dancing, but there is also an overlaid "newspaper" that critiques the targeting of Africans by European tobacco companies, by ironically inverting the relationship. Readers are subtly directed to check out *The Daily African*, an online hoax that features Diesel products prominently.

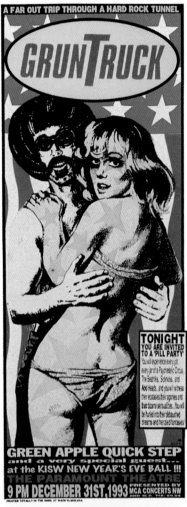

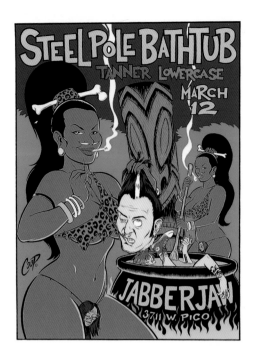

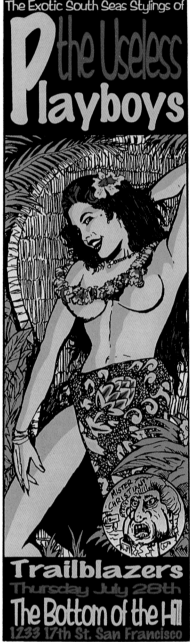

▲ Title: Bummer!/GrunTruck/Green Apple Quick Step
Designer: Frank Kozik

The retro images of blaxploitation films are often used in graphic design to present the conflation of sex and race in a manner that subtly sanctions outrageous racism and stereotypes of sexuality. In this particular instance, the white woman falls happily into the arms of the mustachioed black militant, with an American flag in the foreground.

▲ Title: Steelpole Bathtub/Tanner Lowercase
Designer: Coop

Savage yet sexy, Coop's poster design draws on the most common stereotypes of black women and South Pacific Island cultures. Relying on the Cocktail Nation's obsession with all things tiki, this image takes both primitivism and fear of women to a new level.

▲ Title: Tits and Ass Make the World Go round/
The Useless Playboys/Trailblazers
Designer: Frank Kozik

Another take on the South-sea island woman/pinup girl, this time inviting rather than menacing.

▲ Title: Pavement
Designer: Coop

Using the familiar look of the 1970s blax-
ploitation film, Coop's poster for the rock
band Pavement places his familiar woman
(this time black with an Afro) reclining on an
American flag. The conflation of a sexualized
patriotism with a nearly naked woman and
the generally nerdy band Pavement make for
a confusing caricature of all three.

▶ Title: Hadukoru-panku-raku des/Dinosaur Jr/
My Bloody Valentine/Babes in Toyland
Designer: Frank Kozik

The sexualized schoolgirl is a particularly
common stereotype and fetish in Japanese
culture; here, it is transplanted to an
American context with the caption, which
translated reads "hardcore punk rock."

▲ Title: Blink 182 *Enema of the State* CD cover
Art Direction: Tim Steadman
Designers: Tim Steadman, Keith Tamashiro
Photo: David Goldman
Client: Blink 182

Porn star Janine acts out the adolescent boy's
naughty-nurse fantasy while the members of
Blink 182 tremble with eager expectation.
These images reinforce the puerile stereotype
of adolescent boys and the horrifying power
of grown women who sexually dominate them.

▶ Title: Kinder
Art Direction: Lee Swillingham, Steuart Spalding
Fashion Director: Katie Grand
Designer: Martin Sebald
Photography: Sean Ellis
Styling: Charlotte Stockdale
Client: *Big* magazine 28

The sultry woman placed among creepy-looking children
tells a story of horror and submission. In the end, the
children appear, bloody mouthed, having—we assume—
consumed the body of the woman. Who exactly the
perpetrator is in this story is not clear, however.

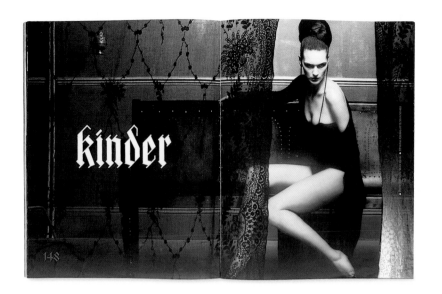

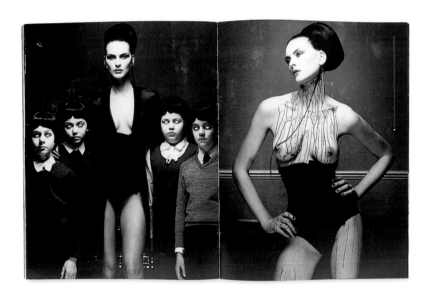

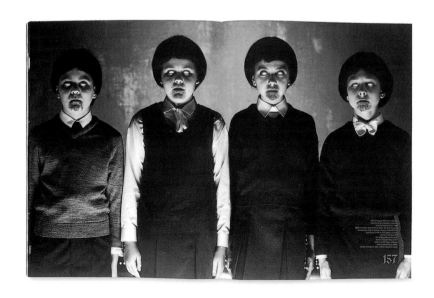

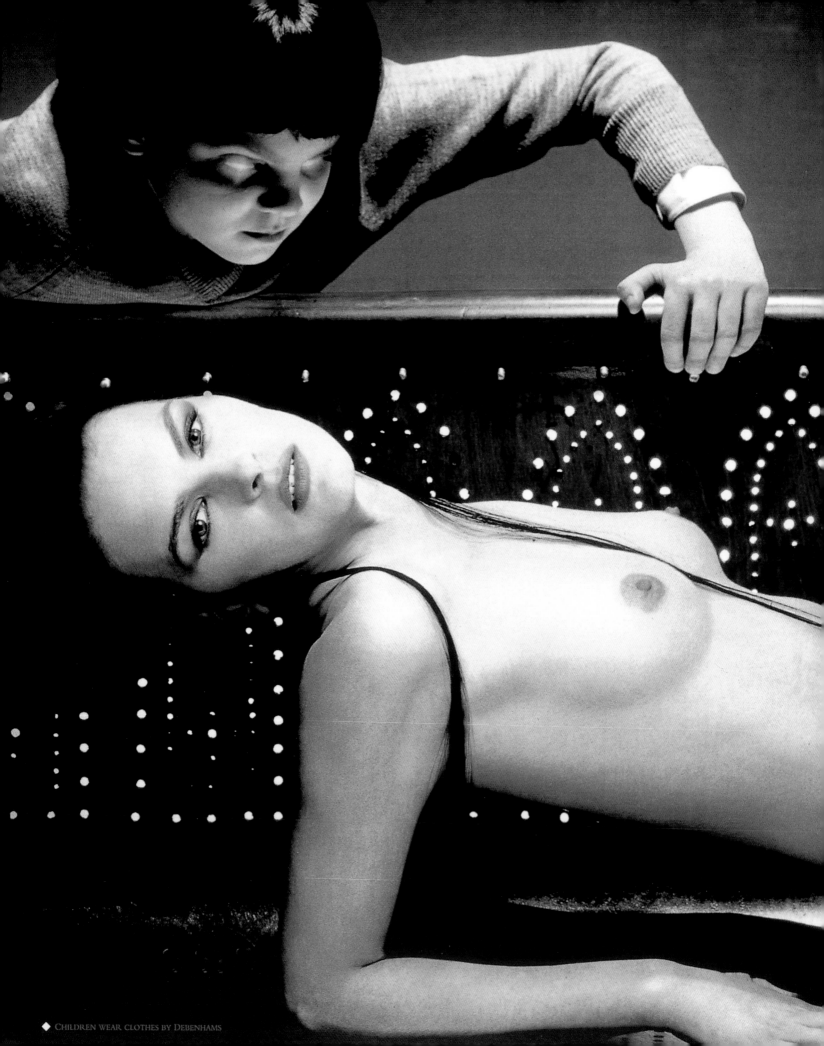

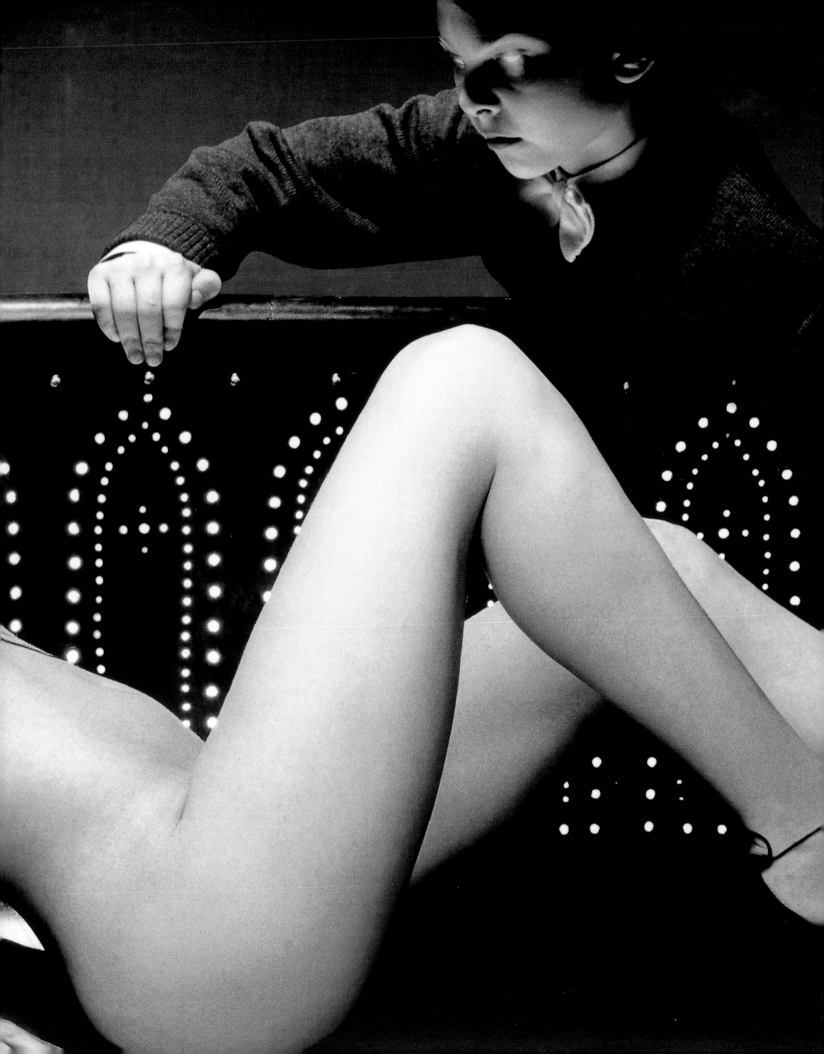

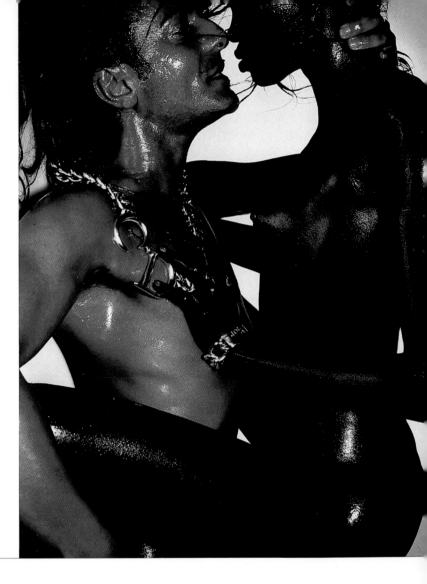

JOHN GALLIANO'S PARTING GESTURE AT THE DIOR COUTURE SHOW SAID IT ALL. IMMACULATE in top hat and Dior tails, he walked to the end of the catwalk, raised both arms in a triumphal champ's salute, and exited. The parade of exotic Freudian deviants he'd just unleashed had left the audience open-jawed. Twisted Edwardian ladies, handcuffed bridegrooms, French maids, hanging judges, nuns, sailors, slaves, soldiers, centurions...they'd been treated to it all. Those who loved it, adored it. As for the others, they were muttering, yet again: 'The man must be mad! How far does he think he can go?' That has been one of the most riveting questions in fashion since Galliano renewed his contract with Dior in July 1999, after three years in the House. Never mind the Freudian catwalk imagery; what every fashion insider would pay to understand is the complex dynamic between the mind of Galliano and the executive power structure at Dior. 'I don't mind if people think I'm mad,' says Galliano. 'At the end of the day, we're in a business, and it's doing incredibly well.' The truth is that, without yielding an inch of his own idiosyncratic vision, everything at Dior – from the advertising to the sales figures – has turned precisely his way.

GALLIANO'S RESPONSE TO EVERY NAYSAYER HAS BEEN THE BEST IN THE BOOK: SUCCESS is the best revenge. Nothing announced his triumph of will better than the explosively erotic relaunch of Dior's corporate image he and his co-conspirator, photographer Nick Knight, have brought about this year. 'The brief was a complete volte-face, not at all the same woman John was describing to me three years ago,' says Knight. 'She's much more confident, much more strident. I think that's John's way of dealing with something as large as Christian Dior. This is a much sturdier vision. It's going to withstand things much better than what he was putting out before.' In spite of the controversy surrounding episodes like the hobo/lunatic theme of his spring couture collection, Dior's sales figures have just kept climbing. For the first half of 2000, Dior Couture revenues were $127 million, 42 per cent higher than the same period in 1999, with Galliano's own label posting similar percentage gains. So much for all those minnies who've made a habit of moaning, 'But where are the *clothes*?' By the end of the year,

CORPORATE SAVAGE
THE NAKED TRUTH ABOUT HOW JOHN GALLIANO AND NICK KNIGHT
ARE TAKING IT ALL THE WAY AT CHRISTIAN DIOR, BY TIM BLANKS

Photography by NICK KNIGHT

GETTING 26 AND ALL EXITED.

Title: Birthday Card
Designer: Stefan Sagmeister
Studio: Sagmeister

Sagmeister invited friends to his twenty-sixth birthday,
using an image of a man with a variable penis,
sometimes excited, sometimes flacid. The card is
an interesting reflection on a man's image of his own
virility and the process of aging.

Title: Corporate Savage
Art Directors: Markus Kiersztan, Petra Langhammer (MP)
Photograper: Nick Knight
Hair: Sam McKnight
Makeup: Val Garland at Untitled
Model: Alek Wek
Digital Imaging: Core London Ltd.
Client: *The Fashion*

Playing on the both the words "corporate" and "savage,"
the story starts with an image of a very black woman
having sex with a white man who is wearing a big
chain around his neck. It is useful to contrast this image
with that of the biracial gay couple in the *Colors*
magazine cover [page 46)]. Although these images have
a similarity, because the woman in this images is black,
the image can resonate with other graphic stereotypes of
black women as "savage" and highly sexualized.
Throughout the story there are images of coercion and
voyeurism, which raise interesting questions about the
nature of the "civilized" as opposed to the "savage."

Sadomasochism (S&M) and fetish-oriented sex have evolved into the present through a history of sanctioned and unsanctioned behaviors. It is thought that the religious practice of self flagellation, common among Roman Catholic priests and nuns in the European Middle Ages, was a wholly accepted manner of worship. The Marquis de Sade and Leopold Sacher-Masoch both lent their names (via sexologist Krafft-Ebing) to the practice that thereafter became associated with deviant sexual behavior involving the consenting exchange of power. Cutting, flagellation, bondage, branding, and power-based role-playing are all common manifestations of S&M sex practices.

Because of its specialized nature, often involving props and costumes, or clothing made of specific, highly tactile materials such as leather or fur, S&M is often classed with fetish in studies of sexuality and in representations of sex. S&M, bondage, and fetish imagery is perhaps the most consistently used representation of deviant sex practice in graphic design, particularly advertising design, since it reads so clearly as taboo to so many. Because S&M deals with the highly personal nature of desire, part of the effectiveness of using such images is to appeal to a wide variety and diversity of tastes and experiences. S&M and fetish images are part of graphic design history, particularly as part of underground and pornographic books and magazines. It has only been since the 1970s, however, that it has made its way into mainstream design.

When designers use S&M images, they are referencing a style of a subculture. It could be argued that this creates a broader cultural acceptance of different lifestyles and sexual expressions, making it easier for more people to take risks in design and fashion where they might not otherwise. On the other hand, when S&M is taken from its lived context and reprocessed through a rhetoric designed to send other messages (such as product advertisement), the power of these images is diluted. S&M and fetish most readily lend their imagery to fashion design and layout. The drama of a consensual power play is a very effective plot for fashion layouts because the action, whatever it may be, is automatically sexualized, although the sex act need not be shown. In addition, the influence of fetish clothing on fashion over the past three decades is unmistakable. Thanks to the leather suits worn by Jane Fonda in *Barbarella*, Diana Rigg in the *Avengers*, and Madonna's popularization of Jean Paul Gaultier's bondage-inspired stage wear, elements of S&M and fetish gear can now be purchased in teen accessory stores at malls across America.

Fashion is not the only realm in which this culture is represented. In *Sex Appeal*, Michael Worthington observes that, "There seem to be many ways in which type designs can associate themselves with sex: Some work by association to a vernacular within a given culture (Blackletter = S+M, domination)..."(Heller, 2000:59) The Winky font by Orange Juice Design [page 118] takes vernacular associations a step further by creating a typeface that integrates actual S&M objects into the design. Piercings, cock rings, zippers, rope, spikes, barbed wire, and other implements of domination, bondage, and torture are all represented. The letterforms feature the anus and penis prominently, associating this font with a particularly gay male context.

Fetish is traditionally associated with religious activities, and the fetish is an object that is worshipped or used in the practice of worship. Freud's analysis of the fetish as standing in for the taboo of the exposed genitals still carries credence in anthropological and mythical analysis of the fetish. In contemporary consumer culture, Laura Frost's observations offer a more comprehensive view: "Fetishism is precisely about the power of inanimate objects to excite sexual desire, stoking the libidinal fires by way of obstacles and substitutions." ("Circuits of Desire: Techno Fetishism and Millennial Technologies of Gender" in Heller 2000, 152–158.) Fetishizing consumer goods seems to be the point of many advertising campaigns, even when the object itself does not seem to be overtly fetish material.

In *Colors* 18, "Shopping for the Body," the designers explore the nature of consumer desire as it is associated with the body. The result is a sometimes humorous and always thought-provoking insight into what people buy for the one thing we all have in common: our bodies. The editors of this issue of *Colors* scoured religious stores in Rome, markets in Ho Chi Minh City, and transvestite beauty contests in Colombia to bring back products that might show how the thing we buy reflects who we are and what we have in common or not. The resulting global collection of objects is an illuminating, surprising, and sometimes shocking display of products that enlarge, enhance, beautify, or mutilate the body. From the hi-tech to the everyday, these images show how people clean their bodies, how they decide who to sleep with, how they get their kicks, or how they change their sex (with sandwich wrapping, for example). It is, at times, hard to tell the difference between a torture instrument and a self-improvement device.

A second example of an oblique graphic treatment of fetish is Sean Tejaratchi's clip art zine, *Crap Hound* [page 122–123]. Tejaratchi produced two full issues of his zine devoted to sex and kitchen gadgets in 1994 and 1995, liberally reproducing some of the finest clip art of the twentieth century. In his introduction he writes, "I stay completely away from pictures that are identifiable by style as someone's artwork, unless the picture is very old or the artist is very dead." His do-it-yourself aesthetic, collaborative style, and punk ethics give his work a distinctly intuitive feel, and stylistically he prefers the humor or critique located in collection and juxtapositions of images better than direct commentary. The exhaustive quality of these images is paralleled perhaps only by the Dover clip art books, which to the knowledge of the author, has never done a book on sex.

In the West, we live in a culture that is perhaps as permissive as it has ever been with regard to deviant, or nonnormative, sexualities, and sex practices. When designers use sex to shock and get the attention of their viewers, they must continue to push limits, since what was once risqué is now commonplace. Once again, explicitness serves to push the boundary of what is acceptable, and serves the perhaps unintentional purpose of liberating the general public from prudery enforced through institutions such as church, school, and the medical establishment. S&M and fetish images take a personal and unique set of desires and project them on to public consciousness. These images, of course, have little to do with individuals and their sexual expression, lifestyle, or politics; they remain, on the one hand, liberating and, on the other hand, reductive.

▶ Title: Where Is Here spreads
Designer: Stefan Sagmeister
Studio: Sagmeister
Illustration: Kevin Murphy
Photographer: Tom Schierlitz

Two spreads for the book *Where Is Here* published by Booth Clibborn, designed by Laurie and Scott Makaela. The first spread talks about design versus the fine art world, with hand as phallus. The second spread features the carving work of Hjalti Karlsson and Sagmeister's own back and balls.

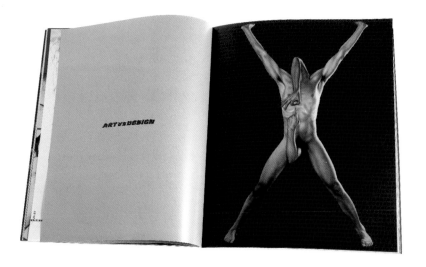

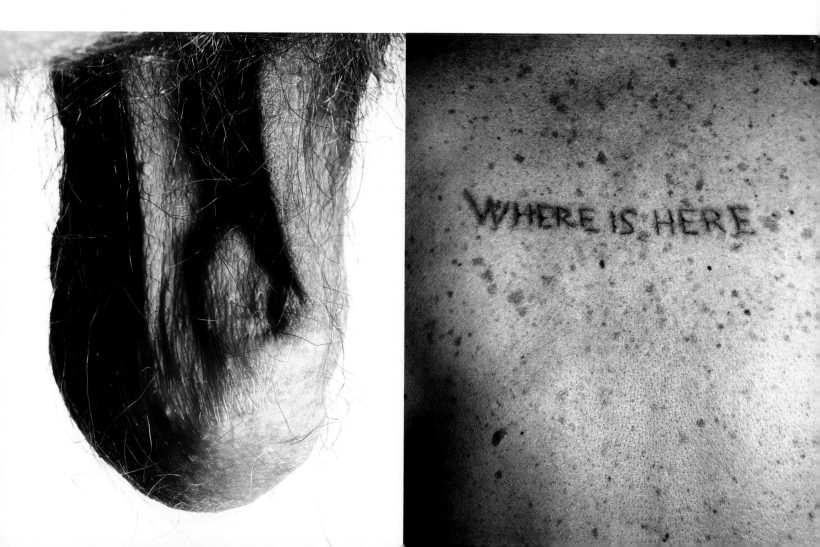

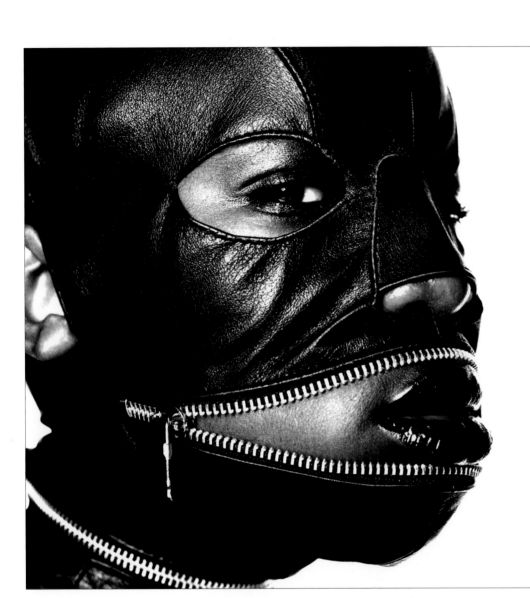

AT LAST,
YOU CAN CONFESS
TO YOUR URGE
FOR ZIP, STUDS AND
CHAINS.

eVOLUTION
FRANCESCO**BIASIA**

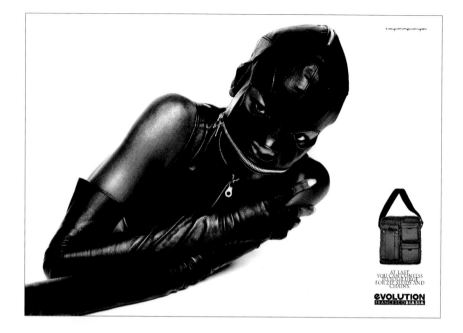

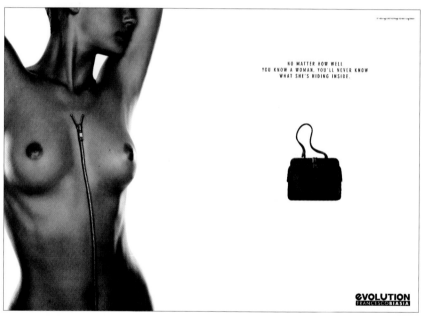

Title: Leather
Art Director: Gianpietro Vigorelli
Copywriter: Pino Rozzi
Photographer: Conrad Goddly
Agency: D'Adda, Lorenzini, Vigorelli, BBDO
Client: Franceso Biasia
Product/Service: Handbags

The copy for this ad reads, "At last you can fess to your urge for zips, studs, and chains"—implying the risqué element of these products catapult the consumer into a new realm of sexual deviance.

Title: Woman-mind
Art Director: Selmi Bali Barissever
Copywriter: Andrea Rosagni
Photographer: Jean Baptiste Mondino
Agency: D'Adda, Lorenzini, Vigorelli, BBDO
Client: Franceso Biasia
Product/Service: Handbags

The agency comments, "It is not a sexual image but a poetic parallel between the soul of a woman and the interior of a handbag, introspective symbol of the women." The copy reads: "No matter how deeply you know a woman, you'll never know what she hides inside," recalling the mythic figure of Pandora.

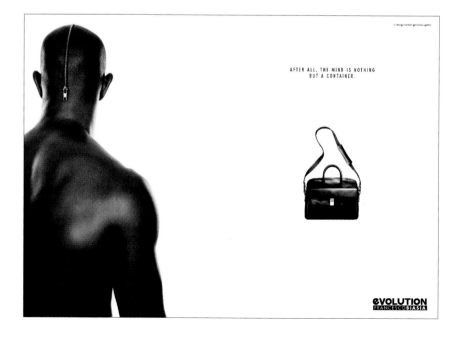

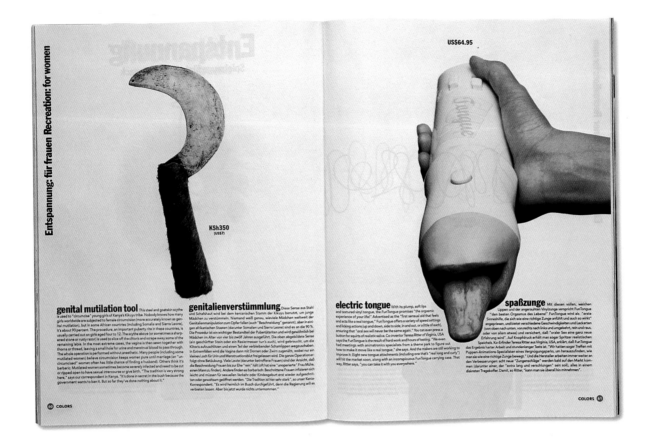

KSh350
(US$7)

US$64.95

genital mutilation tool
This steel and goatskin scythe is used to "circumcise" young girls of Kenya's Kikuyu tribe. Nobody knows how many girls worldwide are subjected to female circumcision (more accurately known as genital mutilation), but in some African countries (including Somalia and Sierra Leone), it's about 90 percent. The procedure, an important puberty rite in these countries, is usually carried out on girls aged four to 12. The scythe above (or sometimes a sharpened stone or rusty razor) is used to slice off the clitoris and scrape away some of the remaining labia. In the most extreme cases, the vagina is then sewn together with thorns or thread, leaving a small hole for urine and menstrual blood to pass through. The whole operation is performed without anesthetic. Many people (including some mutilated women) believe circumcision keeps women pure until marriage (an "uncircumcised" woman often has little chance of finding a husband). Others think it's barbaric. Mutilated women sometimes become severely infected and need to be cut or ripped open to have sexual intercourse or give birth. "The tradition is very strong here," says our correspondent in Kenya. "It's done in secret in the bush because the government wants to ban it. But so far they've done nothing about it."

genitalienverstümmlung
Diese Sense aus Stahl und Schafshaut wird bei dem kenianischen Stamm der Kikuyu benutzt, um junge Mädchen zu verstümmeln. Niemand weiß genau, wieviele Mädchen weltweit der Genitalienmanipulation zum Opfer fallen (auch "Beschneidung" genannt), aber in einigen afrikanischen Staaten (darunter Somalien und Sierra Leone) sind es an die 90 %. Die Prozedur ist ein wichtiger Bestandteil der Pubertätsriten und wird gewöhnlich bei Mädchen im Alter von vier bis zwölf Jahren ausgeführt. Die oben abgebildete Sense (ein geschärfter Stein oder ein Rasiermesser tun's auch), wird gebraucht, um die Klitoris aufzuschlitzen und einen Teil der verbleibenden Schamlippen wegzuschaben. In Extremfällen wird die Vagina dann mit Dornen oder Zwirn zugenäht, wobei nur ein kleines Loch für Urin und Menstruationsblut freigelassen wird. Die ganze Operation erfolgt ohne Betäubung. Viele Leute (darunter betroffene Frauen) sind der Ansicht, daß die Beschneidung Frauen bis zur Ehe "rein" hält (oft hat eine "unoperierte" Frau Mühe, einen Mann zu finden). Andere finden es barbarisch. Beschnittene Frauen infizieren sich leicht und müssen für sexuellen Verkehr oder Kindesgeburt erst wieder aufgeschnitten oder gewaltsam geöffnet werden. "Die Tradition ist hier sehr stark", so unser Kenia-Korrespondent. "Es wird heimlich im Busch durchgeführt, denn die Regierung will es verbieten lassen. Aber bis jetzt wurde nichts unternommen."

electric tongue
With its plump, soft lips and textured vinyl tongue, the FunTongue promises "the orgasmic experience of your life!" Advertised as the "first sensual aid that feels and acts like a real tongue," FunTongue offers a variety of speed settings and licking actions (up and down, side to side, in and out, or a little of each), ensuring that "oral sex will never be the same again." You can even press a button for squirts of realistic saliva. Co-inventor Teresa Ritter of Virginia, USA says the FunTongue is the result of hard work and hours of testing. "We even had meetings with animatronics specialists from a theme park to figure out how to make it move like a real tongue," she says. And the makers are still working to improve it. Eight new tongue attachments (including one that's "real long and curly") will hit the market soon, along with an inconspicuous FunTongue carrying case. That way, Ritter says, "you can take it with you everywhere."

spaßzunge
Mit diesen vollen, weichen Lippen und der angerauhten Vinylzunge verspricht FunTongue "den besten Orgasmus des Lebens!" FunTongue wird als "erste Sinneshilfe, die sich wie eine richtige Zunge anfühlt und auch so wirkt" angepriesen, und bietet verschiedene Geschwindigkeiten und Leckarten (von oben nach unten, von rechts nach links und umgekehrt, rein und raus, oder von allem etwas) und versichert, daß "oraler Sex eine ganz neue Erfahrung wird". Auf Knopfdruck erhält man sogar Spritzer realistischen Speichels. Ko-Erfinder Teresa Ritter aus Virginia, USA, erklärt, daß FunTongue das Ergebnis harter Arbeit und stundenlanger Tests ist. "Wir hatten sogar Treffen mit Puppen-Animations-Spezialisten eines Vergnügungsparks, um herauszufinden, wie man sie wie eine richtige Zunge bewegt." Und die Hersteller arbeiten immer weiter an den Verbesserungen: acht neue "Zungenschläge" werden bald auf den Markt kommen (darunter einer, der "extra lang und verschlungen" sein soll, alles in einem diskreten Tragekoffer. Damit, so Ritter, "kann man sie überall hin mitnehmen".

Title: *Colors* 18 Shopping for the Body
Editorial Director: Oliviero Toscani
Editor in Chief: Alex Marashian
Art Director: Robin King
Designer: Jean Baptiste Bolo
Studio: *Colors* Magazine
Photography:
Shoe Gag: Oliviero Toscani
Food Wrap: Oliviero Toscani
PUD Balls: Marirosa Toscani Ballo
Inset of PUD: courtesy of NORM
Genital Mutilation Device: Marirosa Toscani Ballo
Fun Tongue: Oliviero Toscani

Body manipulation and fetish objects from around
the world were featured in this issue of *Colors*.

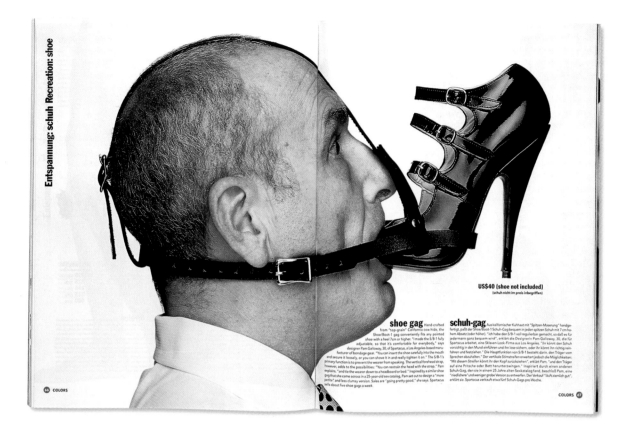

US$40 (shoe not included)
(schuh nicht im preis inbegriffen)

shoe gag Hand-crafted from "top-grain" California cow hide, the Shoe/Boot-1 gag conveniently fits any pointed shoe with a heel 7cm or higher. "I made the S/B-1 fully adjustable, so that it's comfortable for everybody," says designer Pam Galloway, 30, of Spartacus, a Los Angeles-based manufacturer of bondage gear. "You can insert the shoe carefully into the mouth and secure it loosely, or you can shove it in and really tighten it on." The S/B-1's primary function is to prevent the wearer from speaking. The vertical forehead strap, however, adds to the possibilities: "You can restrain the head with the strap," Pam explains, "and tie the wearer down to a headboard or bed." Inspired by a similar shoe gag that she came across in a 25-year-old sex catalog, Pam set out to design a "more petite" and less clumsy version. Sales are "going pretty good," she says. Spartacus sells about five shoe gags a week.

schuh-gag Aus kalifornischer Kuhhaut mit "Spitzen-Maserung" handgefertigt, paßt der Shoe/Boot-1 Schuh-Gag bequem in jeden spitzen Schuh mit 7cm hohem Absatz (oder höher). "Ich habe den S/B-1 voll regulierbar gemacht, so daß es für jedermann ganz bequem wird", erklärt die Designerin Pam Galloway, 30, die für Spartacus arbeitet, eine Sklaven-Look-Firma aus Los Angeles. "Ihr könnt den Schuh vorsichtig in den Mund einführen und ihn lose sichern, oder ihr könnt ihn richtig reinfahren und festziehen." Die Hauptfunktion von S/B-1 besteht darin, den Träger vom Sprechen abzuhalten. Der vertikale Stirnstreifen erweitert jedoch die Möglichkeiten: "Mit diesem Streifen könnt ihr den Kopf zurückziehen", erklärt Pam, "und den Träger auf eine Pritsche oder Bett herunterzwingen." Inspiriert durch einen anderen Schuh-Gag, den sie in einem 25 Jahre alten Sexkatalog fand, beschloß Pam, eine "niedlichere" und weniger grobe Version zu entwerfen. Der Verkauf "läuft ziemlich gut", erklärt sie. Spartacus verkauft etwa fünf Schuh-Gags pro Woche.

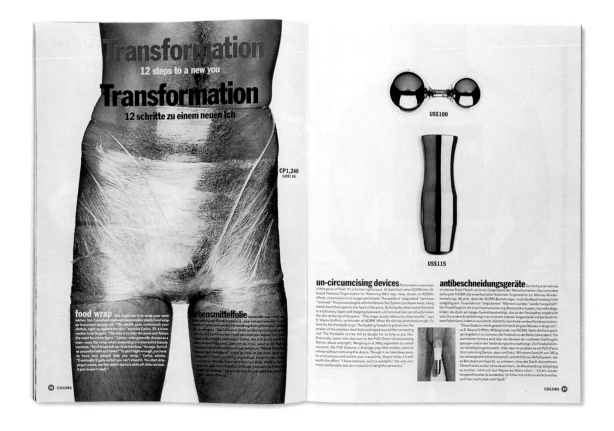

Transformation
12 steps to a new you
Transformation
12 schritte zu einem neuen Ich

CP1,240
(US$1.24)

US$100

US$115

food wrap You might use it to wrap your sandwiches, but Colombian transvestites consider plastic food wrap an important beauty aid. "The plastic goes underneath your clothes, right up against the skin," explains Carlos, 29, a transvestite from Bogotá. "The idea is to hide the penis and flatten the waist for a trim figure." Carlos—who generally dresses as a man—uses the wrap when competing in transvestite beauty contests. "My friends tell me I look fabulous," he says. But is it as uncomfortable as it looks? "To get it tight enough, you have to have two people help you wrap," Carlos admits. "Eventually it gets so hot you can't stand it. You start dripping in sweat, and the plastic starts to slide off. After an hour, it just doesn't work."

lebensmittelfolie [German text partially legible]

un-circumcising devices The foreskin is more than a little piece of flesh: It's a human rights issue. At least that's what NORM (the US-based National Organization for Restoring Men) says. Now, thanks to NORM's efforts, circumcision is no longer permanent: Thousands of "amputated" men have "restored." The process begins with the Restore Skin System (not shown here), a long elastic band that tapes to the head of the penis. By fixing the other end of the band to a stationary object and stepping backward, a circumcised man can actually loosen the skin at the tip of his penis. "This stage usually takes only a few months," says R. Wayne Griffiths, co-founder of NORM. When the skin has stretched enough, it's time for the Foreballs (top). The budding foreskin is pulled over the smaller of the stainless steel balls and taped around the connecting rod. The Foreballs can be left to dangle for as long as you like. Eventually, some men also turn to the PUD (Penis Uncircumcising Device, above and right). Weighing in at 340g (equivalent to a small coconut), the PUD features a drainage pipe that enables users to urinate without removing the device. Though it can take three years to uncircumcise and reclaim your masculinity, Wayne thinks it's well worth the effort: "I have restored, and it is wonderful. Not only am I more comfortable, but sex is now full of delightful sensations."

antibeschneidungsgeräte Die Vorhaut ist mehr als ein kleines Stück Fleisch: es ist ein Gegenstand der Menschenrechte. Das zumindest behauptet NORM (die amerikanische Nationale Organisation zur Männer-Wiederherstellung). Ab jetzt, dank der NORM-Bemühungen, muß die Beschneidung nicht endgültig sein. Tausende von "amputierten" Männern wurden "wieder hergestellt". Der Prozeß beginnt mit einem Hautrestaurierung (Restore Skin System, hier nicht abgebildet), die durch ein langes Gummiband erfolgt, das an der Penisspitze angebracht wird. Das andere Ende befestigt man an einem stabilen Gegenstand und der beschnittene Patient kann, indem er zurücktritt, Schritt für Schritt die vordere Penishaut lockern. "Diese Stadium nimmt gewöhnlich bloß ein paar Monate in Anspruch", so R. Wayne Griffiths, Mitbegründer von NORM. Wenn die Haut genügend gedehnt ist, kommen die Foreballs an die Reihe (siehe oben). Die wachsende Vorhaut wird über die kleinere der rostfreien Stahlkugeln gezogen und an der Verbindungsachse befestigt. Die Foreballs können beliebig lange baumeln. Oder aber Sex wird probiert es mit PUD (Penis Uncircumcising Device, oben und links). Mit einem Gewicht von 340g (so vielwiegt eine kleine Kokosnuß), enthält PUD ein Abflußsystem, das es Benutzern ermöglicht, zu urinieren, ohne das Gerät abzunehmen. Obwohl es bis zu drei Jahre dauern kann, die Beschneidung rückgängig zu machen, ist Wayne die Mühe schon: "Ich bin wieder hergestellt und es ist wunderbar. Ich fühle mich nur sehr einfach wohler, auch Sex macht jetzt mehr Spaß."

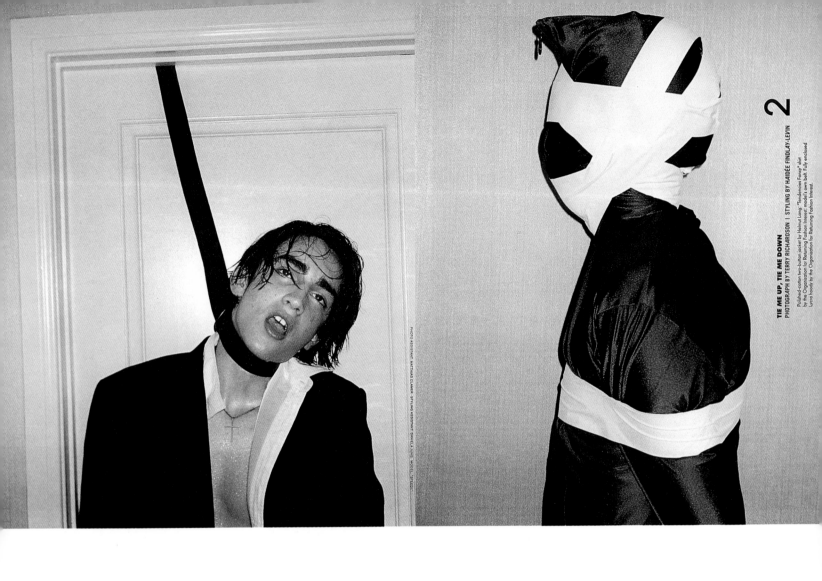

2

TIE ME UP, TIE ME DOWN
PHOTOGRAPH BY TERRY RICHARDSON | STYLING BY HAIDÉE FINDLAY-LEVIN

Polished-cotton two-button jacket by Helmut Lang. "Tendencies Fancy" shirt
by the Organisation for Returning Fashion Interest; model's own belt. Fully enclosed
Lycra hoody by the Organisation for Returning Fashion Interest.

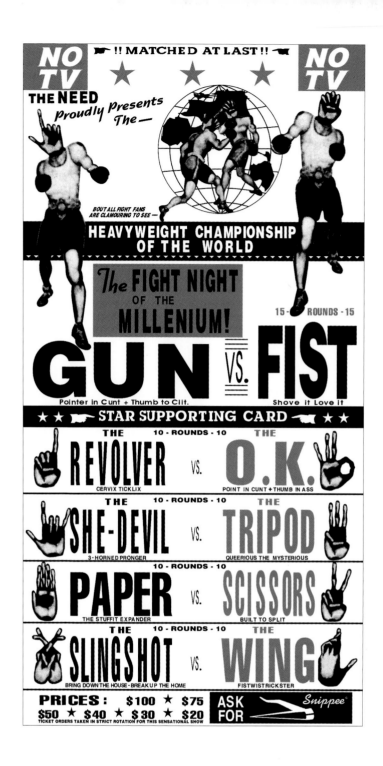

◄ Title: *Spin* spread
Art Director/Designer: Markus Kierzstan
Photographer: Terry Richardson
Client: *Spin* magazine

Skirting the edge between orgasm and death, these extreme bondage images display a level of explicitness generally avoided in mainstream design.

► Title: Bloody Knuckle Sexxxing poster
Studio: Lux
Designer: Rachel Carns
Format: 23" x 48" (58 cm x 122 cm)
ammonia process blue print

Using the classic boxing poster as a model, Carns addresses sexuality not only as the axis of queer identity and connection but as an arena, private and public, where radical micropolitics are played out. Rather than use typical "sexual" imagery, Carns unhooks the viewer consciously from dominant points of sexual subjectification. Indicative rather than interpretive, she elevates the hand, a primary yet underrepresented sexual tool, to fetish status.

THE STROKES IS THIS IT

◄ Title: Winky Font
Designer: Garth Walker
Art Director: Garth Walker
Illustrator: Garth Walker
Studio: Orange Juice Design
Client: i-jusi
Client's Product/Service: Magazine/font

Using elements of gay male S&M, Winky is a highly entertaining display font developed by Orange Juice Design.

▲ Title: The Strokes international album package
Designers: Brett Kilroe, Tracy Boychuk
Studio: RCA Records Creative
Photographer: Colin Lane
Client: RCA Records

In completing this assignment, the band was able to communicate "more what they didn't want, than what they did," and combined with their knowledge of and taste in modern art and photography, came up with a classic fetish image. The package was designed for overseas release that was a few months earlier than domestic. RCA says that the band decided to change the artwork for reasons unrelated to its "sexual content." Hailing from New York, the Strokes are consistently pegged by critics as the last best hope for rock 'n' roll and cultivate a very fashion-conscious, sexy style in all aspects of their public band persona.

▲ Title: Skin
Designer: Art Chantry
Studio Name: Art Chantry Design
Client: Printer's Devil Theater

Using typography, Chantry represents the skin as an impermeable container that can nonetheless be effectively bound.

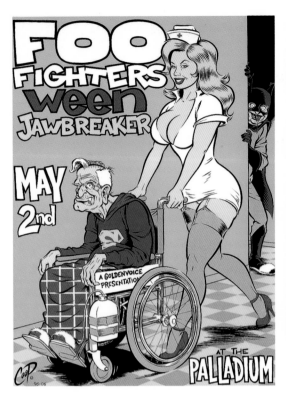

▲ Title: Foo Fighters/Ween/Jawbreaker
Designer: Coop
Illustrator: Coop

The naughty nurse makes her appearance
once again in this poster, where she wheels
the decrepit Superman and is spied on by the
drooling Batman.

▲ Title: The Muffs, New Year's Eve 1993
Designer: Coop
Illustrator: Coop

With a background of fetish torture devices,
Coop's poster for the all-girl band The Muffs
recalls a typical student/"teacher" power play
while simultaneously enacting a lesbian porn
fantasy scenario.

▲ Title: Ministry/The Jesus Lizard
Designer: Coop
Illustrator: Coop

Irreverent to the point of blasphemy, Coop
satirizes nuns and Jesus Christ, turning the
latter into a foot-worshiping submissive.

▷ Title: Zip
Agency: D'Adda, Lorenzini, Vigorelli, BBDO
Art Directors: Stefano Rosselli, Vicky Gitto
Copywriters: Vicky Gitto, Stefano Rosselli
Photographer: Pier Paolo Ferrari
Client: Franceso Biasia
Product/Service: Handbags

This is one in a series of advertisements for a
luggage shop in Italy that capitalized on the
leather used in the product to titillate with
S&M images in the design. The copy for the
ads implies a latent desire for not only this
particular brand of handbag but for a riskier
sexual repertoire.

FRANCESCO**BIASIA**
HANDBAGS

OPENING SOON, VIA DURINI 4, MILAN.

Title: *Crap Hound* (clip art zine), Sex and
Kitchen Gadgets issues
Designer: Sean Tejaratchi

Ironic juxtaposition of every imaginable
kitchen gadget with sexual images creates a
graphic world where even the ladle is latent.

Title: Fetish &
Creative Directors, Designers: Jeffrey Keyton,
Stacy Drummond, Tracy Boychuk
Photographer: Jason Stang
Graphic Artists: Kevin Gepford, Joe Fernandez
Graphic Art Supervisors: Elinor Johnston, Patti Rogoff
Studio: MTV Off-Air Creative

This book, given as a program to the 1997 MTV
Music Awards, is not really about sex, even though
the cover has a strong sexual feel. It is ultimately
about how the word "fetish" was hijacked as some-
thing sexual and kinky and lost its bigger meaning as
a talisman. It is an appropriate theme for an event
such as this, since the outcome depends so heavily
on luck. In addition, these pieces offer an intimate
glimpse into the personalities of the stars who would
potentially be receiving awards, linking the public
persona with something more real.

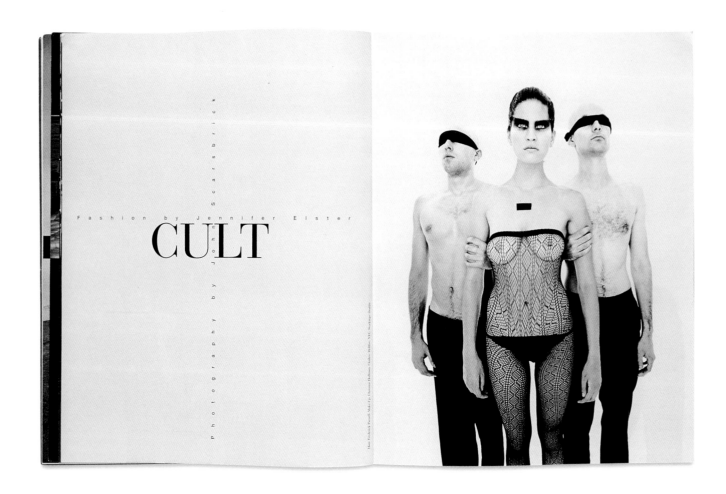

Fashion by Jennifer Elster

Photography by John Scarsbrick

CULT

Title: Cult
Creative Director: Marcelo Jüneman
Editorial and Design Director: Gary Koepke
Photographer: John Scarsbrick
Stylist: Jennifer Elster
Fashion Director: Debbi Manson
Client: *Big* magazine 15

In the issue dedicated to fashion and particularly to fashion stylists, Jennifer Elster and John Scarsbrick worked together to create a series of strong images. Jennifer writes: "I wanted a feeling of a tension-free world where its members gave up on the harshness of reality opting to be brainwashed. The style is a metaphor for their existence; abstract yet minimalistic."

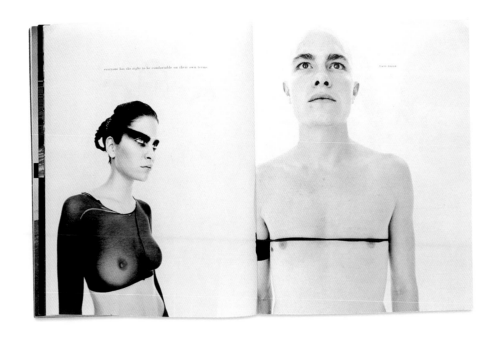

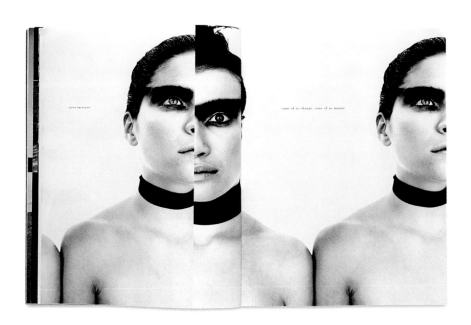

jason evershurst · some of us change, some of us mutate

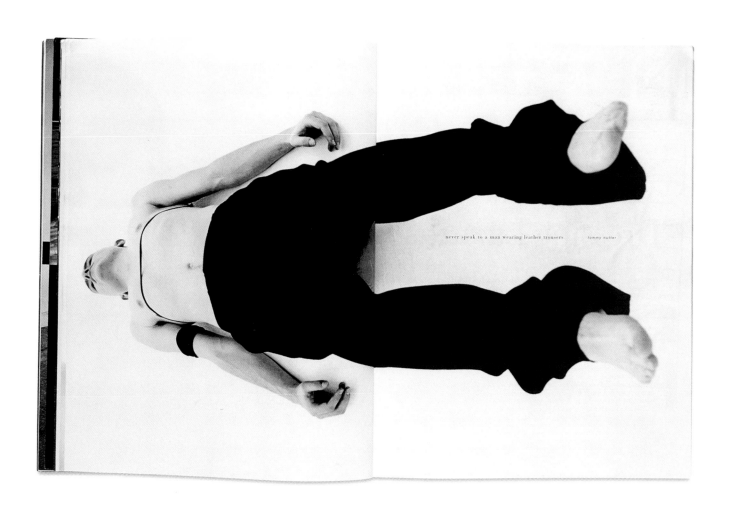

never speak to a man wearing leather trousers · tommy nutter

Although the visual landscape of sex and sexuality has become more extreme as permissiveness has expanded its territories, the vast majority of design we have encountered in our survey uses the evocation of sex and sexuality, rather than explicitly picturing the act. This technique is effective and conforms to what sexologists have known for years: that our most important sex organ resides between our ears.

Most design that uses sex and sexuality contains some element of fantasy. Fantasy is different from plain old storytelling and is diametrically opposed to realism or documentary arts. Generally associated with science fiction in literary genre, in the design arts, fantasy presents idealized worlds in which both desire and drama are invoked to motivate specific messaging. To fantasize is to imagine a world where the ideal is possible, where hierarchies are possibly inverted, and where social convention is eschewed.

A crucial element of the fantasy's role in advertising design is the dynamic between desire and product. Both use fantasy scenarios to elevate or associate product with fantasy results—i.e., sex/sexual fulfillment. More than just hoping to achieve what is personified in ads, these ads play on our basic human emotions—the need and longing for love, fulfillment, happiness—and equate these needs with a product. These ramifications are compounded when played against a climate of sexual repression. This is one of the oldest tricks in the advertiser's—and graphic designer's—toolbox, and the amazing thing is, it still works. Elements of fantasy imagery are diverse but often include standard representations of youth, virility, wealth, idealized body types, and power. Designers adhere to the rhetorical focus of the client, representing what the client believes (or hopes that the consumer will believe) is true: that their product or service will actually make you sexier, that personal association with a product or brand will confer upon the buyer all the attractive qualities of the fantasy scenario.

With even a small degree of media literacy, the savvy viewer understands the ruse of the sexy design. The relationship between sexual desire and consumer desire is easily exposed as a fraud. Some of the most interesting permutations of design result from this realization; self-conscious and ironic representations of sex and sexuality are now also commonplace. The recent spate of 1940s-style pinup girls advertising mints or whisky recalls a repressive (and oppressive) era when images of scantily clad ladies really pushed the limits of advertising design. In the present context, they are no longer relegated to the car mechanic's garage wall but brandish nostalgic nakedness for all to see. This type of advertising does two things: it uses sexy ladies to sell product, and it recalls a time gone by, a time before women's lib, a time before the sexual revolution, a time when a repressed sexual culture objectified and fetishized nearly naked women. It is a fantasy for the past expressed in the language of the designer's own past, and yet it illustrates that such imagery still resonates in contemporary culture.

Coop's posters for Banned in Boston and Super V Frontier vol. 11 both use this retro, ironic aesthetic to advertise graphic arts events. The pinup cartoon style invites the viewer to look forward (this is cutting edge design) and back (it is rooted in mid twentieth-century assumptions and graphic codes). The stripper with the ogling Shriners stare the viewer right in the face, while the woman/devil on the Banned in Boston poster [page 140] play on the masochistic man's fantasy of encounter with this beast whose grimace suggests she is up to no good. In nearly identical poses, these versions of femininity are exaggerated representations of the woman who debilitates men—she turns the Shriners to fools, and she'll take you straight to hell.

Appealing to a somewhat similar style of low-brow humor, [page 130] Saatchi & Saatchi advertisements for Club 18–30 pose young, sexy people in leisure settings (bar, beach, pool party), and use skillfully art directed and obviously photomanipulated images in casual, yet sexualized, poses. Sly use of fore- and background set figures in relationship to one another to create scenes that, on second glance, are both innocent and explicit.

The broad continuum of fantasy can create idealized visual narratives. Whether these narratives take place in another place and time, with imaginary characters or real, they often contain the fundamental fantasies that sex is easy to get, that you are sexy no matter who you are, that sex is not condemned even if it is perverse, and that sex has no consequences other than pleasure.

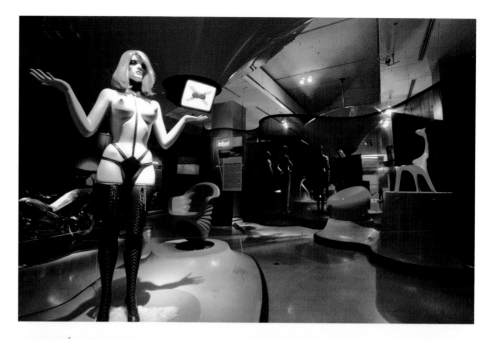

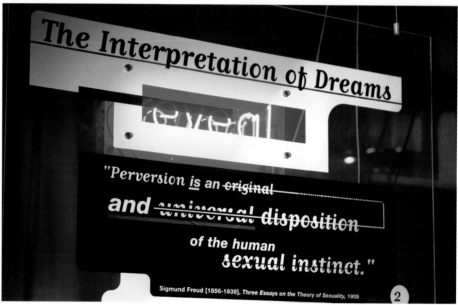

◁ Title: "Perspective" campaign with three executions:
"Bar," "Beach," and "Pod"
Creative Team: Anthony Nelson, Mike Sutherland
Creative Director: Dave Draga
Photographer: Trevor Ray Hart
Studio: Saatchi & Saatchi
Client: Club 18–30

Club 18–30 position themselves as the youth holiday
destination to their core target audience of 17– to 24-
year-olds (male and female equally) and have a distinc-
tive and recognizable brand in the UK. The advertising
has always been sexually suggestive, so there were no
issues raised by the client about using sexually sugges-
tive imagery. Aside from the high awareness of the cam-
paign and press coverage, the results for Club 18–30 are
shown in their sales, which are up 10 percent on last
year. The advertising implies that going to Club 18–30
will put you in a series of compromising positions that
you may not even be aware of, and that you will wel-
come. The artifice of this fantasy scenario ironically
makes it more enticing as opposed to less realistic.

▷ Title: The Power of Erotic Design
Art Direction/Design: Why Not Associates
Client: Design Museum, London
Exhibition Designers: Branson Coates Architecture

Why Not Associates was charged with designing informa-
tion panels and an audio-visual piece for an exhibition
about the influence of eroticism in design. As the exhibi-
tion revolved around images and objects of sexual nature,
Why Not decided that the exhibition graphics needn't be
sexually explicit—quite the opposite. Instead, they were
influenced by aspects of censorship and the taboo,
designing the words and sentences to be obscured or
hidden, and using neon to lend a sense of seediness.

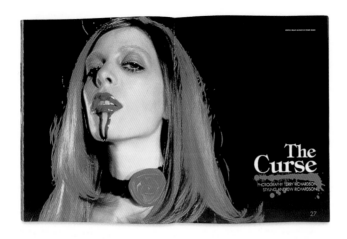

The
Curse

PHOTOGRAPHY TERRY RICHARDSON
STYLING ANDREW RICHARDSON

27

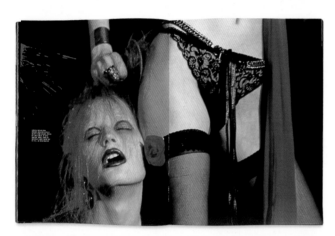

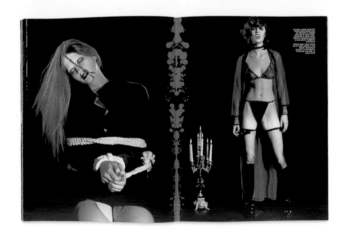

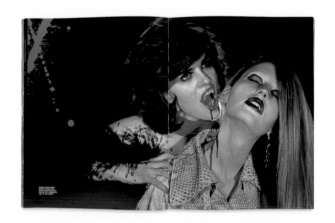

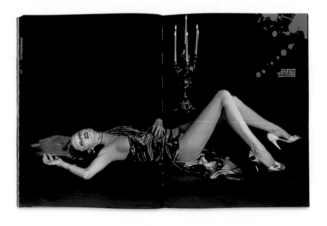

Title: The Curse
Photographer: Terry Richadson
Styling: Andrew Richardson
Client: *Big* magazine 28

In a fashion story based on gothic-style fashion and horror narratives, these representations include much blood and fetish gear. From a thematic issue of the magazine based on horror, the generally low-brow from of entertainment—the horror movie—gets a new face in its use with high-brow fashion.

Title: *Teaches of Peaches* LP cover art
Design: Peaches
Additional Design: alorenz, Berlin
Photographer (front): Tyler Burke
Photographer (inside): Lisa Kannakko
Client: Kitty-yo Int (record label), Peaches (artist)

Peaches' music is provocative, mixing a lo-fi electronic dance sound with rapping and singing that generally does not stray from the subject of sex and rock 'n' roll (tracks have titles such as "Fuck the Pain Away" and "Lovertits"). These album images, culled by Peaches herself, give a good idea of her live performances, which often feature film, back-up dancers, striptease, and plenty of dirty dancing. It is a sonic and visual environment that turns a rock club into a sex club, a fantasy that ends when the show is over.

◀ Illustrator: Stephan Jay-Rayon aka Stephenwolf
Client: Hysteric Glamour

Ironic inasmuch as the English language in these designs is not automatically comprehensible to its Japanese consumer, both the women as guitars and "Go for It" hold meaning that is suggestive and aggressive. A woman with a gun—always a defiant image—suggests transgressive behavior associated with love (as signified by the heart surrounding the text). But who is going for what? This woman? All women? Is it a challenge, or a threat?

▲ Illustrator: Stephan Jay-Rayon aka Stephenwolf
Client: Hysteric Glamour

The fantasy of a woman-as-guitar has been fodder for rock lyrics since their birth in the blues. These updated images have a distinctly metal edge, a genre long renowned for its consistent objectification of women.

▲ Designer/Illustrator: Rinzen
Studio: Rinzen

Each of these illustrative designs provide a
different fantasy scenario, and all imply that
sex somehow transports people to another
place: outer space (for nightclub), strange
dildo-landscape (cover for style magazine
The Face), or psychedelic kiss-world (CD
sleeve for Australian band, Montana).

▶ Title: Amerika über alles/Dwarves/The
Rev.Horton Heat/Supersuckers
Designer: Frank Kozik

▶ Title: American Dream
Pt.1/Hemet/Jawbox/Thought Industry
Designer: Frank Kozik

Nearly grotesque in their parody, both of
these female figures encompass an element
of fantasy—one as the hot dog/phallus-eating
all-American, the other as almost topless and
menaced by Charles Manson.

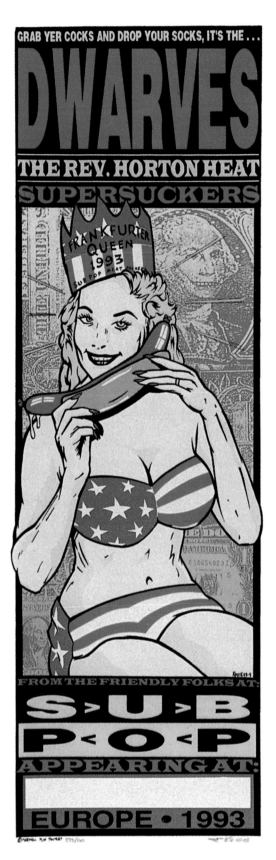

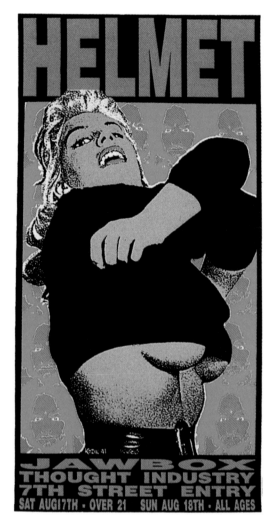

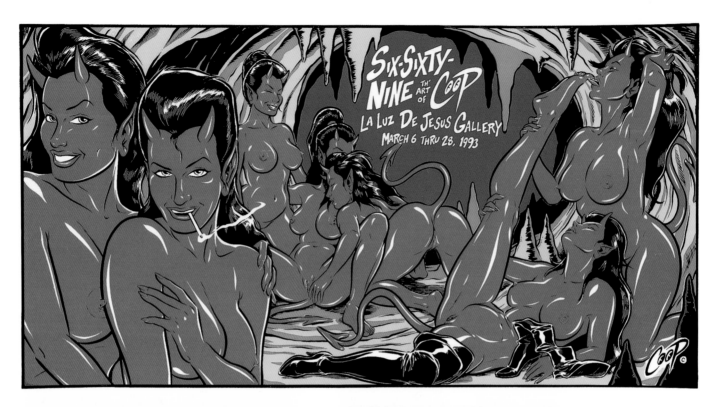

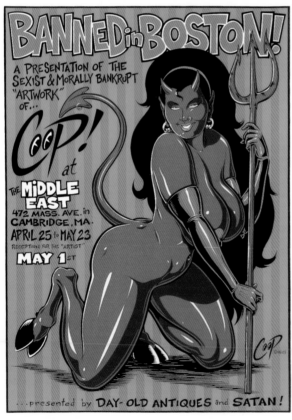

◁ Title: Banned in Boston, Six sixty-nine
Designer: Coop

Describing his art as "sexist and morally bankrupt" in order to advertise his retrospective, Coop's devil woman manifests the sexually overwhelming woman whose pitchfork is poised. Long friend of the devil in Christian morality, the sexual woman entices with the promise of punishment.

◁ Title: Super V Frontier, vol. 11
Designer: Coop

In this poster featuring Shriners incapacitated by the sexy stripper, the artist explores a nostalgic and ironic view of femininity that causes men to become stupid. It represents a fantasy world where this confused awe is actually rewarded rather than scorned.

△ Title: The Butthole Surfers/Bad Livers/
Rockbusters
Designer: Frank Kozik

Using otherwise wholesome cartoon characters from the *Flintstones*, Kozik reorients our view of them to encompass power and sex in a S&M scene laced with lesbian voyeurism.

▷ Title: Tits and Ass Make the World Go Round/
Green Day/Tilt
Designer: Frank Kozik

This poster for the rock band Green Day turns a stereotypically sexy lady into a pot leaf, conflating a teenaged stoner boy's most intense desires.

舞馬宿人
My Friend

鏡に囲まれた回転木馬。ひねくれ回る遊びのトリックだ
Two merry-go-rounds in a maze of mirrors.

Eyes, rich black n°1 Mascara, gray-green luster n°25 Eyeshadow; skin, Fluid Base moisturizer; lips, n°2 Smooth Finish lipstick, all Giorgio Armani Cosmetics; fragrance, Higher by Christian Dior

◄ Title: *Satellite of Love*
Designer: Kyoichi Tsuzuki
Client: Aspect Street Design File

Crowded out by restrictive zoning laws and a trend towards redecoration, the so-called "love hotel" is a dying phenomenon in Japan. These photos represent a larger book that is devoted to the subject by Japan's foremost commentator on popular sexual culture, Kyoichi Tsuzuki. In it he examines the fantastical, practical, and strange world of love hotels, asserting that the reason for their existence is not that Japanese people are oversexed, simply that "sex is something else entirely."

▲ Title: Ultra Violet
Creative Director: Steven Baillie
Photography: Todd Barry
Client: *Surface* magazine

This image is one in a series of spreads that play off color and light to beautiful effect. The scene of two women almost kissing is nothing new. The juxtaposition of the typography and image reflect the larger themes of the story.

Title: Identity for Harmony licensed sex shops
Art Directors: Steven Gilligan, Chris Bradley
Designers: Steven Gilligan, Chris Bradley
Photographer: Trevor Watson
Studio: Utd
Client: Harmony Limited
Client Service: Adult retailer

Utd. set out to challenge the stereotypical
image of the "seedy" Soho sex shop. The
identity draws upon the theme of Saints and
Sinners to reflect individuals mindsets when
shopping for sex products, and a reminder
that it can be fun. The theme is rigorously
continued throughout the store and point-of-
sale material. The client specifically request-
ed sexual imagery, in order that the content of
the shop be understandable, while not being
offensive to passers by. Clever postcards use
words associated with sex and begin with the
letter *E* to advertise the sex-shop's Web site.

Title: The Witch
Art Direction, Design: Naomi Hirabayashi
Illustration: Ippei Gyobu
Client: *Big* magazine 32

This illustrator is a game character designer
by trade whose work includes SNK's Cool Cool
Toon. These images feature the common
image of a fantasy woman controlled by a boy
at a joystick. Ultimately, however, this magical
woman will destroy the boy.

ILLUSTRATION
Ippei Gyobu

TITLE
The Witch
-Fighting-

P066-P069

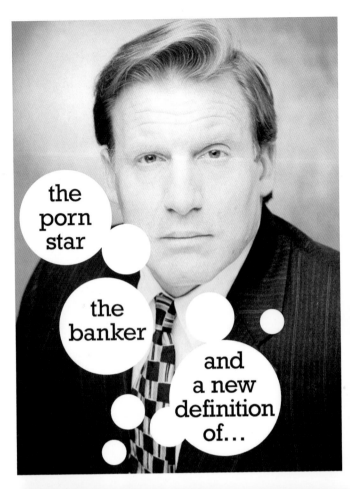

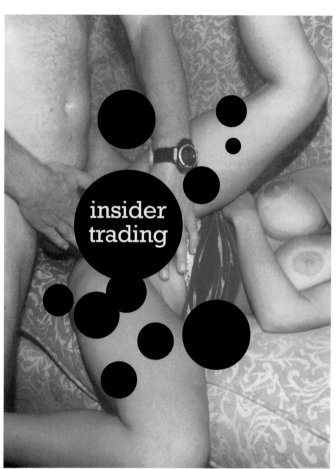

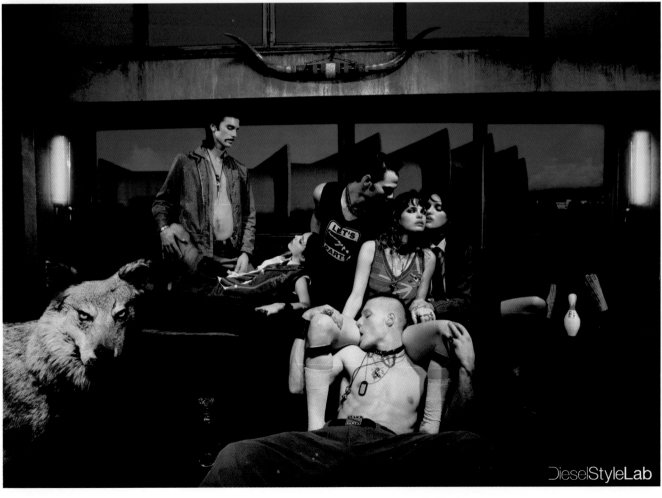

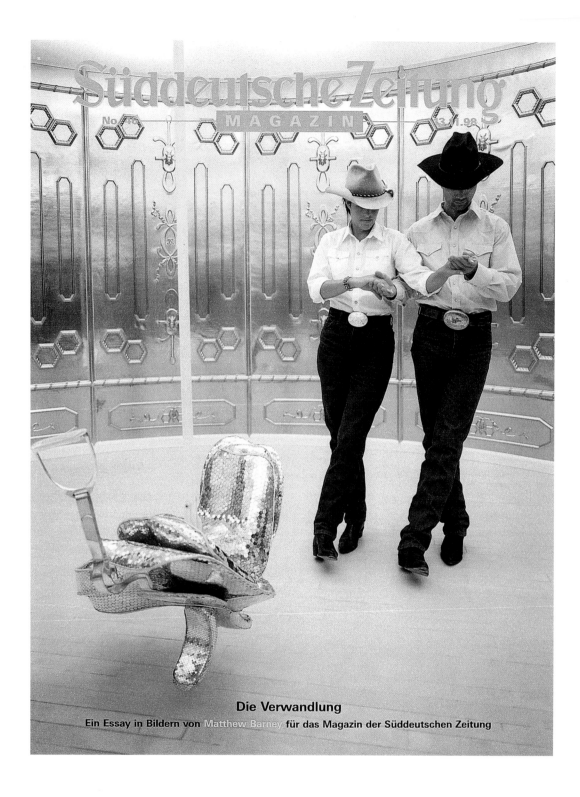

Die Verwandlung

Ein Essay in Bildern von Matthew Barney für das Magazin der Süddeutschen Zeitung

◁ Title: Insider Trading
Creative Director: Steven Baillie
Client: *Arena for Men* magazine

The contrast of the serious face of a
clean-cut man with a barely covered penis
and uncovered woman's breasts is striking.
The images conflate power of a banker
(economic) and the power of a porn star
(sexual), making a double entendre of the
phrase "insider trading."

◁ Title: Diesel Style Lab/Wolf
Design: Diesel
Studio: Diesel

The presence of a wolf in this photo of high-
qua-low-style models in sexually charged
poses lends an air of menace to the scene.
Their ambi-sexuality creates an environment
where anything appears to be possible, partic-
ularly because they are all so attractively
outfitted in Diesel.

△ Title: *Süddeutsche Zeitung* cover
Design: Markus Kiersztan
Photography: Matthew Barney
Client: *Süddeutsche Zeitung*

Matthew Barney cover story features a still
image taken from Barney's *Cremaster 2*,
an elliptical narrative of punishment and
redemption. Every object from tables and
chairs to the Canadian mounted police and
Gary Gilmore's Mormon on Mormon homicide
is lined with sexual tension. Here, we see two
step dancers with a suspended silver double-
rider saddle.

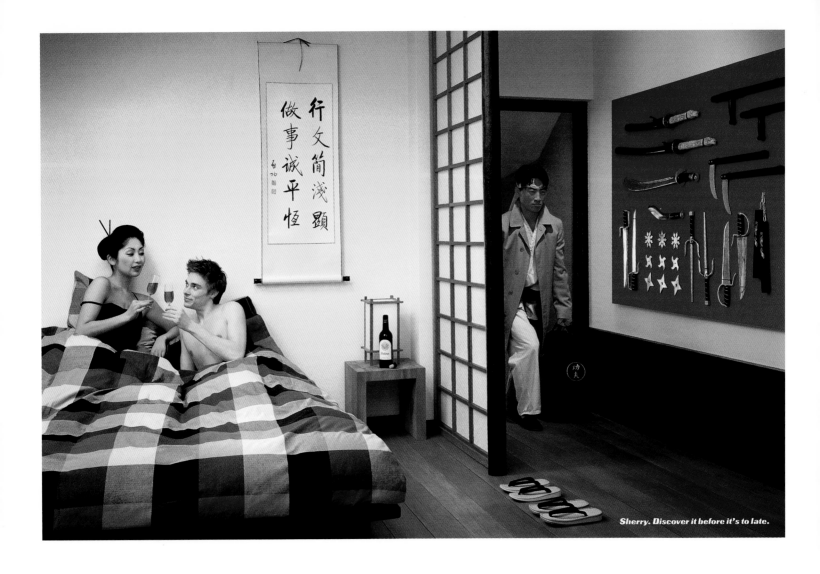

Sherry. Discover it before it's to late.

▲ Title: Samurai
Art Director: Jorn Kruijssen
Copywriter: Jeroen van de Sande
Photographer: Paul Ruigrok
Agency: Benjamens van Doorn Euro RSCG
Client: Dutch Sherry Institute

The narrative of this piece is quite dramatic, and offers a negative repercussion for a clandestine sexual liaison. The ad copy urges the reader to discover sherry before it is too late, implying the delectability of the drink might be worth having your head chopped off for. The ad resulted in a clear image boost for the Dutch sherry industry among the target audience.

▶ Title: Psychokinesis—Brain Control
Art Direction, Design: Naomi Hirabayashi
Illustration: Yutanpo Shirane
Client: Big magazine 32

Responding to the theme of the issue, Games, illustrator Yutanpo Shirane chose to relate a somewhat realistic representation of camping anxiety and pleasure with a man whose head is encased in wood. "Woody," of course, is slang for a hard-on. This spread also refers to the discontinuity between waking and dreaming life and the prominent role of sex in each of these states. Shirane graduated from the Kuwasawa Design Lab and is part of a new generation of Japanese illustrators.

ILLUSTRATION
Yutanpo Shirane

TITLE
Psychokinesis
-Brain Control-

P098-P099

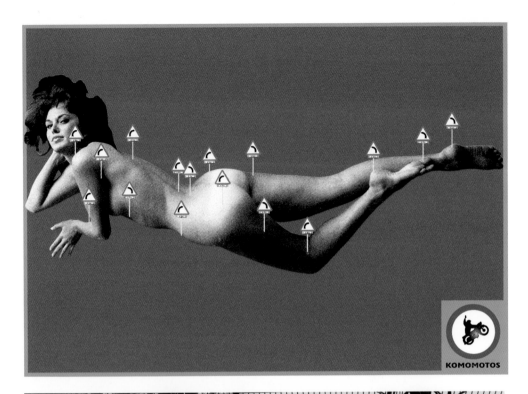

▲ Title: Curves
Art Director: Rebeca Diaz
Designer: Rebeca Diaz
Photographer: Rebeca Diaz
Studio: McCann-Erickson, Madrid
Client: Komomotos Shop

A woman's body is used in this ad to represent itself both as an object of sexual attention, and as a road, which this particular brand of motorbike would potentially have no trouble handling. The driver of the motorbike thus dominates both literally and metaphorically.

▲ Title: Magazine
Art Director: Rebeca Diaz
Designers: Rebeca Diaz, Juan Nonzioli
Photographer: Sara Zorraquino
Studio: McCann-Erickson, Madrid
Client: Coca-Cola Light Spain

Confusing sexual allure with thinness, this Coca-Cola ad from Spain substitutes a "perfect" magazine body for a "real" body. It is not clear whether the inventor of this fantasy is a woman who wants to see a thin woman as the object of her desire for herself or a man who wants to see a thin woman as an object of sexual attention.

▶ Title: Nude, *Big* magazine 26
Editors: Tim Moss, Koji Yoshida
Guest Editor: Kyoichi Tsuzuki
Art Director: Markus Kiersztan
Designers: Garland Lyn, David Lee
Photographer: Daido Moriyama
Client: *Big* magazine 26

This photo spread is accompanied by a narrative entitled "Yokosuka"—the name of the largest U.S. Army base in Japan. The photographer describes shooting photos of a Japanese woman, dressed in a slip, fleeing from two men. The narrative of prostitution and violence is captured in these images, which is much a part of the "tradition" of U.S. de facto occupation as the article on Inu Dogs that follows.

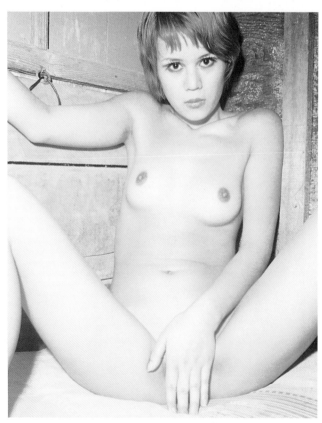

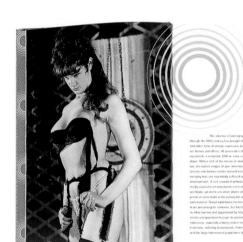

▲ Title: The Christy Report
Published: Taschen
Designer: Armando Chitolina

The Christy Report provides a survey of pornographic
photography from its earliest manifestations in the
late nineteenth century to the present. In this vividly
illustrated book, some of the most classic images of
mid-century repressed sexuality are shown with
excellent context and commentary. Perhaps the
book's most interesting design element is the cover,
which features pink foil, the material opposite of the
brown paper bag. It suggests that a book about porn
can actually be fun.

▶ Title: Don't Let This Happen to You
Art Direction: Lee Swillingham, Steuart Spalding
Fashion Director: Katie Grand
Design: Martin Sebald
Photographers: Matt Atlas, Marcus Piggott
Styling: Katie Grand
Client: *Big* magazine 28

Reflecting the "horror" theme of the issue, this spread
uses high fashion to tell a grizzly, yet indistinct, story
about two women. The directive in the title serves more
to titillate than to actually warn, recalling tales of
"fallen" women from mid-century magazines. Sexual
adventurousness will lead you down a path of doom.

153

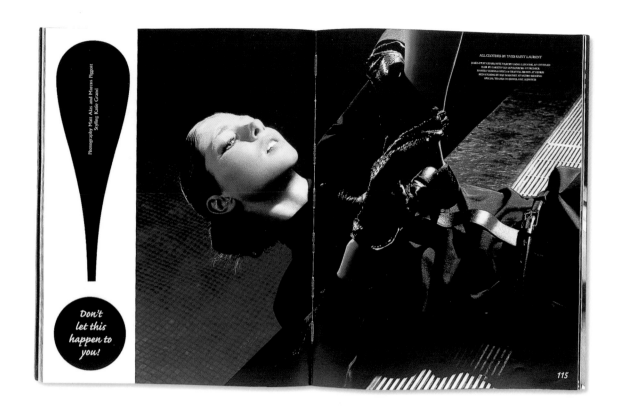

Photography Mert Alas and Marcus Piggott
Styling Katie Grand

Don't
let this
happen to
you!

ALL CLOTHES BY YVES SAINT LAURENT

MAKE-UP BY CHARLOTTE TILBURY USING LANCÔME AT UNTITLED
HAIR BY GARETH VAN GEYRADE BIG AT PREMIER
MODELS XENDRA GRIZA & CHANTAL DID FOX AT STORM
RETOUCHING BY DIGI MALONEY AT METRO IMAGING
SPECIAL THANKS TO HOTEL ONE ALDWYCH

115

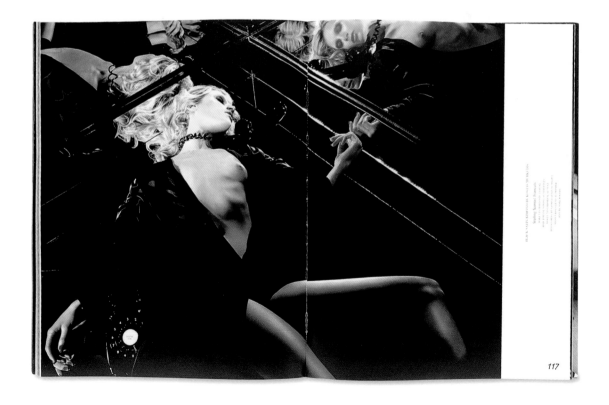

117

Title: *Arena for Men* magazine covers
Creative Director: Steven Baille
Client: *Arena for Men* magazine

Arena magazine had to compete with the "lad" explosion in the UK. *Loaded*, *FHM*, and *Maxim* were taking over the men's market of magazines that generally feature articles on men's fashion, gadgetry, female starlets, and sex tips. *Arena* needed to compete with the tits-and-ass titles that dominated the market. Men's magazines like *Esquire* and *GQ* were forced to use titillation as well. At *Arena*, the art directors tried to give it a luxurious and modern twist by using high-end photography (which the brand was famous for), and using artists like Mario Testino, Vincent Peters, and Sean Ellis to shoot sexy, interesting girls. It was conceived to be something along the lines of the original *Playboy*. *Arena* had to walk a fine line between presenting fashion stories and stories that appealed to men on a more base level. These covers use standard imagery—one features a group of nearly naked women reminiscent of Jimi Hendrix's original *Electric Ladyland* LP cover, one shows lesbian intrigue, and one uses the classic woman on fast machine.

Title: American Booty
Creative Director: Steven Baillie
Art Director: Matt Brooke
Photograper: Luis Sanchez
Client: *Arena for Men* magazine

These "New York girls worth their weight in gold" are beautifully and almost pornographically photographed in this spread that just barely reveals the jewelry and accessories it is purportedly displaying.

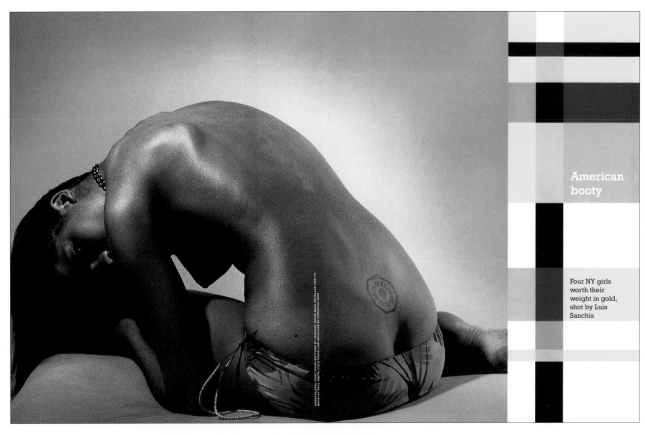

American booty

Four NY girls worth their weight in gold, shot by Luis Sanchis

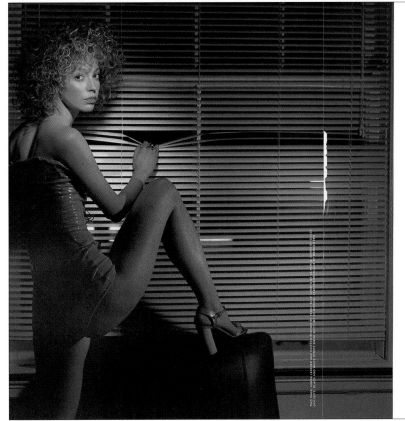

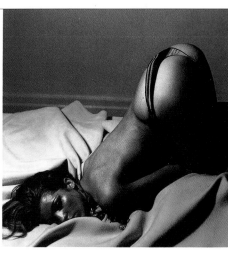

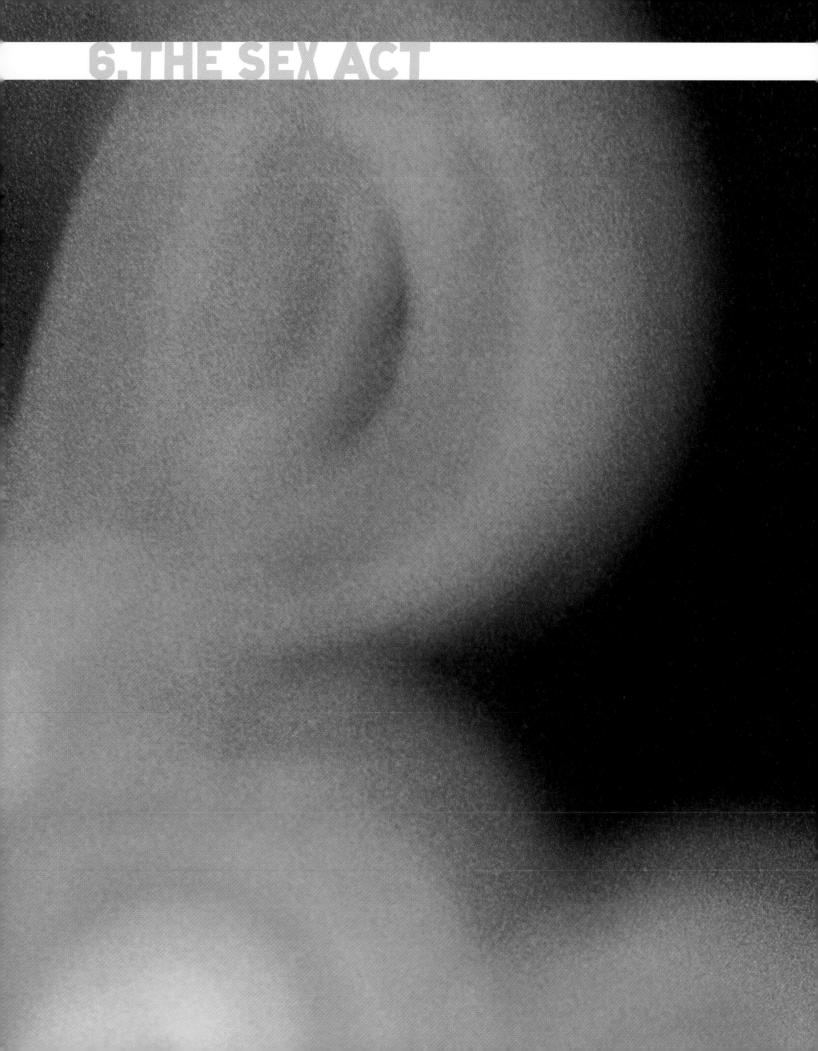

6. THE SEX ACT

With dire predictions about the spread of AIDS in China, and recent findings that different strains of AIDS can infect one human body, the evidence is overwhelming that sex in the twenty-first century comes at a high cost. And yet, simultaneously, Western (and particularly American) versions of sex and sexuality are transmitted daily over satellite and radio waves, through print and digital media, passing on information about the "right" way to look sexy or act sexual. It is not a message of restraint nor of diversity—no wonder fundamentalists the world over curse the explicit nature of the Hollywood machine and American media culture. Nevertheless, at the same time graphic and advertising design show off more and more, they also contain messages calling for awareness and caution.

By necessity, graphic artists have addressed the global AIDS epidemic from its first incarnations as the "gay cancer." Striking down so many of their own, the epidemic inspired designers in New York and San Francisco to take action and participate in awareness-raising by creating effective graphics and messaging in the activist organization ACT-UP. Since that time, AIDS education and awareness has seen many manifestations across the spectrum of design media. It has brought frank and explicit images into spaces they would not otherwise be seen—the schoolroom, the billboard—and they have devised an entirely new language of sexual explicitness for education's sake.

One example of this trend is the Benetton-sponsored magazine, *Colors*, which is printed in sixty-one countries the world over, and often takes on challenging political debate. One of the early leaders in making the AIDS crisis graphically accessible, the *Colors* AIDS issue (#7) featured a global perspective and a frank, up-to-the-minute information about the transmission, prevention, and culture of AIDS. For a photo-driven fashion story, *Colors* took condoms out of their wrappers with garments and accessories made entirely out of latex. Latex condoms are the only ones that prevent the transmission of HIV. In addition, *Colors* offered the safe sex kama sutra: six alternatives to sex that don't exchange body fluids.

A contrasting approach comes from Art Chantry, whose work traditionally uses retro images to poke fun at sexual repression and gender roles. By evoking an informational poster of the 1950s, Chantry uses ironic humor to make his client's point about condom use. The juxtaposition of a policeman's head and the large word "PENIS!!" is especially effective, calling attention to the offending body part and at the same time poking fun at law enforcement. In fact, there are still three states in the U.S. (and many outside its borders) that criminalize sodomy. In some places, such as Egypt, it is punishable by death. The police officer enforcing safe sex on a poster geared toward gay men ultimately fetishizes the police *and* gets the message across in a funny and nonjudgmental way.

The widespread public campaigns to prevent AIDS, as well as advertising for condoms, have greatly influenced the degree of explicitness that has become acceptable in the mainstream media. In addition, the sheer abundance of public-interest messaging and commercial efforts have pushed designers to more complex levels of creativity to get their points across. In addition to visual humor, word play is a common device, since it alleviates the requirement for explicit sexual content for a given ad.

Although it is difficult to determine if the seemingly contradictory explicit/protected messages of condom manufacturers and safe-sex advocates have substantially changed the field of design to make explicitness more acceptable, these trends were simultaneous through the 1980s and 1990s. Certainly the contradiction is nowhere more obvious than in the way that sex is represented to young people. Since cries of corruption still emanate from some quarters when condoms get near high schools, and young women are consistently denied access to reproductive healthcare (including abortions), this double message is especially detrimental to youth.

The sex act is surrounded by so much external meaning that it is rarely shown directly in contemporary design. In addition to being morally problematic for some, the act itself slips away under a crowd of products, feelings, and environments. It is in pornography where the sex act retains its full glory—but to discuss the design of porn would take another book entirely. Meanwhile, contemporary graphic designers use the edges of the sex act—the body part, the innuendo, the bed, the lingerie—to make their points and to evoke the meaning of sex without actually showing the act. Through these acts of design, the regular world becomes sexual, and sex—every kind of sex—is naturalized into the regular world.

CoCo de Mer
EROTIC SHOPS

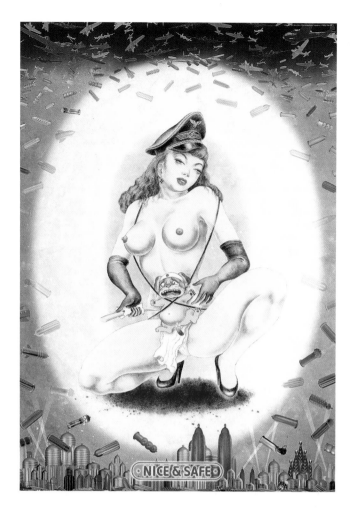

Title: Coco de Mer Erotic Shops
Art Directors: Adam Scholes, Michael Long
Photography: Frank Budgen
Agency: Saatchi & Saatchi, London
Client: Coco de Mer

Coco De Mer claims to be London's "first erogenous zone," featuring bed linen, bedroom toys, books and boxes, lingerie and lounge wear, as well as an apothecary. The shop is named after a palm nut from the Seychelles that looks in its male and female forms very much like human genitalia. No product is shown in these advertisements, nor is the environment of the shop immediately apparent. Instead, the faces of satisfied customers demonstrate the diversity not only of sexual expression but, ultimately, of the shop's clientele.

Title: Nice & Safe
Designer/Illustrator: Yokimasa Okumura
Studio: The Studio Tokyo Japan
Client: Tokyo Art Directors Club

These colorful, almost playful images of girls, toys, and condoms, use both Japanese and American pop and traditional culture to advertise the message "Nice & Safe." There is an interesting military theme running through these designs, where toy airplanes seem to be dropping bombs—or are they condoms?—out of the sky, complicating the seemingly fun approach to sex.

Title: *Portable Ecstacy*
Designer: Kyoichi Tsuzuki
Client: Apect Street File

The dildo is ancient, the vibrator a benefit of the electronic age. Japanese innovation on this technological inspiration is perhaps best known by the sometimes-whimsical and often-complicated vibrators shaped as animals or cartoon characters. The most famous is the *kumanko*, which has both vaginal and clitoral stimulation, as pictured on the cover of this book.

163

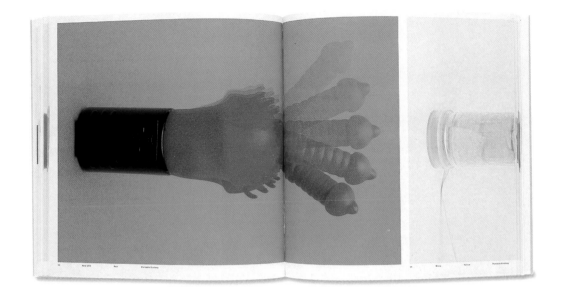

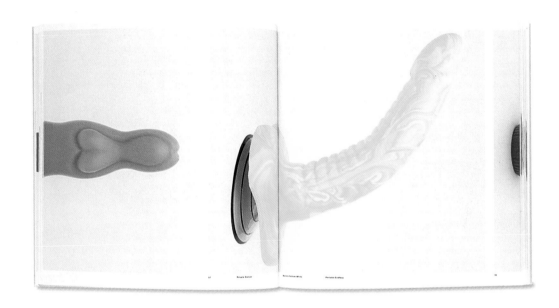

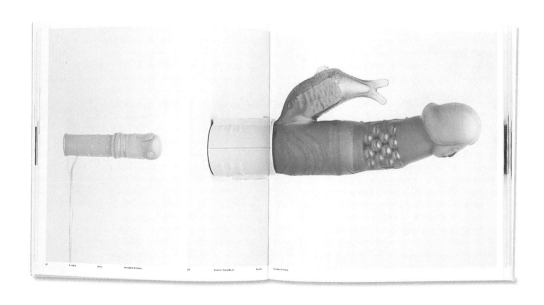

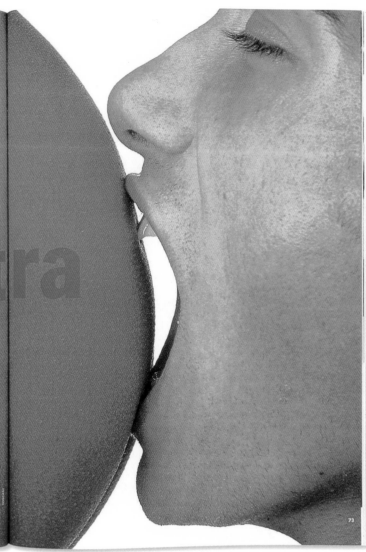

BITING Don't be ashamed to let your lover see your tender side. The gluteal region is one of the body's erogenous zones. The skin is delicate, excitable, delicious. Perfect for a nibble.
MORSI Non ti vergognare di mostrare al/la partner il tuo lato tenero. I glutei sono una delle zone erogene del corpo. La pelle è delicata, eccitabile, deliziosa. Perfetta per un morsetto.

AIDS has made sex dangerous.
We have to re-invent it.
Let's get to work.

safe sex
il kama sutra
del sesso sicuro

L'AIDS ha reso il sesso pericoloso.
Dobbiamo riinventarlo.
Mettiamoci al lavoro.

It's a whole new experience. Caressing, fondling and licking aren't the things we do before we make love; they are making love. The body is a long, complex field of pleasure zones. So make a map: lick armpits and abdomens, suck toes and fingertips, nibble your lover's inner thighs. Create sensations. Dominate with a tickle. Soothe with a massage. Just one rule: don't exchange fluids. The rest is up to you. Sex isn't just one thing. It's anything you care to try.

There's much to be done.

È un'esperienza completamente nuova. Accarezzarsi, toccarsi, leccarsi, non sono le cose che facciamo prima di fare l'amore, è fare l'amore. Il corpo è un lungo e complesso campo di zone erogene. E allora fai una mappa: lecca le ascelle e l'addome, succhia gli alluci e le dita della mano, mordicchia le gambe dietro le giunture. Crea sensazioni. Domina il/la partner con il solletico. Rilassa con un massaggio. Una sola regola: non scambiare liquidi. Il resto sta a te. Il sesso non è solo quella cosa. È qualsiasi cosa che hai voglia di provare.

C'è tanto da fare.

72

73

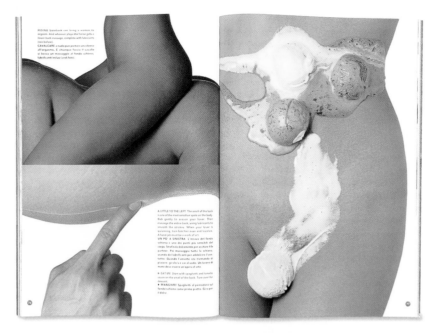

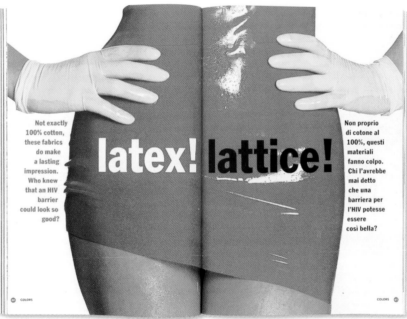

latex! lattice!

Not exactly 100% cotton, these fabrics do make a lasting impression. Who knew that an HIV barrier could look so good?

Non proprio di cotone al 100%, questi materiali fanno colpo. Chi l'avrebbe mai detto che una barriera per l'HIV potesse essere cosi bella?

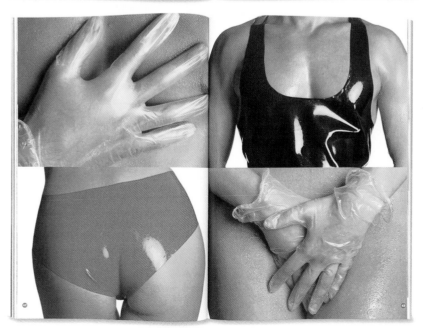

Title: *Colors* 7, AIDS issue
Editor in Chief: Tibor Kalman
Art Director: Scott Stowell
Designer: Leslie Mello
Photographer: Oliviero Toscani
Client: *Colors* magazine

Flippant, fast paced, unflinching, this issue on safe sex mounts an aggressive visual assault on the ignorance and prejudice surrounding AIDS.

Title: Officer 69, I Have Something for You
Designer: Art Chantry
Agency: Cole & Weber
Client: King County Department of Health

Targeted at gay men, this poster won a
Bronze Lion at the Cannes festival for inter-
national advertising. The images used in this
series draws on camp sensibility and humor
to make its life-or-death point.

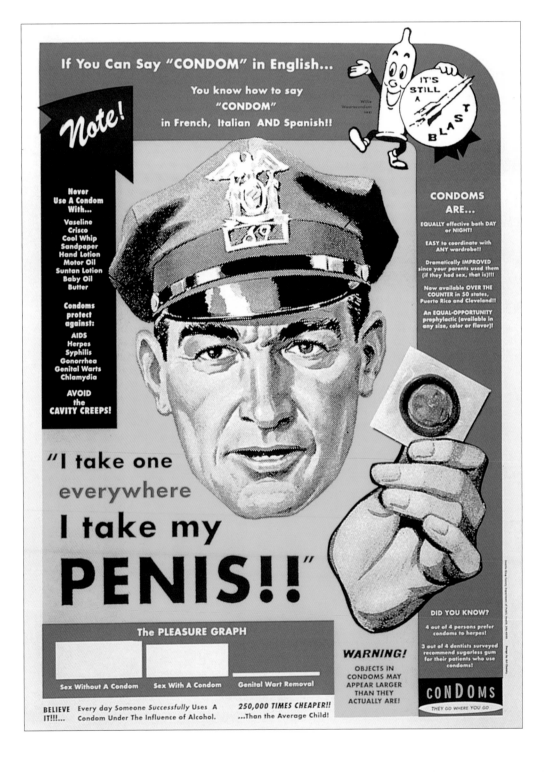

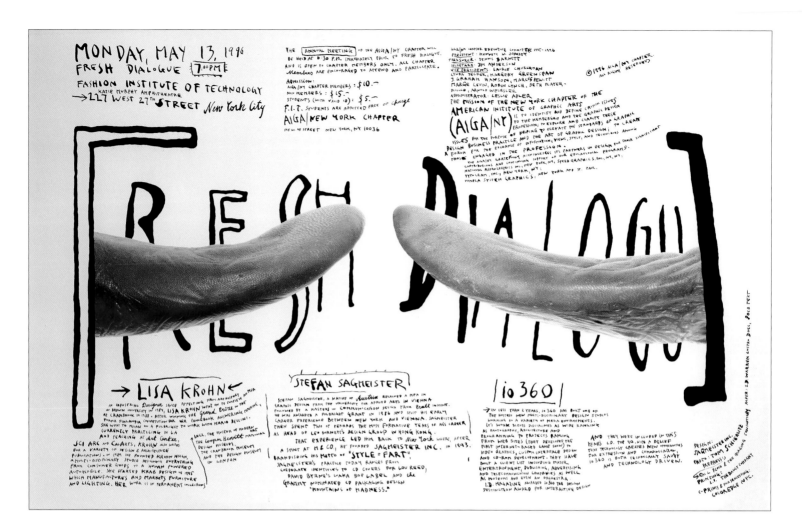

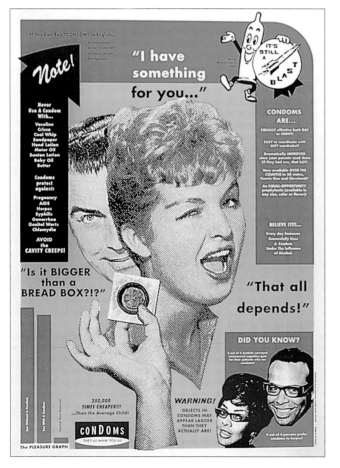

Title: AIGA Conversation Event
Designer: Stefan Sagmeister
Studio: Sagmeister

Consciously refusing high-tech representation, Sagmeister uses handwritten text and photos of cow tongues in this promotional poster for an AIGA "designers in conversation" event. The promoters initially objected to the poster because of its phallic nature, but the participating speakers gave it the thumbs up. Cashing in on the literalism of "wagging tongues," Sagmeister has produced a work that is simultaneously provocative in its abstracted and quasisexual form. The tongues strain towards each other as if to kiss, but the interchange is as purely cerebral as the event it advertises.

(quit facti?) is knowing under what conditions duration becomes in fact

Design, Imaging, and Production: Rebeca Méndez, reasonsense
E-mail Text: Adam Eeuwens and Rebeca Méndez
Text Over Images: From *Bergsonism* by Gilles Deleuze
Images were captured on a screen VT-1045 scanner

Adam Eeuwens, 4/11/96 9:53 A.M.,Re: Guilty

Rebeca Méndez, 4/23/96 0:11 A.M.,Re: loosing grip

The images in this printed piece are isolated frames of an animation I created for Adam. Adam lives in Amsterdam and I live in Pasadena. We met in Amsterdam, but a few days later I came back home. Immediately we began communicating through e-mail and telephone. The disembodied language of e-mail and a double distance, not only physically but most importantly a distance in time, woke a desperate and silent attempt of making the writing machine into a sensual machine.

I began scanning parts of my body and sending them to Adam. But a still image fell so short from conveying my desire to feel his beautiful white skin on my hands, even if for a few seconds. The closest I could get to his machine and, therefore, to him was to caress the scanner itself, leaving behind fingerprint traces also captured by the scanner. A monotonous female voice softly calls to her lover, "I love you," over and over and over.

I live though my own duration, that is, the flow of time, and Adam through his. We both place our "love production" into an abstract site, into a messenger that primarily moves through time, not space. A sensory expression is thrown into this site, it oscillates in the threshold between projection and memory, it is in my mind, it is passive and virtual in my future/past. When I'm able to be back in my body and in the present, the abyss of the double distance becomes apparent, striking at my very core as I sit in silence staring at the glass of this machine.

Cyber stroke is twenty seconds long and was constructed on a Power Macintosh 7100/80 AV using Adobe Premiere and Photoshop and SoundEdit 16 software.

—Rebeca Méndez

Title: MTV sex video stills
Art Director: Jeffery Keyton
Studio: MTV

This is a fifteen-second promo for the show called sex2k. In the visual landscape of the popular music video, a show about sex stands out simply by its level of explicitness. It appears to be some kind of alt-porn situation until the last frame that features the name of the show and the actor looking at the camera. Sex2k won a degree of notoriety for focusing on deep subcultures of sex, including stuffed animal fetishists, and drag kings.

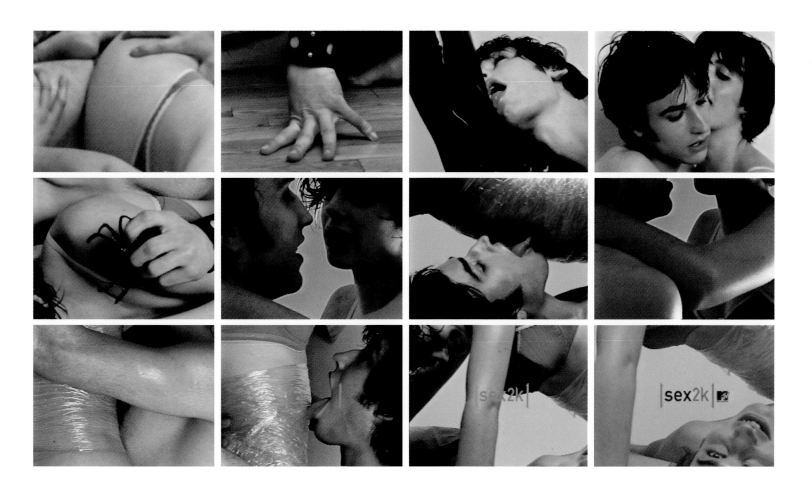

Besser sehen, was Bill Clinton treibt.

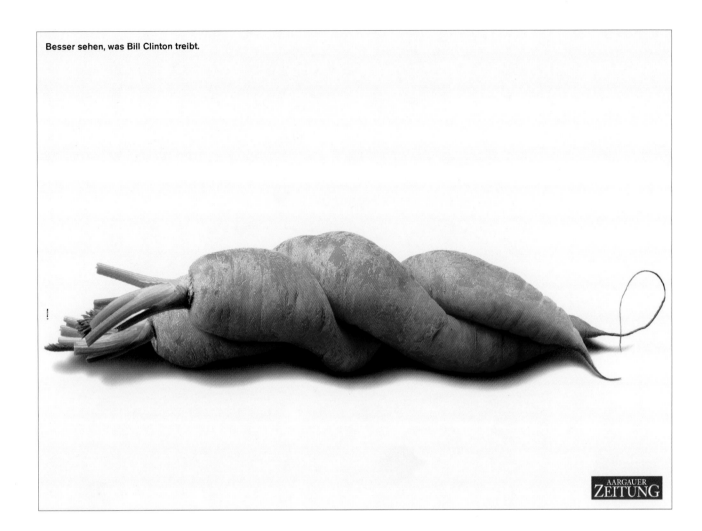

▲ Title: Bill Clinton
Designer: Rüdi Wyler
Studio: Wyler Werbung
Client: Süddentsche Zeitung
Client's Service: Newspaper

The captions for these intertwined carrots read,
"See better what Bill Clinton does/screws," a
double entendre made even more ironic by the
depiction of vegetables in what looks to be a
metaphorically compromised position.

▶ Title: Security/Protection/Durability
Art Directors: Nguk Siag, Charles Chua
Copywriter: Alexander J. Patterson
Digital Illustrator: Haniza Hashim
Photographer: Charles Chua
Studio: McCann Erickson Singapore
Client: Durex International
Client's Product: Condoms

In these three advertisements, the designers
cut through the clutter of sexual relations to
communicate the effectiveness of the condoms,
creating aesthetic objects in the process.

Security. durex

Protection. durex

Durability. durex

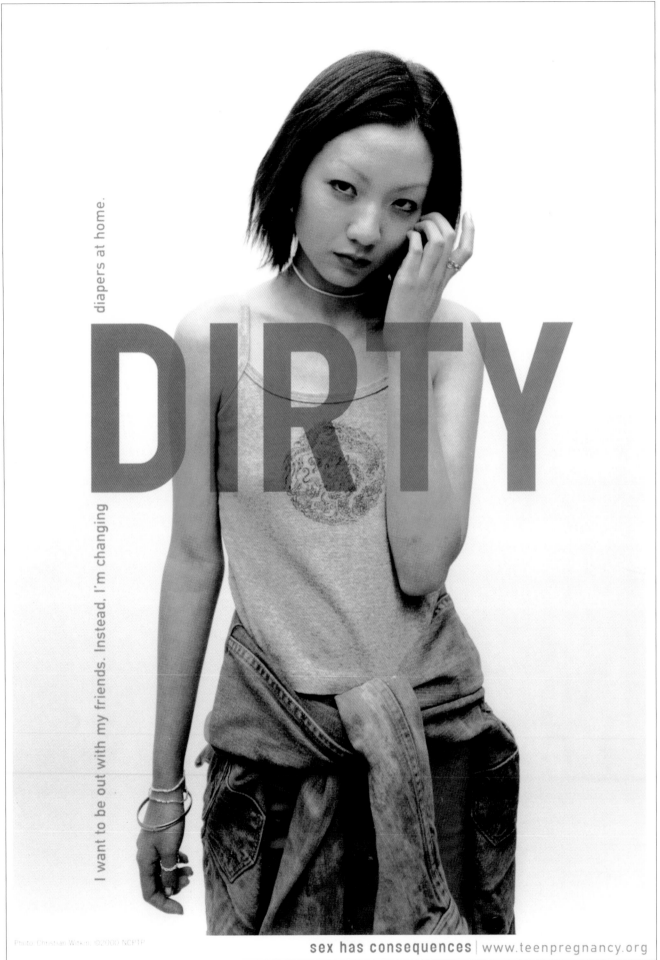

diapers at home.

DIRTY

I want to be out with my friends. Instead. I'm changing

Photo: Christian Witkin. ©2000 NCPTP

sex has consequences | www.teenpregnancy.org

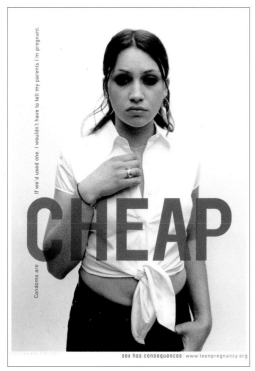

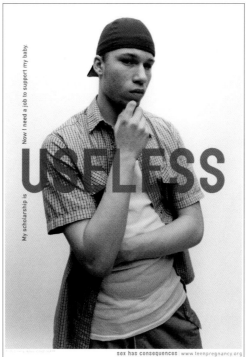

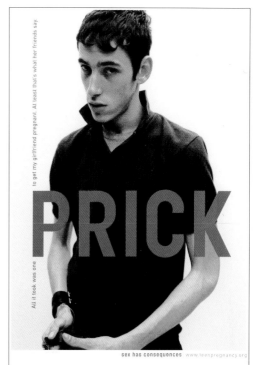

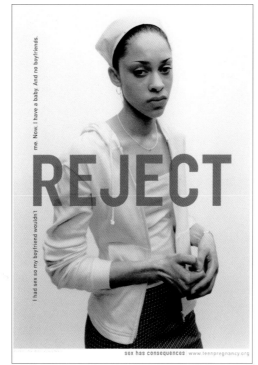

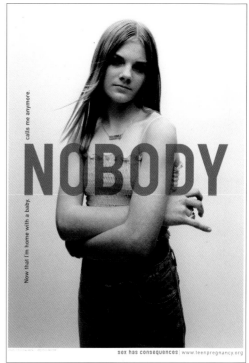

Title: Sex Has Consequences
Designers: Tony Arefin, Arturo Gigante
Copywriter: Chris Skurat
Photographer: Christian Witkin
Agency: Olgivy & Mather
Client: Teenpregnancy.com

The consequences of unprotected sex are starkly
described in this powerful series of advertise-
ments for teenpregnancy.com. Reflecting the
socially imposed judgment of teen parents
("cheap," "dirty," "useless"), the ads also
describe the realities of teen parenting ("My
scholarship is useless now that I need a job
to support my baby"). The advertised Web site
redirects the reader to adoption-focused "parent-
profiles.com," which nowhere acknowledges
the option of abortion for teens faced with the
difficult dilemma of unplanned pregnancy.

The Swiss STOP AIDS Campaign

 The Swiss Federal Office of Public Health, together with the Swiss AIDS Foundation, launched the STOP AIDS campaign in 1986 as a long-term prevention and education campaign with the purpose of reinstating the condom and ensuring the constant public presence and updating of the topics of HIV and AIDS. During the early years, a poster campaign was run to create an attitude of ready acceptance and familiarity for the condom, with more than a dozen different motifs restricted to individual words that contained the letter *O* and had something to do with love, sex, or the application of condoms. Examples: Bravo, Rendez-vous, Olè!, Tonight. A second campaign showed the nighttime skylines of the biggest Swiss cities, over which the moon was in each case replaced by a pink condom. Both series put the message across as succinctly as possible.

 With progress in the new therapies for AIDS, the fear of the disease has dwindled. AIDS lost its terrifying dimension, and with it also the awareness of safer sex. The condom and the topics of HIV and AIDS had to be more explicitly broached than is possible with a poster. Some of the topics: the right size of the condom, the quality of the condom, the increase in prostitution among immigrant women, the quantity of medication that has to be swallowed and its side effects, the subject of oral sex. In the pavilion that deals with love and sex at the Swiss National Exhibition "Expo 02," we refer to the subject by covering the billboards with ambiguous pictures of phallic and vaginal symbols from the world of food. The textual commentary can be dispensed with since after a fifteen-year campaign the concept STOP AIDS has become the synonym for safer sex.

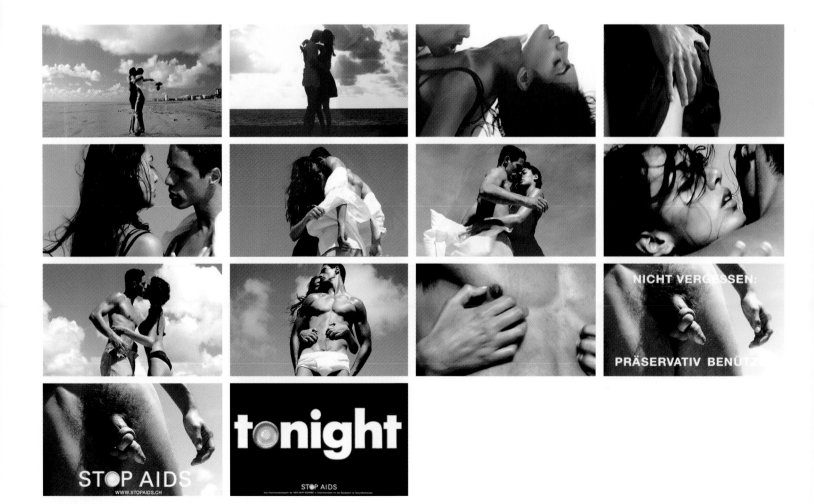

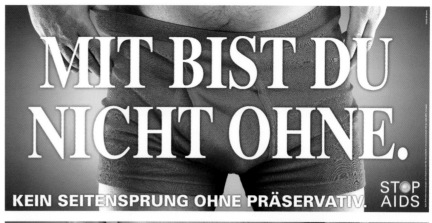

Title: TV/Cinema flashes for young men and women
Agency: CR DDB Werbagentur
Art Director: Urs Mangold

Before the invention of the tissue, it was customary to remind oneself of something important by tying a knot in one's handkerchief. In this advertising, an emotional film with an intense love scene, a spot for Italian fashion or for men's cosmetics, unexpectedly and provocatively finished with a surprising final shot of a knot in a penis. The caption over it reads: Don't forget condoms protect.

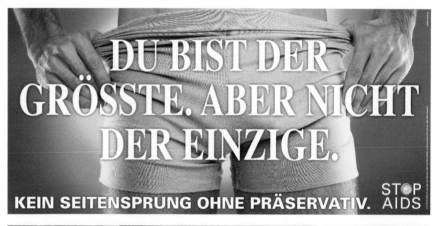

Title: Underpants posters

An example from a poster campaign with various photos of men's underpants with textual invitations to combine sex with sense. Although the multiple and humorous meanings of these messages are difficult to convey in English, the translations read:

[Mit bist du nicht ohne.]
With it [a condom] you aren't alone.

[Ohne dings kein bums.]
Without the thing [a condom], no fuck.

[Du bist der grösste. Aber nicht der einzige.]
You are the biggest one, but you aren't the only one.

[Denk mal mit dem kopf.]
Use your head for once.

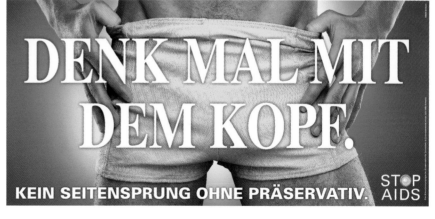

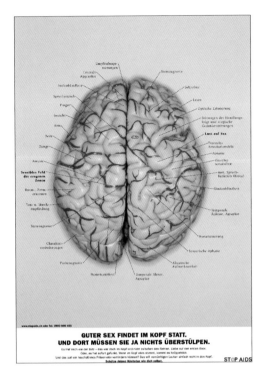

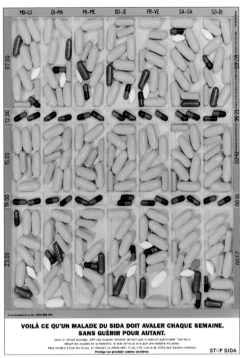

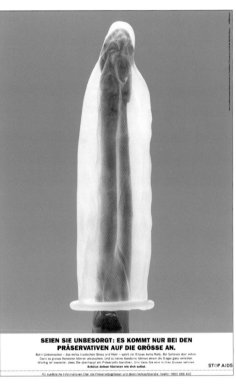

Translations this page (left to right, top to bottom):

[Guter Sex findet im Kopf statt. Und dort müssen sie ja nichts überstülpen.]
Good sex happens in your mind, and there you don't have to put on a condom.

[Voila ce qu'un malade du SIDA doit avaler chaque semaine. Sans guérir pur autant.]
Here is what a person with AIDS has to take every week. And without possibility of a cure.

[Schütze Deine(n) Nächste(n) wie Dich selbst.]
Protect your next like you protect yourself.

[Fünfundvierzig und kein bisschen weise.]
45 and none the wiser. (Text of the paper reads: "Over 45 years, I'd rather risk it than use a condom!")

[Ist Sie es Wert, die lauschige Nacht?]
Is it worth it, this lovely night?

[Seien Sie unbesorgt: es kommt nur bei den präservativen auf die grösse an.]
Don't worry, how big you are only has to do with the condom.

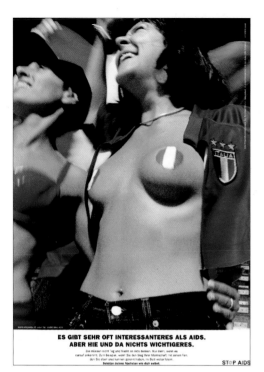

ES GIBT SEHR OFT INTERESSANTERES ALS AIDS. ABER HIE UND DA NICHTS WICHTIGERES.

Schütze deinen Nächsten wie dich selbst.

STOP AIDS

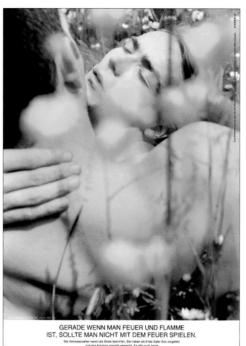

GERADE WENN MAN FEUER UND FLAMME IST, SOLLTE MAN NICHT MIT DEM FEUER SPIELEN.

Schütze deinen Nächsten wie dich selbst.

STOP AIDS

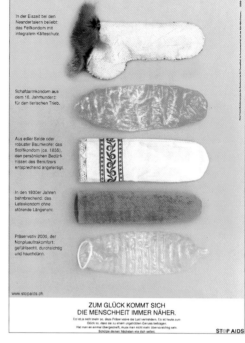

ZUM GLÜCK KOMMT SICH DIE MENSCHHEIT IMMER NÄHER.

Schütze deinen Nächsten wie dich selbst.

STOP AIDS

SEIT DEM LETZTEN VALENTINSTAG SIND RUND 20 000 EHEN GESCHIEDEN WORDEN.

Schütze deinen Nächsten wie dich selbst.

STOP AIDS

ROMANTIK PUR. FEHLT NUR DAS PRÄSERVATIV, DAS HÄLT, WAS ES VERSPRICHT.

Schütze deinen Nächsten wie dich selbst.

STOP AIDS

«DU MUSST DIR NICHT DIE HEMMUNGEN WEGSAUFEN, BIS DU DANN NICHT MEHR KANNST.»

Schütze deinen Nächsten wie dich selbst.

STOP AIDS

Translations this page (left to right, top to bottom):

[Es gibt sehr oft interessanteres als AIDS. Aber hie und da nichts wichtigeres.]
There is often something more interesting than AIDS. But sometimes there's nothing more important.

[Gerade wenn man Feuer und Flamme ist, sollte man nich mit dem Feuer spielen.]
Exactly when a person is horny [all fire and flame] is when you cannot play with fire.

[Zum Glück kommt sich die Menscheit immer näher.]
Fortunately, humanity will come even closer together.

[Seit dem Letzten Valentinstag sind rund 20,000 Ehen geschieden worden.]
Since last Valentine's day, about 20,000 marriages have broken up.

[Romantik pur, fehlt nur das Präservativ, das Hält, was es verspricht.]
Pure romance, missing the condom (that doesn't break) keeps its promise.

[Du musst Dir nicht die Hemmungen wegsaufen, bis Du dann nicht merh kannst.]
You have to drink away your fears until you can't get it up anymore.

Title: Runnionkiller, Monica, The End of Print
Studio: Thirst
Art Director: Rick Valicenti
Illustrator: Rick Valicenti
Designer: Rick Valicenti

Rick Valicenti presents a dark commentary on the
sexual nature of both the child murder of Samantha
Runnion and the reputation of Monica Lewinsky.
Both of these cases relied on television if not for
their creation, most certainly for their propagation.
The sex act is not in itself defiled, but reduced by
televisionlike digital distortion to barely recogniza-
ble form. The presence of black dripping substance
reminiscent of blood overlays the image of the killer
of a five-year-old southern California girl; a fly sits
on the hyperpixelated face of Monica Lewinsky; the
media as a fly in the ointment? A fly settling
on excrement?

VOL:7 NO:5

BUMMER

COMING DOWN OFF HEROIN

WITH ~~A PIMP~~ A CHEAP LADY-BOY

PROSTITUTE

DAVIS 2000

DIRTY NON-DARWINISM

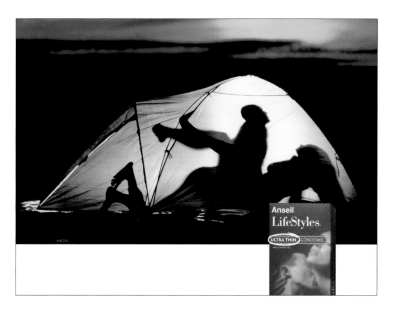

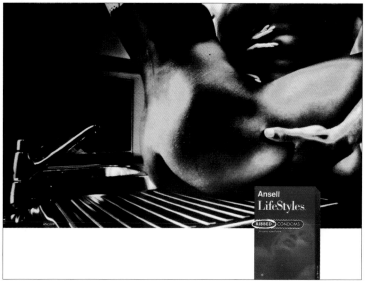

Title: Lifestyles Condom Ads, Australia

Because condom use has become a common practice and the market is overwhelmed with options, Lifestyles presents a dizzying array of choices for different sexual needs. From a destroyed bed to a bondage scene, these Lifestyles condom ads suggest that the different grades of condom, which all essentially do the same thing, might be required for each of the different sexual situations pictured here. These ads are unique because they are so graphic and also picture gay and straight sex next to each other.

Designer/Illustrator: Paul Davis

This illustrator and designer uses his wry sense of humor to manipulate the viewer into supplying genitalia in many of these drawings. These images are part of a show in New York where one of the directors of the company decided that even with the penis and vagina obliterated they were still deemed pornographic drawings, so Davis had to run down to Staples and buy some large golden stars and stick them over *nothing*. Someone later told the artist that the complaint came from a Baptist. The sex workers are portraits drawn from the small ads in the back of newspapers and magazines. The artist makes them look vunerable instead of idiotic.

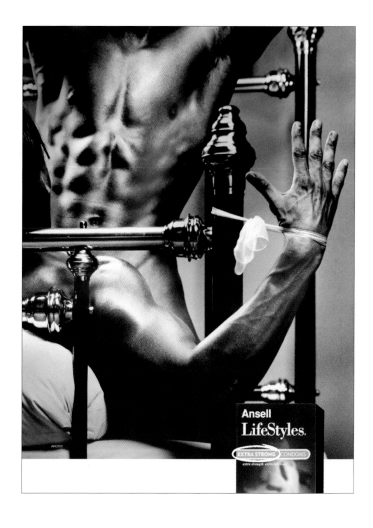

She likes bananas.

I like meat.

ファック ミー　ラヴ ミー

Title: Bananas and Meat
Artist: Pete McCracken
Studio: Crack Press

Implying a highly sexualized and metaphorical
relationship of food to desire, these posters divorce
this desire from bodies and relocates them into the
setting of a supermarket or kitchen. The halftone
color of the images recalls newspaper advertisements
for food. By making the common food object sexual,
and using the phallus/vagina dichotomy, McCracken
also makes a statement about the commercialized
reinforcement of (hetero) sexual preference.

Title: Fakku Mi, Labbu Mi
Artist: Pete McCracken
Studio: Crack Press

The text of this poster reads "Fakku Mi, Labbu Mi"—
the Japanese phonetic approximation of "Fuck me,
love me"—and demonstrates a nearly desexualized
sequence of condom use. The characters and images
are silkscreened on rubber.

Title: Art Director's Club 78th Annual Call for Entries:
"Creative Stimulation"
Art Direction and Design: Stacey Drummond, Tracy
Boychuk
Illustration: Jordan Nogee
Copywriter: Amanda Brokaw
Studio: MTV Off-Air Creative
Client: Art Directors Club

Based primarily on what designers themselves
find interesting and important, contests such as
this posit the award show as the ultimate form of
masturbation, which pokes fun at the egos and
pleasures of designers themselves.

Contributors

Jesse Alexander
3218 SE 22nd Avenue
Portland, OR 97202 USA
p. 503.267.6965
e. ilovejessealexander@hotmail.com

Ansell Healthcare Incorporated
200 Schulz Drive
Red Bank, NJ 07701 USA
p. 732.345.5400
e. ccarrozza@ansell.com

Bartle Bogle Hegarty
60 Kingly Street
London W1R 6DS UK
p. +44.0207.734.1677
f. +44.0207.437.3666

Bau-Da Design Lab
8641 Hayden Place
Culver City, CA 90232 USA
p. 310.558.5030
f. 310.558.5031
e. prbrown@bauda.com

BBDO Myres Reklamebyra
Parvn 53
0202 Oslo Norway
p. +47.21.02.43.12
f. +47.21.02.40.01
e. jont@bbdo.no

Benjamens Van Doorn Euro RSCG
Burg A. Colijnweg 2
1182 AL Amstelveen Netherlands
p. +31.20.547.07.00
f. +31.20.643.06.00
e. saskia.peters@bvd.eurorseg.nl

Big Magazine
20 Harrison Street, Ground Floor
New York, NY 10013 USA
p. 212.343.3911
f. 212.343.3916
e. info@bigmagazine.com
w. www.bigmagazine.com

Big Orange
150 Curtain Road
London EC2A 3AR UK
p. +44.20.7739.7765
f. +44.20.7613.2341
e. bigorange@btclick.com

Art Chantry
Art Chantry Design Co.
P.O. Box 63275
St. Louis, MO 63163 USA
p. 314.773.9421
f. 314.773.3295
e. achantry@goinet.com

Cayenne Werbeagentur GmbH
Mindener Str. 33
40227 Duesseldorf Germany
p. +49.211.97769.168
f. +49.211.97769.99
e. c.kipping@cayenne.de

COOP
P.O. Box 39997
Los Angeles, CA 90039 USA
p. 323.666.7466
f. 323.666.8696
e. email@coopstuff.com
w. www.coopstuff.com

Colors
Via Ferrarezza
31050 Catena di Villorba
TV Italy
p. 39.0422.516302
f. 39.0422.516308
e. adianna.rinaldo@colors.it

Crack Press
Pete McCracken
P.O. Box 3211
Portland, OR 97208 USA
p. 503.229.0892
f. 503.528.8092
e. pete@plazm.com
w. www.crackpress.com

Crap Hound
P.O. Box 40373
Portland OR 97240 USA
p. 503.502.6466
e. sean@nypress.com

CR DDB
Urs Mangold
St. Jakobs Str. 191
4002 Basel Switzerland
p. +41.61.3777171
f. +41.61.3777100
e. urs.mangold@crddb.ch

Crispin, Porter and Bogusky
2699 S. Bayshore Drive
Miami, FL 33133 USA
p. 305.646.7403
f. 305.854.3419
e. vpqdilla@cpbgroup.com

Daddy
Steven Baillie
480 Canal Street, Suite 1104
New York, NY 10013 USA
p. 212.941.5900 x26
f. 212.941.9895
e. sbaillie@daddydoes.com

D'Adda Lorenzini, Vigorelli, BBDO
Via Lanzone 4
20123 Milan Italy
p. +39.02.8800.71
f. +39.02.8800.7223
e. cmazza@dlvbbdo.com

The Designers Republic
The Workstation
15 Paternoster Row
Sheffield 512BX UK
p. +44.114.275.4982
f. +44.114.275.9127
e. disinfo@thedesignersrepublic.com

Diesel
Via Dell'Industria
36060 Molvena – Vincenza Italy
p. +39.0424.477555
f. +39.0424.411955
w. www.diesel.com

Diesel USA
770 Lexingon Avenue, 9th floor
New York, NY 10021 USA
p. 212.755.9200

The @lement
30A Mosque Street
059508 Singapore
p. +65.6225.2425
f. +65.6225.2660
e. angela@element.com.sg

Euro RSCG Brussel
50, Due du Doyenné
1180 Brussel Belgium
p. +32.2.348.38.00
f. +32.2.348.38.36
e. elena.s@erorscg.be

The Fish Can Sing
24-28a Hatton Wall
London EC1N 8JH UK
p. +44.20.7430.1682
f. +44.79.8621.1422

Hysteric Glamour Workshop
123 5th Avenue, #5
New York, NY 10003 USA
p. 212.228.8965
f. 212.228.8713
e. HGWorks@aol.com

Girl Studio
Katsura Moshino
#B302 1-53 Ikezono Chikusa
Nagoya 464-0818 Japan
p. +52.783.5127
f. +52.783.5127
e. office@girlstudio.org

Gish, Sherwood and Friends
4235 Hillsboro Road
Nashville, TN 37215 USA
p. 615.385.1100
f. 615.783.0500
e. kedwards@gish.com

Greteman Group
1425 Douglas
Suite 200
Wichita, KS 67211 USA
p. 316.263.1004
f. 316.263.1060
e. sgretman@gretmangroup.com

Hank Trotter
Twodot Design
P.O. Box 1736
Seattle, WA 98111 USA
p. 206.323.0352
f. 206.323.0352
e. hank@kutie.com

Jeffrey Keyton
MTV
1515 Broadway
New York, NY 10036 USA
p. 212.258.8000
e. Jeffrey.Keyton@mtvstaff.com

Frank Kozik
1488 Howard
San Francisco, CA 94103 USA
p. 415.861.8325
f. 415.861.8198
e. kozik@netscape.net

Angela Lorenz, c/o Kitty-Yo Int.
Greifswalder Str. 29
10405 Berlin Germany
p. +49.177.258.1687
e. alorenz@bitstream.de

Lux Studio
Rachel Carns
P.O. Box 2912
Olympia, WA 98507 USA
p. 360.402.5547
e. need@olywa.net

MCA Records
2220 Colorado
Santa Monica, CA 90404 USA
p. 310.865.4067
f. 310.865.1624

McCann Erickson Singapore
360 Orchard Road
#03-00 International Building
238869 Singapore
p. +65.969.22154
e. nguk@mail.com

Mccann-Erickson Madrid
po de la Castellana, 165
Madrid 28046 Spain
p. +91.567.9191
f: +91.567.9225

Meat and Potatoes
4216 Santa Monica Boulevard
Los Angeles, CA 96029 USA
p. 323.666.2343
f. 323.666.2635
e. todd@meatoes.com

Rebeca Mendez
2873 Mount Curve
Altadena, CA 91001 USA
p. 626.794.1334
f. 310.280.2538
e. balam@earthlink.net

Mirko Ilić Corp.
207 E. 32nd
New York, NY 10016 USA
p. 212.481.9737
f. 212.481.7088

MOJO Parners
4-16 Yurong Street
East Sydney 2010 Australia
p. +61.9332.0000
f. +61.9332.0090

Ms. Magazine
1600 Wilson Boulevard, Suite 801
Arlington, VA 22209 USA
p. 703.522.4201
f. 703.522.2214

Orange Juice Design
461 Berea Road
Durban 4001 South Africa
p. +27.31.2771860
f. +27.31.2771870

PETA
501 Front Street
Norfolk, VA 23510 USA
p. 757.622.7382
f. 757.622.0457
w. www.peta.org

Plazm Media
P.O. Box 2863
Portland, OR 97208 USA
p. 503.528.8000
f. 503.528.8092
e. design@plazm.com
w. www.plazm.com

Pussyfoot Records
6 Denmark Street
London WC2H 8LP UK
p. +44.0207.240.1700
f. +44.0207.240.1955

R & R Partners
900 S. Pavillion Center Drive
Las Vegas, NV 89144 USA
p. 702.318.4369
f. 702.228.7171
e. bmorton@rrpartners.com
w. www.rrpartners.com

RBA Publicidade
Joao Antonio da Silveira, 126
Centro—93510-300
Novo Hamburgo-RS-Brazil
p. +55.51.594.8555
f. +55.51.593.9307
e. marciano@rba.com.br

RCA Records
1540 Broadway
New York, NY 10036 USA
p. 212.930.4237
f. 212.930.4633

Red Design
11 Jew Street
Brighton BN1 1UT UK
p. +44.1273.704614
f. +44.1273.704615
e. info@red-design.co.uk
w. www.red-design.co.uk

RG Wiestmeier Werbeagentur AG
Maximilianstrasse 30
D-80539 Munich Germany
p. +49.85.290085.0
f. +49.85.2040027.76
e. falterweier@wiesmeir.de

Rinzen
P.O. Box 944
Fortitude Valley
4006 Australia
p. +61.738525351
f. +61.738525361
e. they@rinzen.com
w. www.rinzen.com

Ruiz Nicoli
c/ Villanueva, 13
Madrid 3 Spain
p. +34.91.4328200
f. +34.91.5777249
e. ruiznicoli@ruiznicoli.com

Saatchi & Saatchi, London
80 Charlotte Street
London W1A 1AQ UK
p. +44.20.7636.5060
f. +44.20.7637.8489

Sagmeister
222 W 14 Street, #15 A
New York, NY 10011 USA
p. 212.647.1789
f. 212.647.1788
e. ssagmeister@aol.com

Dan Savage
p. 206.323.7101
e. savage@thestranger.com

Sea Design
70 St. John Street
London EC1M 4DT UK
p. +44.20.7566.3100
f. +44.20.7566.3101
e. carsten@seadesign.co.uk
w. www.seadesign.com.uk

Sisley
United Colors Communication S.A.
Via Nassa, 58
6900 Lugano Switzerland
p. +91.9104180
f. +91.9104189
e. mattei@benneton-lugano.ch

The Studio Tokyo Japan
2F TokijiJambo Bld. 7-15-11
Tukiji, Chuo-ku
Tokyo 104-0045 Japan
e. studio@pluto.plala.or.jp

Taschen GmbH
Hohenzollernring 53
Köln 50672 Germany
w. www.taschen.com

Kyoichi Tsuzuki
2-4-3F, Kojimachi
Chiyoda-ku Tokyo
102-0083 Japan
p. +813.3288.6425
f. +813.3288.6426
e. ktmail@attglobal.net

Martin Tickner
303 Old Street
London EC1V 9LA UK
p. +44.20.7613.2724
e. martin@shoreditch.fsworld.co.uk

United Design Consultants (Udt.)
54 Leyborne Park
Kew Surrey TW9 3HA UK
p. +44.020.8332.2112
f. +44.020.8332.2116
e. chris@utd-design.com

Vinizius Young and Rubicom
Numancia 164 8th floor
08029 Barcelona Spain
p. +34.93.3666600
f. +34.93.3666608

Rick Valicenti
Thirst
132 W. Station
Barrington, IL 60010 USA
p. 847.842.0222
f. 847.842.0220
e. rick@3st2.com

Virgin Records
338 N. Foothill Road
Beverly Hills, CA 90210 USA
p. 310.288.1430
f. 310.288.2439

Why Not Associates
22c Shepherdess Walk
London N1 7LB UK
p. +44.020.1253.2244
f. +44.020.7253.2299
e. info@whynotassociates.com

Christian Witkin
Represented by
David Maloney at Art Department
48 Greene Street, 4th floor
New York, NY 10013 USA
p. 212.925.4222
f. 212.925.4422
e. davidm@art-dept.com

Wyler Werbung
Volkmarstr 5
8006 Zurich Switzerland
p. +41.1.362.7272
f. +41.1.362.7392
e. info@wylerwerbung.ch
w. www.wylerwerbung.ch.

Bibliography

Ballance, Georgette and Heller, Stephen 2001. <u>Graphic Design History</u>. New York: Allworth Press.

Bright, Susie 1995. <u>Susie Bright's Sexwise: America's Favorite X-rated Intellectual Does Dan Quayle, Catherine MacKinnon, Stephen King, Camille Paglia, Nicholson Baker, Madonna, the Black Panthers, and the GOP</u> Pittsburg, Pa: Cleis Press.

Burgin, Victor, James, Donald and Kaplan, Cora 1996. <u>Formations of Fantasy</u> London; New York: Methuen, 1986.

Butler, Judith 1990. <u>Gender Trouble</u> New York and London: Routledge.

Christy, Kim and Quinn, John 2001. <u>Christy Report</u> New York: Taschen America.

Chwast, Seymour and Heller, Stephen 1994. <u>Graphic Style: From Victorian to Post-Modern</u> New York: Harry N. Abrams.

Daniélou, Alain 1995. <u>The Phallus: Sacred Symbol of the Male Creative Power</u>. Translated from the French by Jon Graham. Rochester, Vt.: Inner Traditions.

D'Emilio, John 1988. Intimate Matters: A History of Sexuality in America New York: Harper & Row.

Dijkstra, Bram 1998. <u>Evil Sister: The Threat of Female Sexuality and the Cult of Motherhood</u> Owl Publishing Company.

Dworkin, Andrea 1995. <u>Intercourse</u> Free Press.

Faludi, Susan 1992. <u>Backlash: The Undeclared War Against American Women</u> New York: Anchor Books/Double Day.

Fausto-Sterling, Anne 2000. <u>Sexing the Body: Gender Politics and the Construction of Sexuality</u> New York, NY: Basic Books.

Foucault, Michel 1985. <u>The History of Sexuality</u> New York: Vintage Books.

Frankenberg, Ruth. 1993. <u>White Women, Race Matters: The Social Construction of Whiteness</u>. Minneapolis: University of Minnesota Press.

Freccero, Carla 1993. "Unruly Bodies: Popular Culture Challenges to the Regime of Body Backlash: Two Live Crew and Madonna." *Visual Anthropology Review*, Vol. 9, no 1, Spring 1993. (pp. 74-81).

Gammel, Irene 1999. <u>Confessional Politics : Women's Sexual Self-Representations in Life Writing and Popular Media</u> Carbondale: Southern Illinois University Press.

Gates, H. L., Jr., ed.1990, <u>Reading Black, Reading Feminist</u> New York: Meriden Press.

Haining, Peter 2001. <u>The Classic Era of American Pulp Magazines</u> Chicago: Chicago Review Press.

Halberstam, Judith and del LaGrace Volcano 1999. <u>The Drag King Book: A First Look</u> Serpent's Tail.

Halberstam, Judith 1998. <u>Female Masculinity</u> Durham NC: Duke University Press.

Haraway, Donna. 1991. <u>Simians, Cyborgs, and Women</u> London and New York: Routledge.

Haraway, Donna. 1990. "A Manifesto for Cyborgs: Science, Technology, and Socialist Feminism in the 1980s." In <u>Feminism/Postmodernism</u>, ed. Linda J. Nicholson. New York: Routledge.

Heller, Stephen, ed. 2000. <u>Sex Appeal: The Art of Allure in Graphic and Advertising Design</u> New York: Allworth Press.

Hooks, Bell 1984. <u>Feminist Theory: From the Margins to the Center</u> Boston: South End Press

Hull, Gloria T. et al.eds. 1982. <u>But Some of Us Are Brave: Black Women's Studies</u> Old Westbury, NY: Feminist Press.

Hunt, Lynn, ed 1991. <u>Eroticism and the Body Politic</u>. Edited by Lynn Hunt. Baltimore, MD.: Johns Hopkins University Press, 1991.

Jackson, Stevi 1996. <u>Feminism and Sexuality: A Reader</u> New York: Columbia University Press.

Kipnis, Laura 1996. <u>Bound and Gagged: Pornography and the Politics of Fantasy in America</u>. New York: Grove Press

Kuhn, Annette, 1985. <u>The Power of the Image: Essays on Representation and Sexuality</u> London; Boston: Routledge & Kegan Paul, 1985.

Maglin, Nan Bauer, and Perry, Donna 1996. <u>"Bad Girls"/"Good Girls": Women, Sex, and Power in the Nineties</u> New Brunswick, NJ: Rutgers University Press.

Masters, William H.1994. <u>Heterosexuality</u> New York, NY: Harper Collins.

Michelson, Peter 1971. <u>The Aesthetics of Pornography</u>. New York: Herder and Herder.

Mirzoeff Nicholas, ed 1998. <u>The Visual Culture</u> London; New York: Routledge 1998.

Myrsiades, Kostas and Myrsiades, Linda 1998. Race-ing Representation: Voice, History, and Sexuality Lanham, MD: Rowman & Littlefield Publishers.

Nathanson, Constance 1991. Dangerous Passage: The Social Control of Sexuality in Women's Adolescence Philadelphia: Temple University Press.

The New Museum of Contemporary Art, (New York) 1984. Difference: On Representation and Sexuality.

Peckham, Morse 1969. Art and Pornography: An Experiment in Explanation New York: Basic Books.

Pinkerton, Steven D., ed 1995. Sexual Nature, Sexual Culture Chicago: University of Chicago Press.

Posner, Richard 1994. Sex and Reason Cambridge: Harvard University Press.

Queen, Carol and Schimel, Lawrence, eds 1997. Homosexuals: Challenging Assumptions about Gender and Sexuality San Francisco, CA: Cleis Press 1997.

Rotundo, E. Anthony 1993. American Manhood: Transformations in Masculinity from the Revolution to the Modern Era New York: Basic Books.

Smith, Barbara 1985. "Towards a Black Feminist Criticism," in Showalter, The New Feminist Criticism: Essays on Women, Literature, Theory New York: Pantheon.

Sedgwick, Eve Kosofsky 1990. Epistemology of the Closet Berkeley: Univ. of California Press.

Somerville, Siobhan B. 2000. Queering the Color Line: Race and the Invention of Homosexuality in American Culture Durham: Duke University Press.

Steiner, Wendy 1995. The Scandal of Pleasure: Art in an Age of Fundamentalism. Chicago: University of Chicago Press.

Stryker, Susan 2001. Queer Pulp; Perverted Passions from the Golden Age of the Paperback New York: Chronicle Books.

Terry Smith, ed 1997. In Visible Touch: Modernism and Masculinity Chicago: University of Chicago Press.

Terry, Jennifer and Urla, Jacquiline, eds 1995. Deviant Bodies: Critical Perspectives on Difference in Science and Popular Culture Bloomington: Indiana University Press.

Walters, Suzanna Danuta 2001. All the Rage: The Story of Gay Visibility in America Chicago: University of Chicago Press.

Weil, Kari 1992. Androgyny and the Denial of Difference Charlottesville: University Press of Virginia.

Williams, Linda 1990. Hard Core: Power, Pleasure, and the "Frenzy of the Visible." Berkeley, CA: University of California

About the writer

In addition to holding down a job at Plazm, **Sarah Dougher** is a musician who tours internationally and who has put out six albums in the past six years. She writes about music, gender, and sexuality for regional publications and is working on a book about the gay history of rock 'n' roll. Sarah was instrumental in putting together the first Ladyfest, and is currently raising money and doing publicity for the Rock 'n' Roll Camp for Girls in Portland, Oregon. She also teaches Latin and classical mythology at the Evergreen State College in Olympia, Washington.

About the designer

Joshua Berger is one of three founding principals and the managing partner of Plazm Media. Berger has been recognized by numerous design publications and award shows, among them the Art Directors Club, the Graphis annual and AIGA national show. He was also awarded a gold medal at the Leipzig Book Fair for the design of *Soul of the Game* (a collaboration with John Jay), for Melcher Media/Workman, 1999. With Plazm, he was listed in 1997 in *ID* magazine's ID40 as one of the world's forty most influential designers. His most recent projects include assignments for Lucasfilm, Jantzen, Nike, and MTV.

About Plazm Media

Founded in 1991 by artists as a creative resource, Plazm publishes an eclectic design magazine with worldwide distribution and operates an innovative type foundry. Plazm is also a design firm that builds complete brands, advertising, and retail marketing plans using custom typography.

We would like to hear from you.

Please send comments, criticism, and examples of sex in contemporary design for future publication to:
Plazm Media, P.O. Box 2863, Portland, OR 97208 USA / info@plazm.com / www.plazm.com

About Dan Savage

Dan Savage's column, "Savage Love," is an internationally syndicated sex-advice column read by millions of people every week. He has written the column for ten years and it runs in more than seventy newspapers in the United States, Canada, Europe, and Asia. His latest book, *Skipping Toward Gomorrah: The Seven Deadly Sins and the Pursuit of Happiness in America* is a new collection of essays and was just released to critical acclaim in the fall of 2002. Savage is also the editor of *The Stranger*, Seattle's weekly newspaper. Savage is the author of *Savage Love*, a collection of his advice columns, and the *Kid*, an award-winning memoir about adoption. Savage's writing has appeared in the *New York Times Magazine*, the op-ed pages of the *New York Times*, *Travel & Leisure*, Salon.com, *Nest*, *Rolling Stone*, the *Onion*, and other publications. He has also contributed numerous pieces to *This American Life* on NPR. He lives in Seattle, Washington. More information about his new book can be found at www.skippingtowardsgomorrah.com.

Acknowledgments

The authors would like to thank Kristin Ellison for her guidance and encouragement.

This book could not have been written, designed, and assembled without the help of our assistants Lucia Harold and Sara Lund, as well as our devoted interns, Shannon McMahon, Rob Kelley, Ryan Wantland, and Ben Mulkey. Thanks to Tiffany Lee Brown for editing assistance.

In addition, the authors would like to thank the staff at Plazm Media: Pete McCracken, Jeremy Bittermann, Jon Raymond, Carole Ambauen, and Niko Courtelis.

Production Notes
This book was printed process color with full aqueous coating on a Heidelberg press at Midas Printing International Ltd.,
Hong Kong. Paper is 128GSM Japanese Matte text. Cover is 100 percent rubber. Silkscreened at Midas Printing International
Ltd., Hong Kong

Typography
Headlines are set in Marquee Extra Light, Light, and Regular. Designed by Pablo Medina, based on old Times Square
Marquees famous for twenty-four hour porn. Marquee is available from Plazm Fonts at www.plazm.com.
Text is set in Trade Gothic, cut by Linotype AG and available at www.adobe.com.

Photograph: Pablo Medina